W9-CPG-482

To Eros

From all the offspring
of the earth and heaven
love is the most precious.

—SAPPHO,
translated by Willis Barnstone

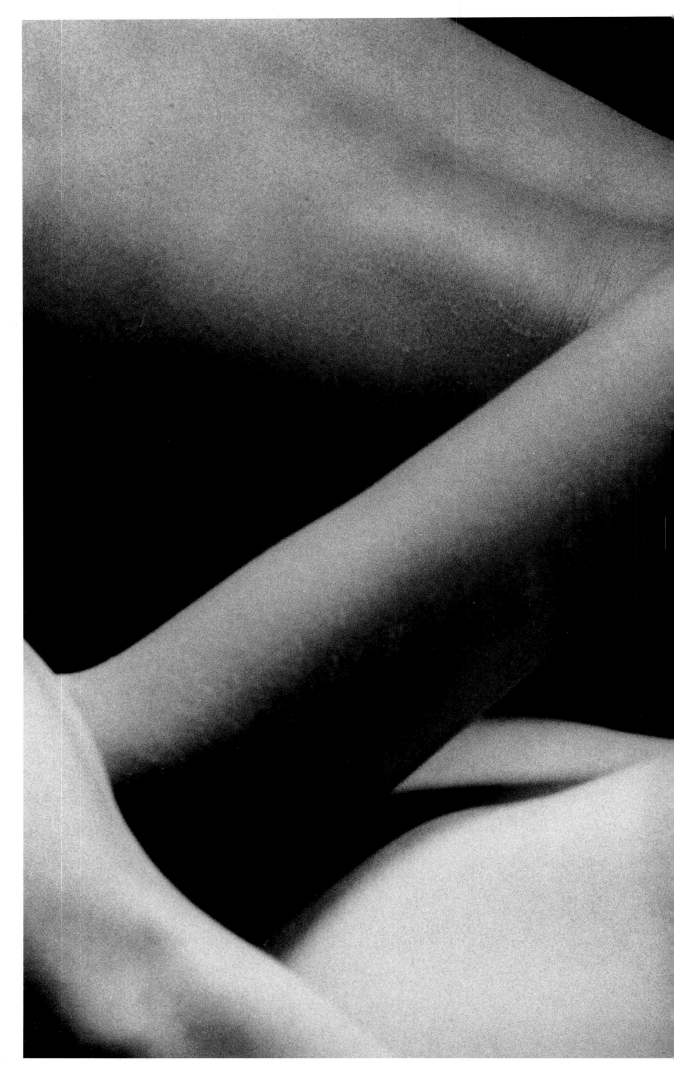

HAROLD FEINSTEIN, *In Love*, 1995

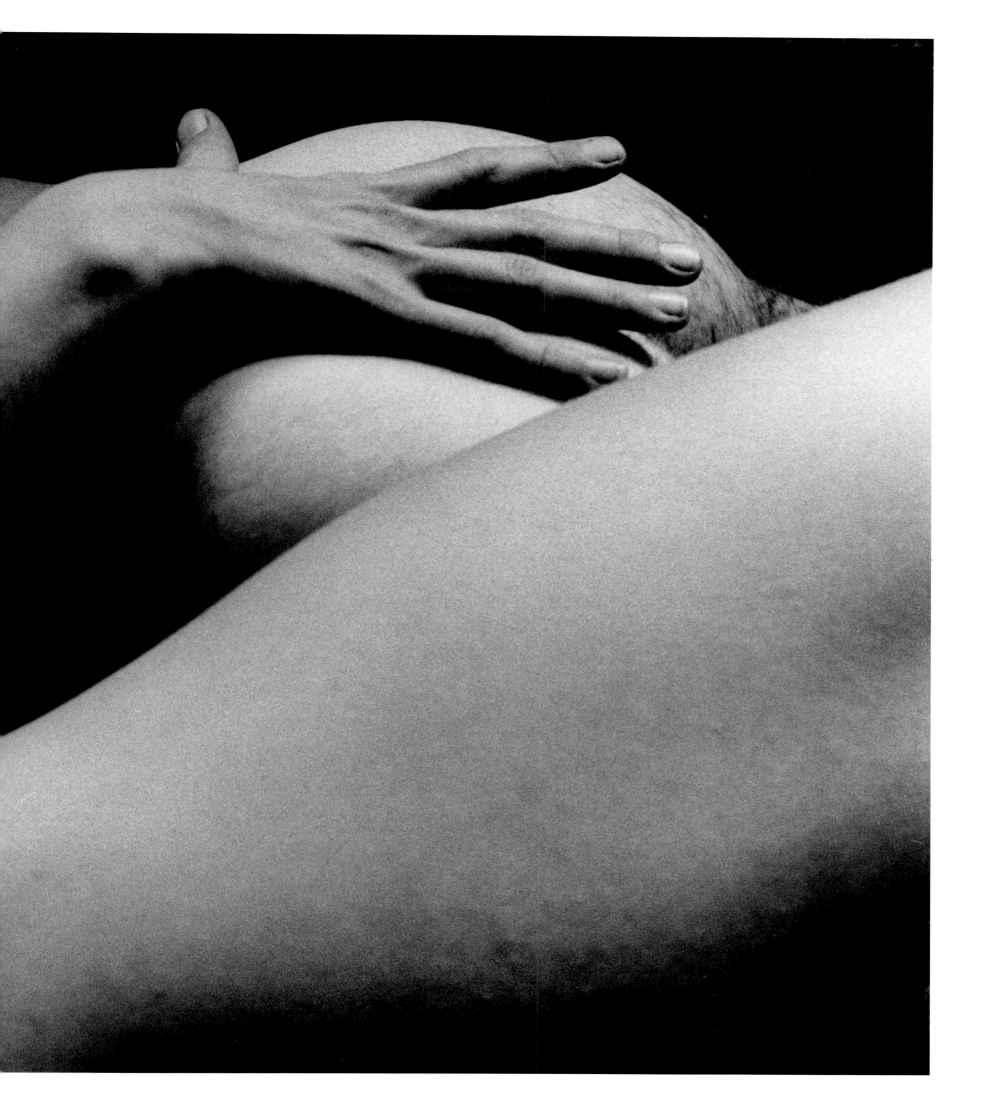

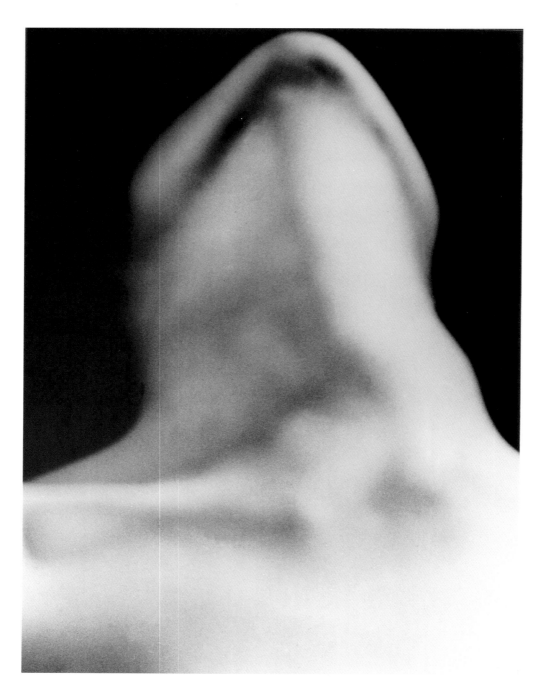

MAN RAY, *Le cou*, 1929

The force that through the green fuse drives the flower
Drives my green age; that blasts the roots of trees
Is my destroyer.
And I am dumb to tell the crooked rose
My youth is bent by the same wintry fever.

The force that drives the water through the rocks
Drives my red blood; that dries the mouthing streams
Turns mine to wax.
And I am dumb to mouth unto my veins
How at the mountain spring the same mouth sucks.

—DYLAN THOMAS,
from *The Force That Through the Green Fuse Drives the Flower*

FRÉDÉRIC BARZILAY, *Untitled*, 1959

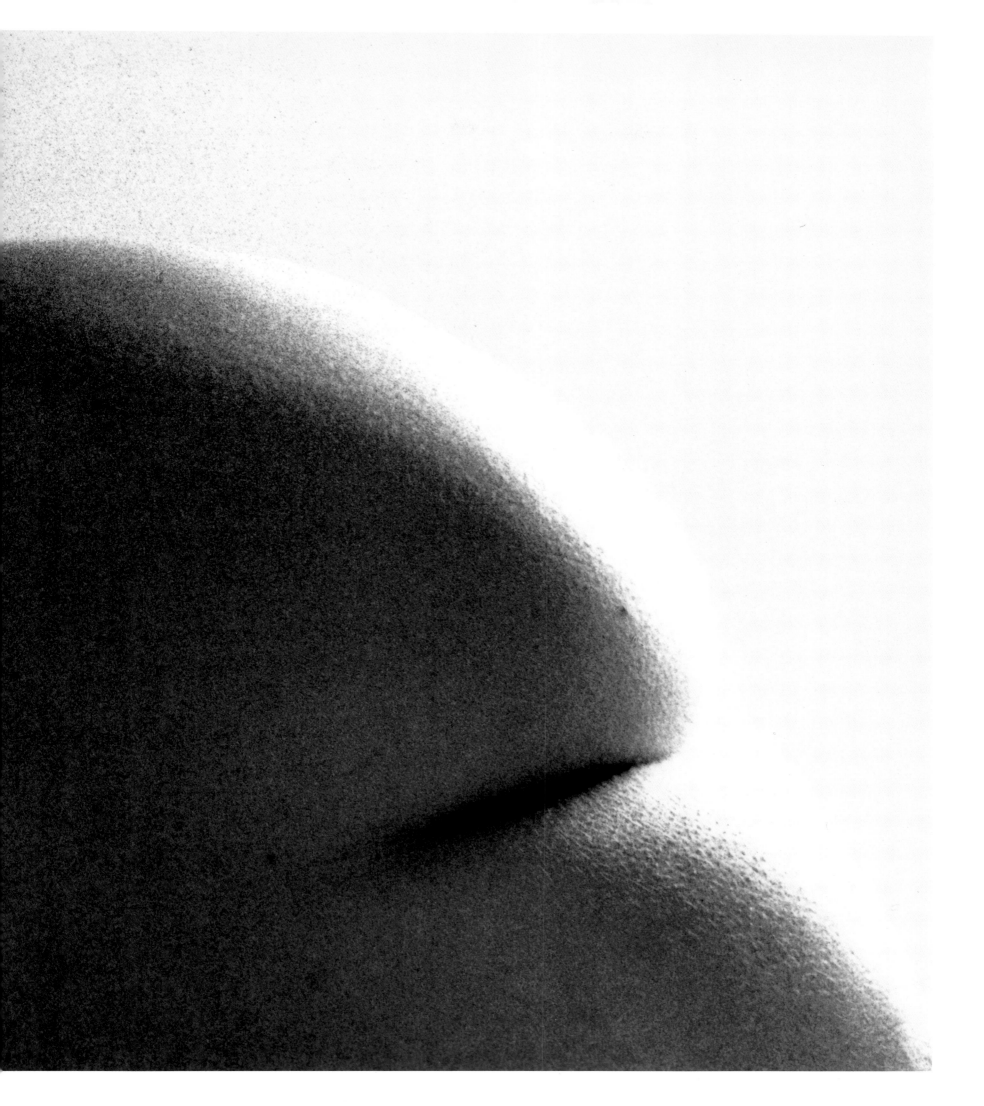

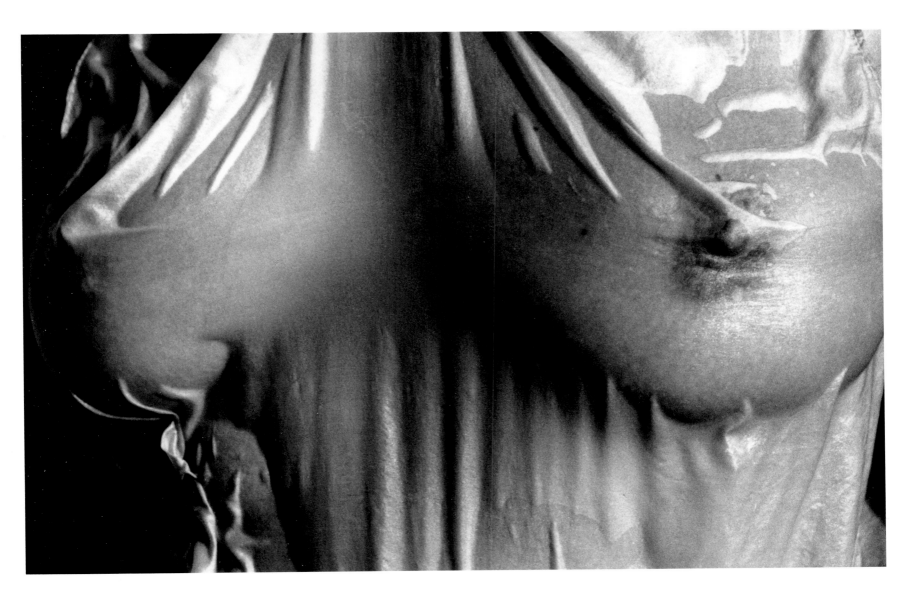

Frédéric Barzilay, *Untitled*, 1990

eros

CURATOR OF PHOTOGRAPHS *Linda Ferrer*

TEXT EDITOR *Jane Lahr*

A WELCOME BOOK

STEWART, TABORI & CHANG

NEW YORK

Western wind, when will thou blow,
The small rain down can rain?

Christ, that my love were in my arms,
And I in my bed again.

—Anonymous English Poet,
from the late Middle Ages

Annie Leibovitz, *David Parsons, New York City*, 1991

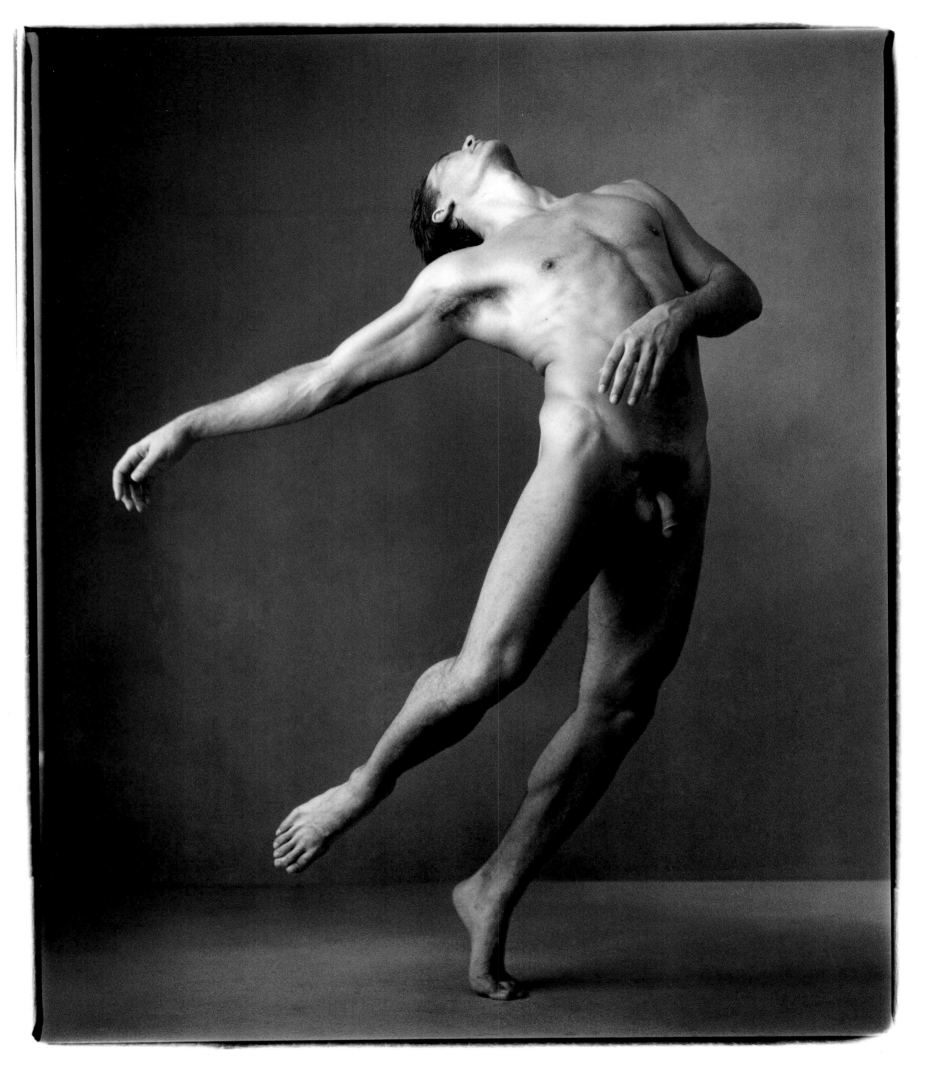

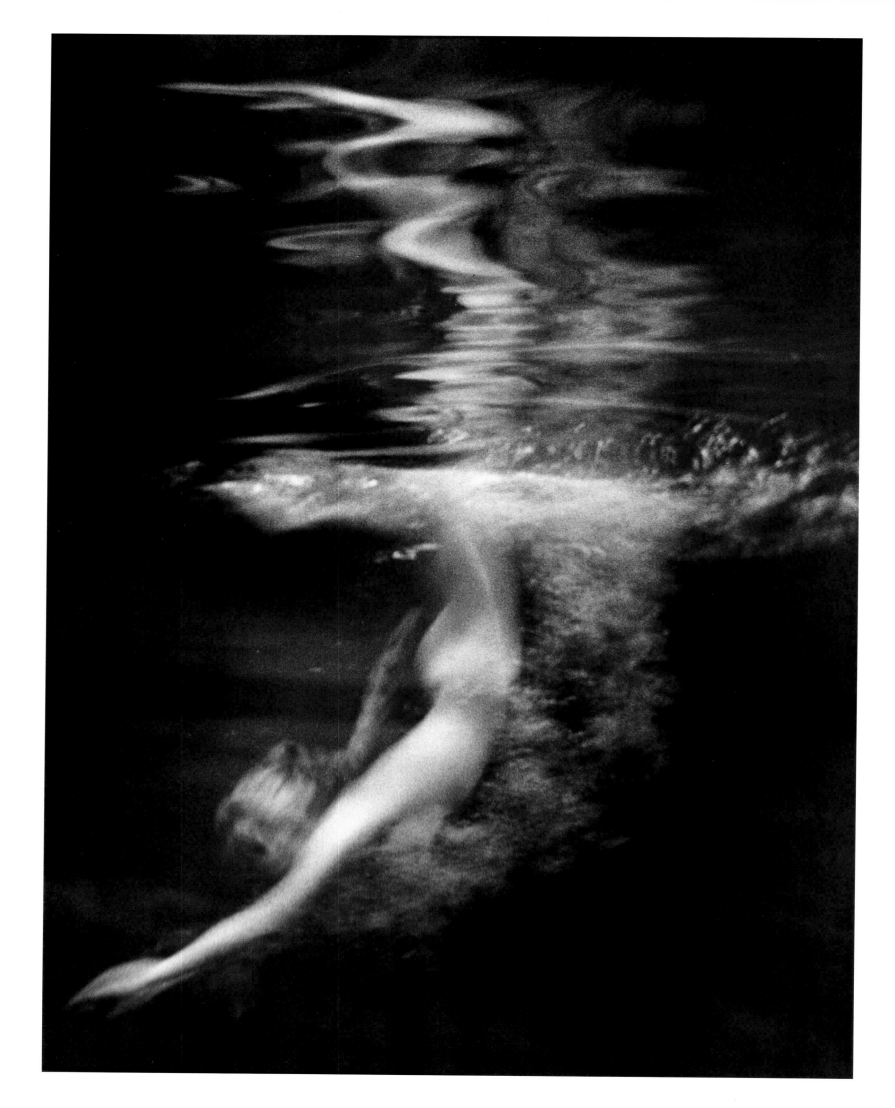

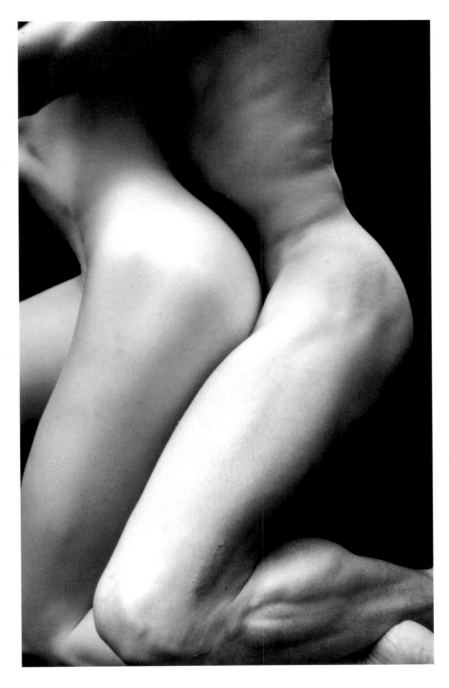

Howard Schatz, *Underwater Study #72A*, 1994

Lillian Bassman, *The Wonders of Water*, 1959

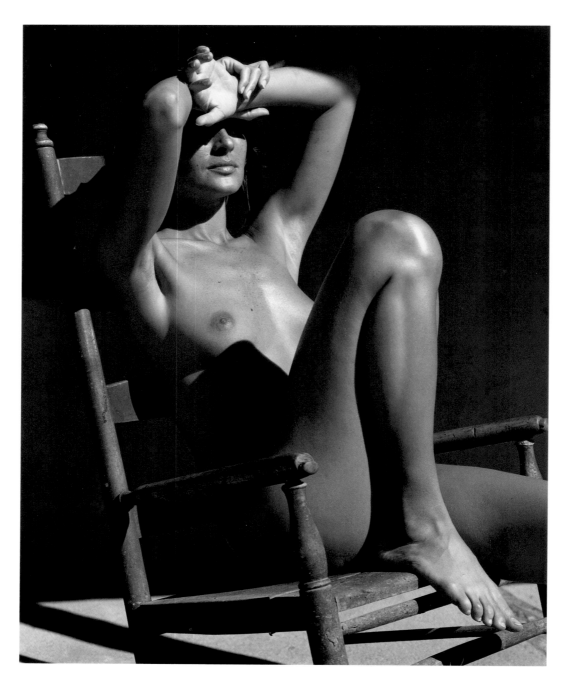

KURT MARKUS, *Cynthia in Rocker*, 1990

i think of you as
rain and i as dry earth cracked
beneath cloudless sky

—KALAMU YA SALAAM, *Haiku #107*

18

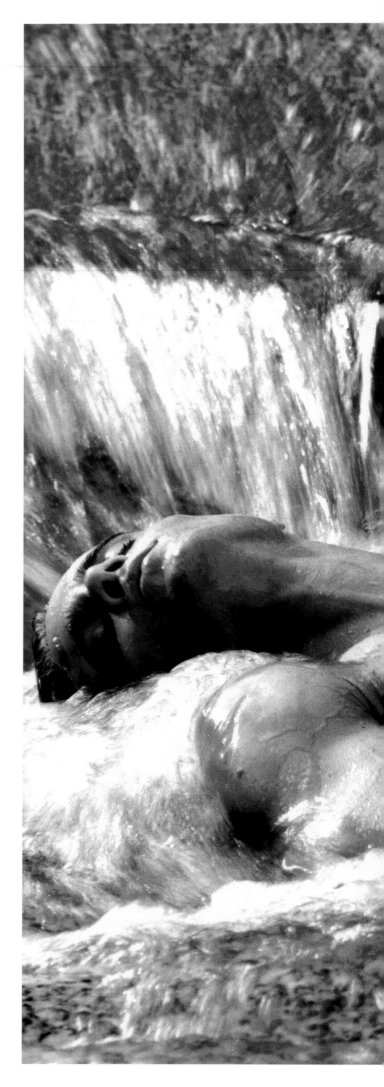

GREG GORMAN, *Scott in Waterfall*, 1990

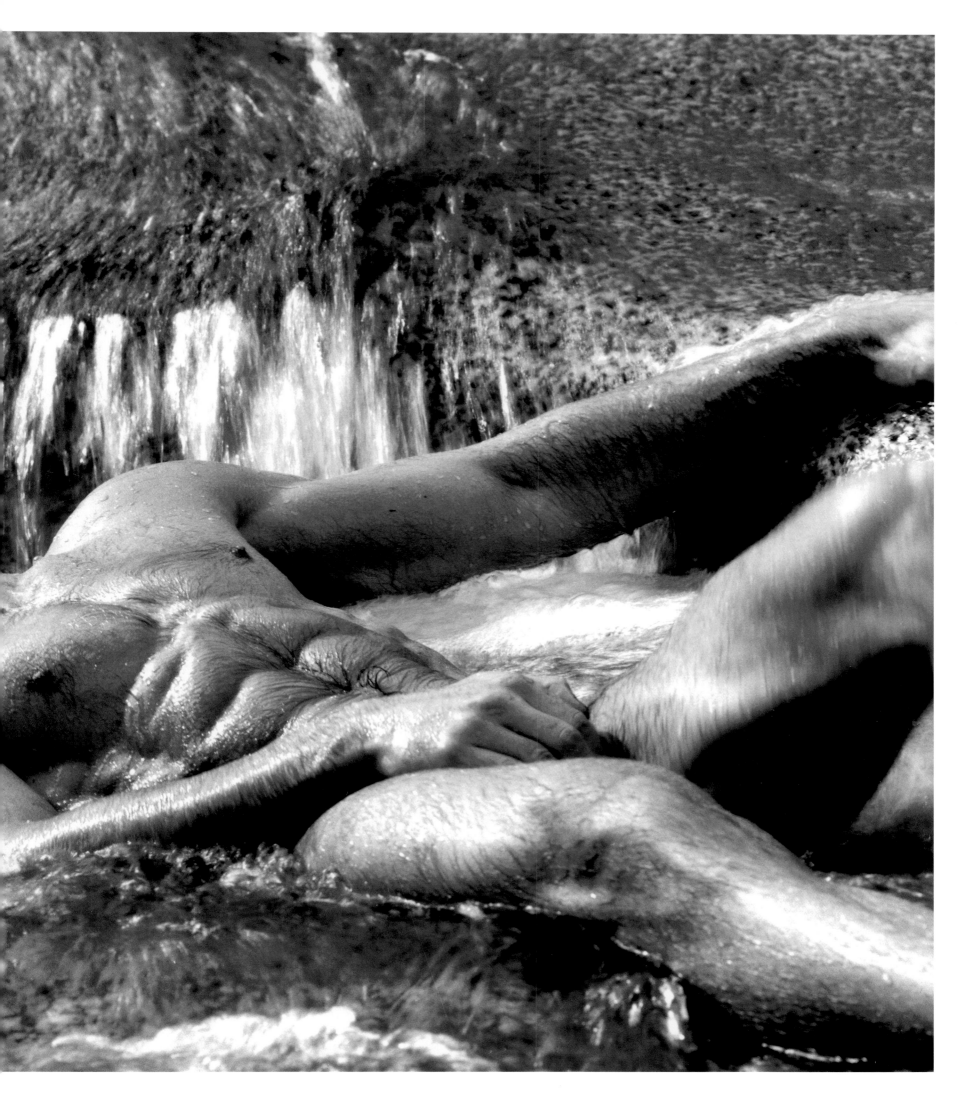

20

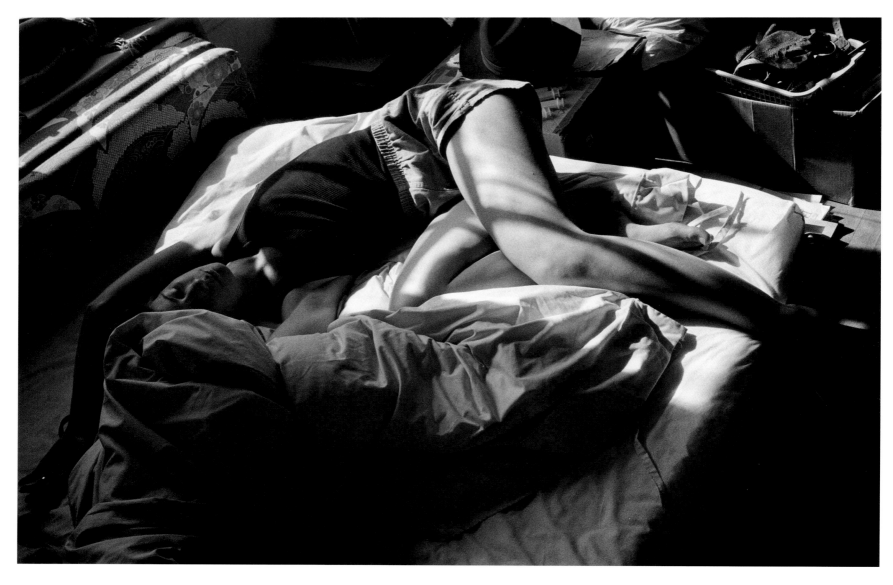

TOMAS SENNETT, *Untitled*, 1985

After weeks of anxiety the day would finally arrive. The girl too, at the last moment. Just when everything augured well, when all it needed—for what?—was a word, a look, a gesture, one discovered to his dismay that he had grown dumb, that his feet were rooted to the spot on which they had been planted ever since entering the place. Maybe once during the whole long evening did the precious one offer the slightest token of recognition. To move close to her, to brush her skirt, inhale the fragrance of her breath, what a difficult, what a monumental feat! The others appeared to move at will, freely. All that he and she seemed capable of was to slowly gravitate about such uninteresting objects as the piano, the umbrella stand, the bookcase. Only by accident did they seem destined now and then to converge upon one another. Even so, even when all the mysterious, supercharged forces in the room seemed to be pushing them toward each other, something always intervened to make them drift apart. To make it worse, the parents behaved in the most unfeeling fashion, pushing and jostling couples about, gesticulating like goats, making rude remarks, asking pointed questions. In short, acting like idiots.

The evening would come to an end with a great handshaking all around. Some kissed each other good-bye. The bold ones! Those who lacked the courage to behave with such abandon, those who cared, who felt deeply, in other words, were lost in the shuffle. No one noticed their discomfiture. They were nonexistent.

Time to go. The streets are empty. He starts walking homeward. Not the slightest trace of fatigue. Elated, though nothing had really happened. Indeed, it had been an utter fiasco, the party. But she had come! And he had feasted his eyes on her the whole evening long. Once he had almost touched her hand. Yes, think of that! *Almost*! Weeks may pass, months perhaps, before their paths cross again. (What if her parents took it into their heads to move to another city? Such things happen.) He tries to fix it in his memory—the way she cast her eyes, the way she talked (to others), the way she threw her head back in laughter, the way her dress clung to her slender figure. He goes through it all piece by piece, moment by moment, from the time she entered and nodded to someone behind him, not seeing him, or not recognizing him perhaps. (Or had she been too shy to respond to his eager glance?) The sort of girl who never revealed her true feelings. A mysterious and elusive creature. How little she knew, how little anyone knew, the oceanic depths of emotion which engulfed him!

To be in love. To be utterly alone. . . .

Thus it begins . . . the sweetest and the bitterest sorrow that one can know. The hunger, the loneliness that precedes initiation.

In the loveliest red apple there is hidden a worm. Slowly, relentlessly, the worm eats the apple away. Until there is nothing left but the worm.

And the core, that too? No, the core of the apple lingers, even if only as an idea. That every apple has a core, is this not sufficient to counterbalance all uncertainty, all doubts and misgiving? What matter the world, what matter the suffering and death of untold millions, what matter if everything goes to pot—so long as *she*, the heart and core, remains! Even if he is never to see her again he is free to think about her, speak to her in dream, love her, love her from afar, love her forever and ever. No one can deny him that. No, no one.

—HENRY MILLER, from *The World of Sex*

21

Turkish. Belly-dancer. Sexy tricks.

(That quivering! Those fingernails!)

What do I like best? Hands here, here,

Soft, soft, stroking—or better,

Piping that little old man of mine,

Fondling each foldlet, tonguing,

Tickling, easing, teasing,

Then slipping on top, and . . .

I tell you, she could raise the dead.

—AUTOMEDON, from 90–50 B.C.,
translated by Kenneth McLeish

22

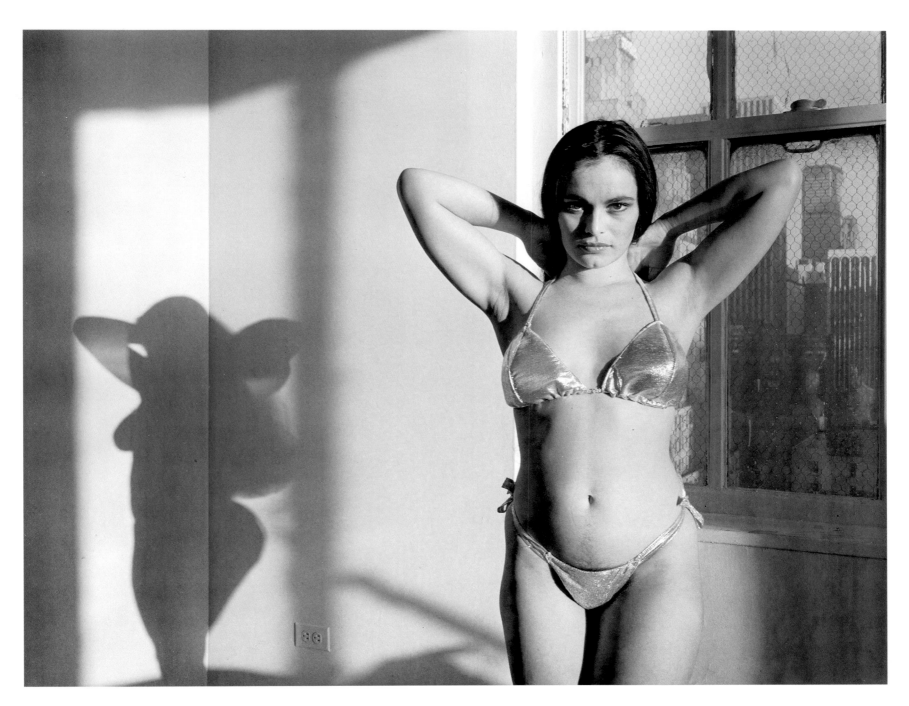

23

JOYCE BARONIO, *Portrait from 42nd Street Studio*, 1980

Marco Gl *Cynthia Antonio, Paris,* 1993

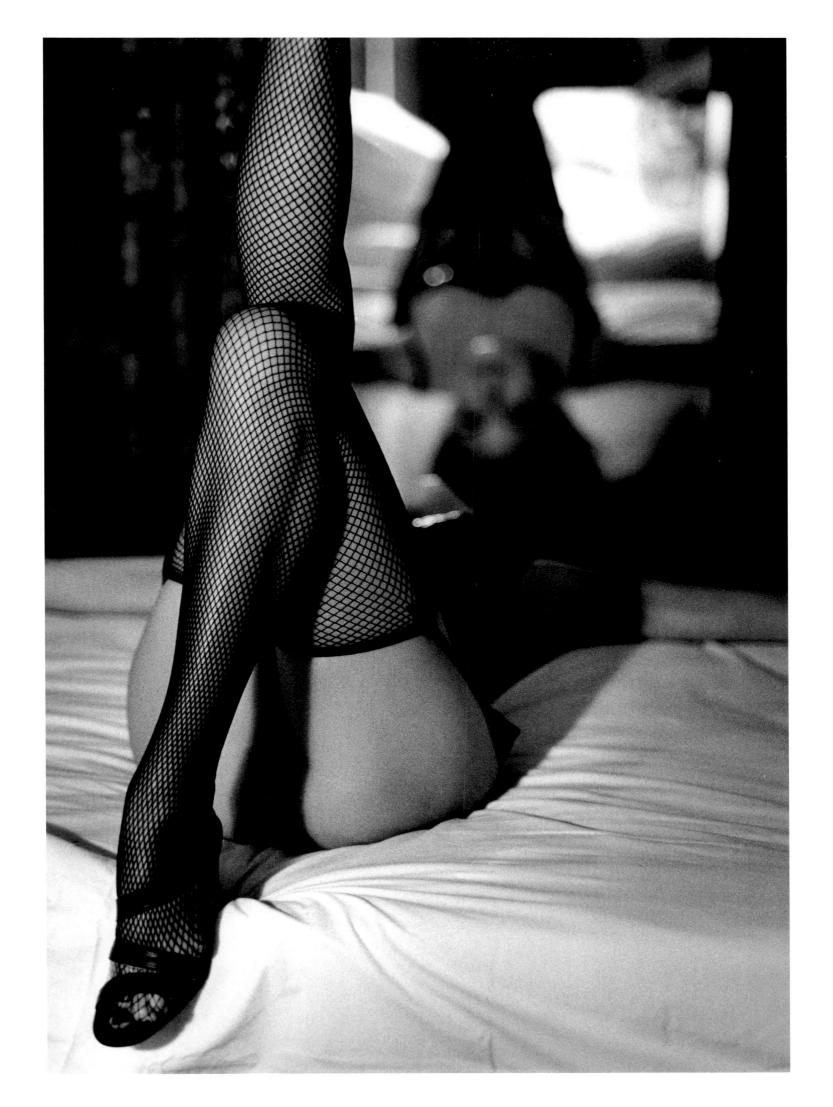

26

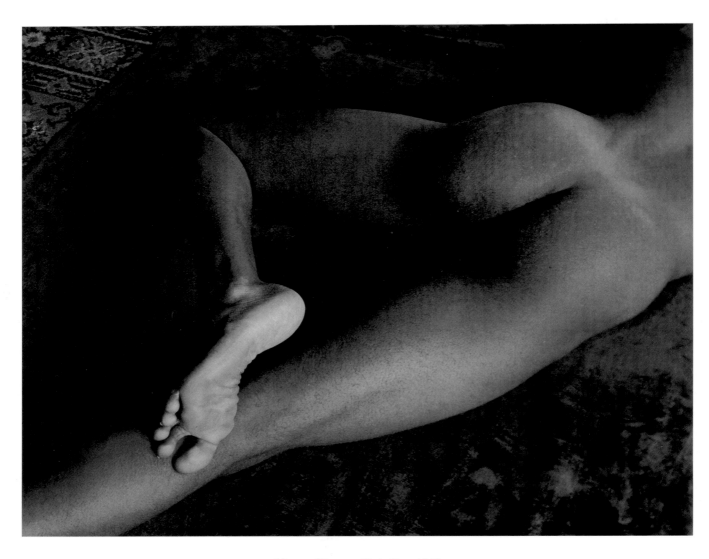

Minor White, *Nude Foot*, 1947

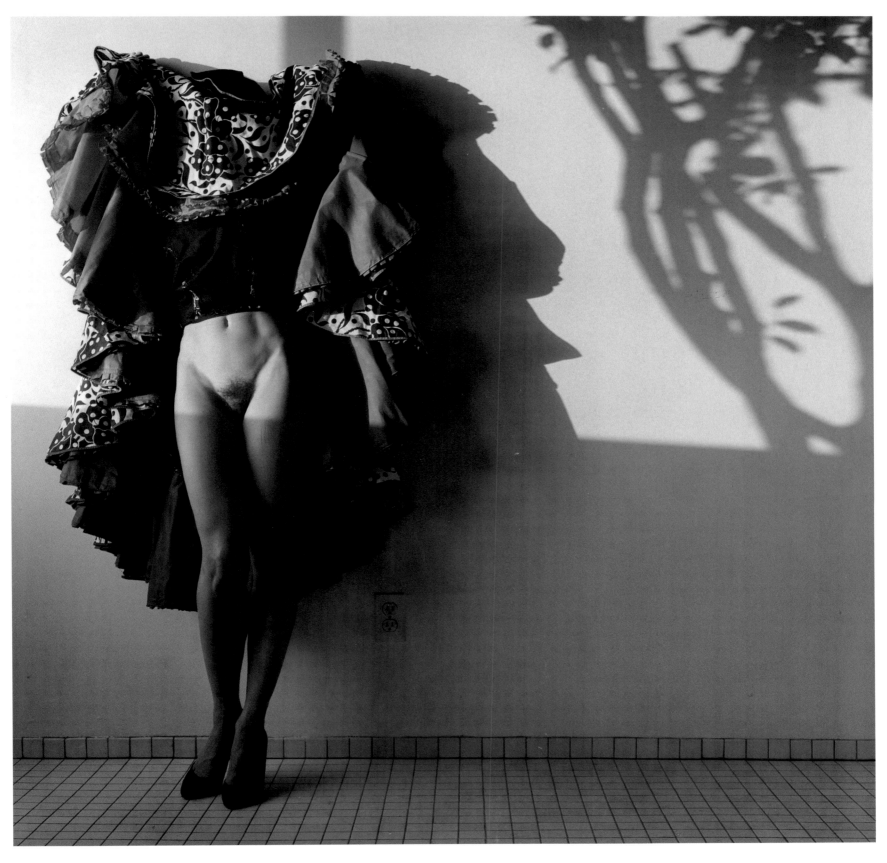

ROBERT MAPPLETHORPE, *Lisa Lyon*, 1982

28

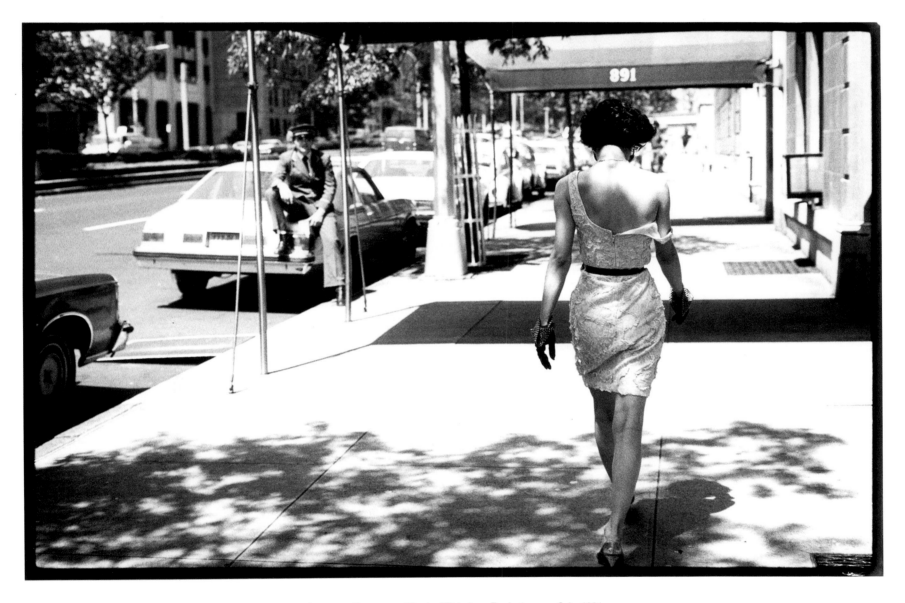

ARTHUR ELGORT, *Wendy Whitelaw, Park Avenue, July 1981*

And all her face was honey to my mouth,
 And all her body pasture to mine eyes;
 The long lithe arms and hotter hands than fire,
The quivering flanks, hair smelling of the south,
 The bright light feet, the splendid supple thighs
 And glittering eyelids of my soul's desire.

—ALGERNON CHARLES SWINBURNE, from *Love and Sleep*

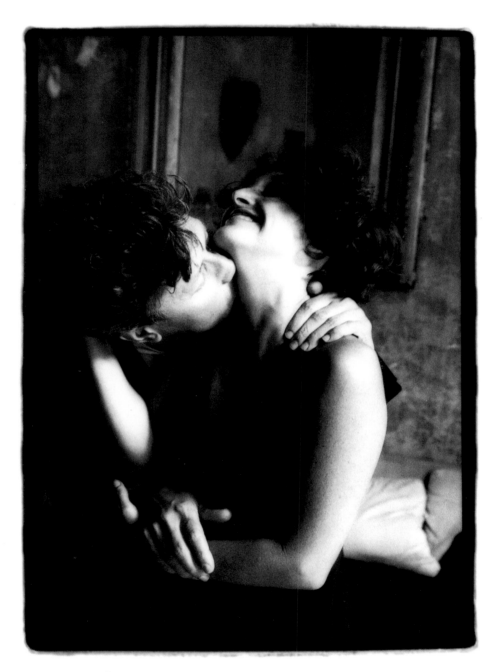

ELIZABETH ZESCHIN, *Claire and Stephen, London, 1991*

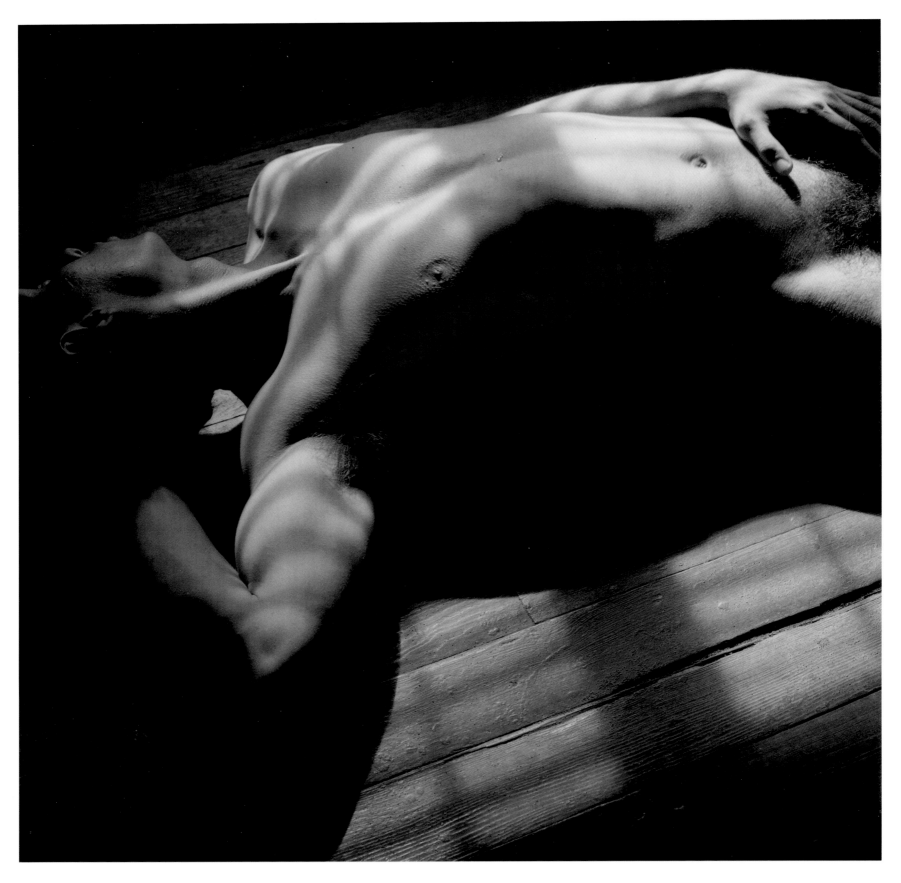

32

DANIEL HERNÁNDEZ, *Siesta de Verano*, 1990

Midwinter, the window
is luminous with blown snow, the fire
burns inside its bars

 On the floor your body curves
like that: the ancient pose, neck slackened, arms
thrown above the head, vital
throat and belly lying
undefended . light slides over you,
this is not an altar, they are not
acting or watching

You are intact, you turn
towards me, your eyes opening, the eyes
intricate and easily bruised, you open

yourself to me gently, what
they tried, we
tried but could never do
before . without blood, the killed
heart . to take
that risk, to offer life and remain

alive, open yourself like this and become whole

—MARGARET ATWOOD,
from *Book of ancestors* in *You Are Happy*

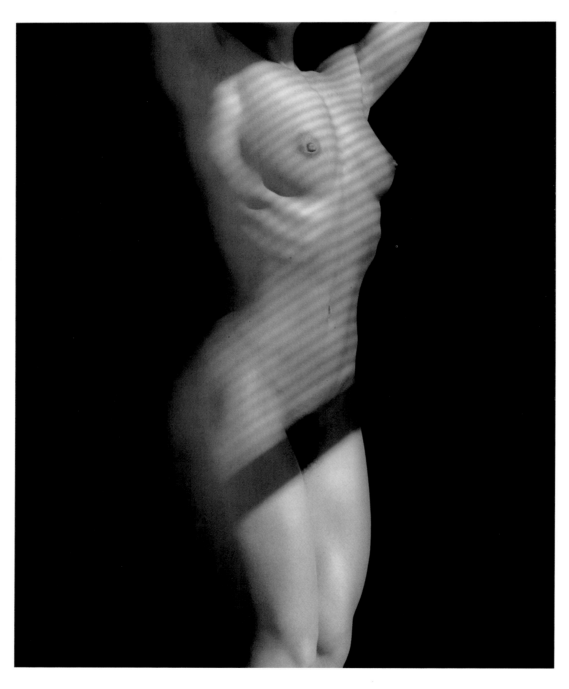

ROBERT MAPPLETHORPE, *Lydia Cheng*, 1987

MAN RAY, *Retour à la raison*, 1923

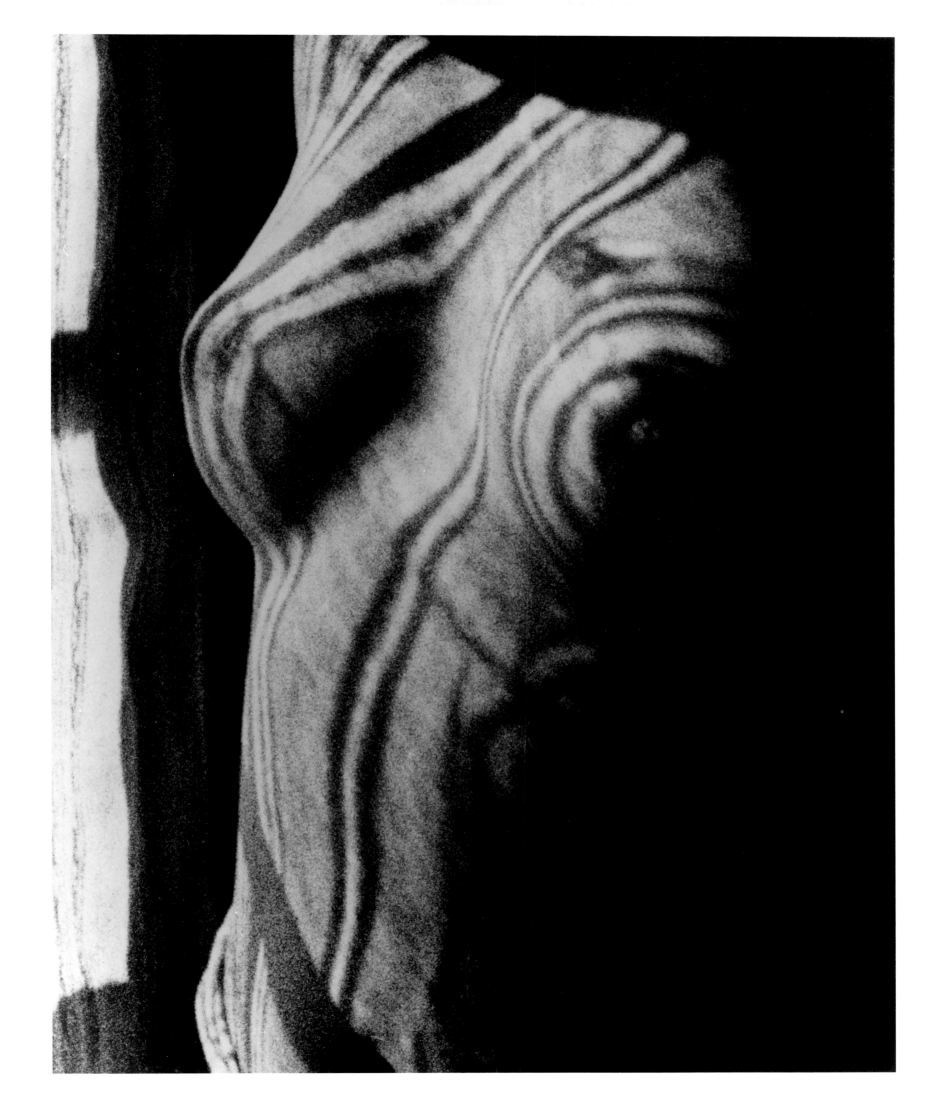

36

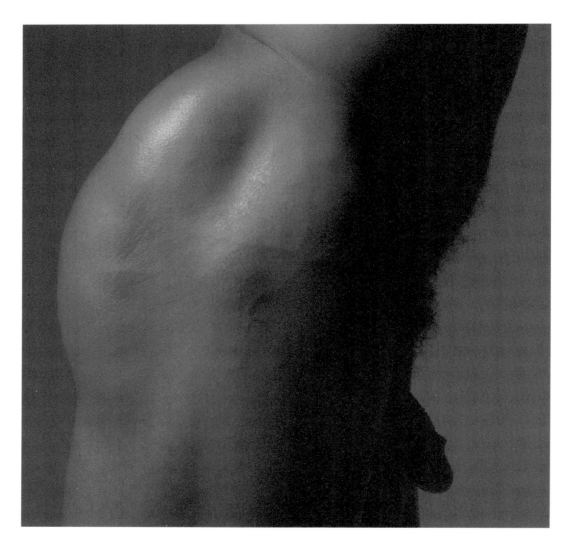

Barbara Bordnick, *Untitled*, 1996

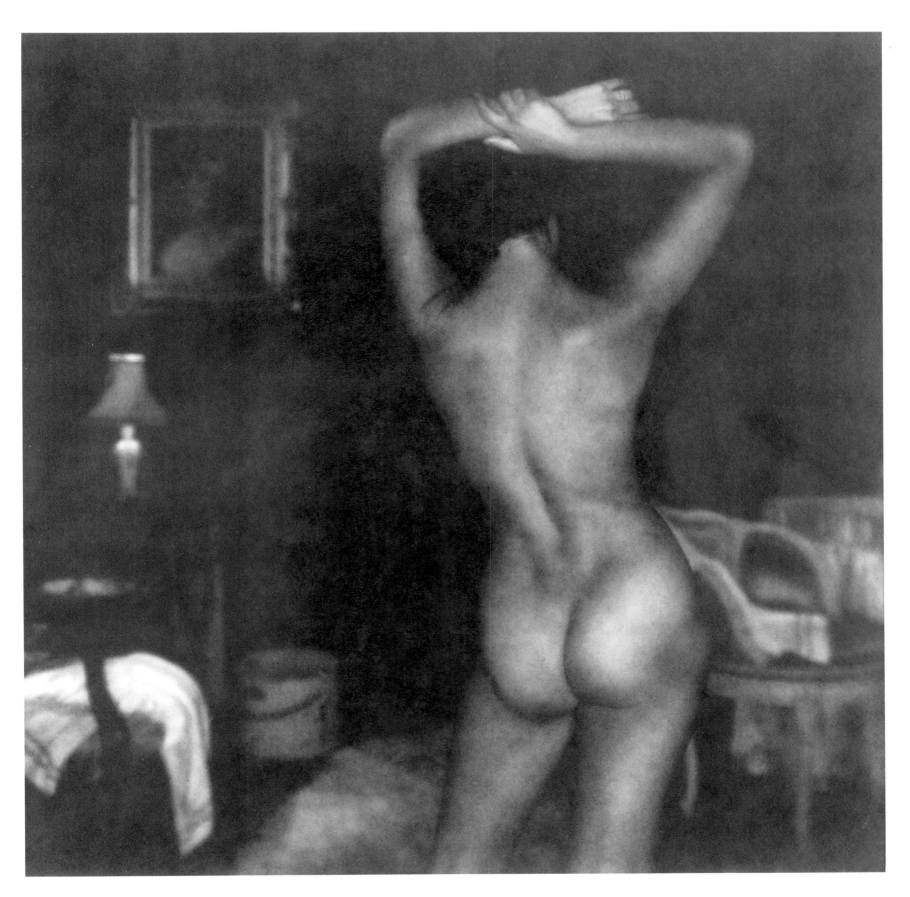

37

38

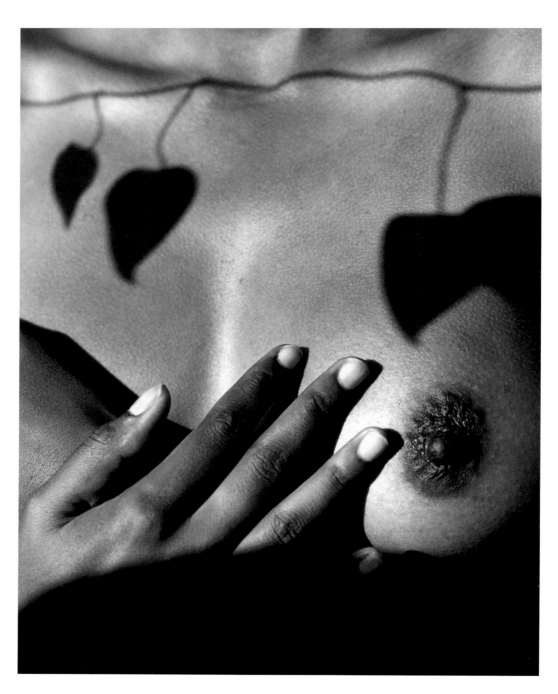

KURT MARKUS, *Marla with leaf on chest*, 1990

When I think of you,
fireflies in the marsh rise
like the soul's jewels,
lost to eternal longing
abandoning my body

—Izumi Shikibu, 970–1030 A.D.

39

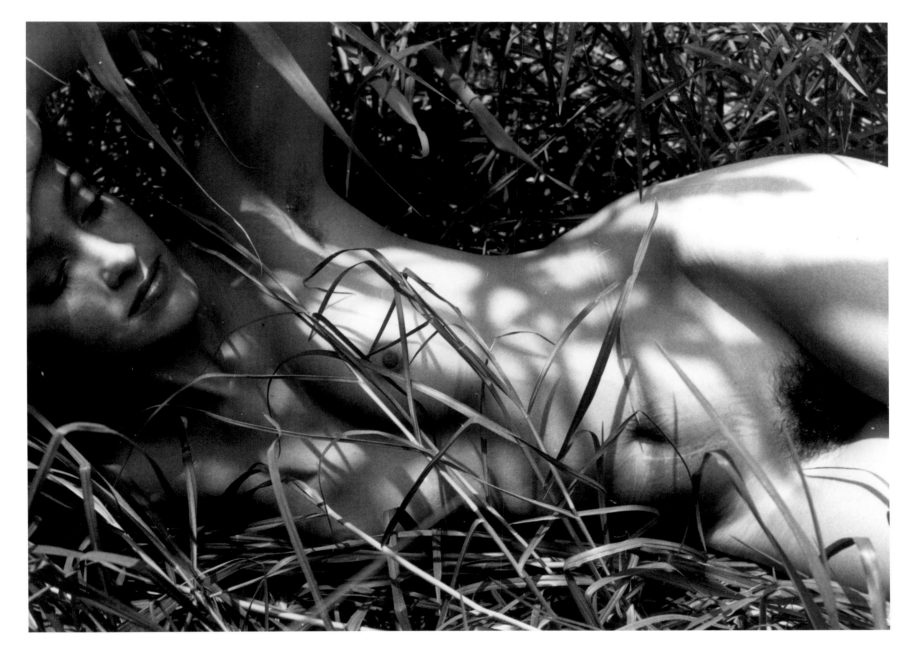

MANUEL ALVAREZ BRAVO, *Desnudo en el pasto*, 1978

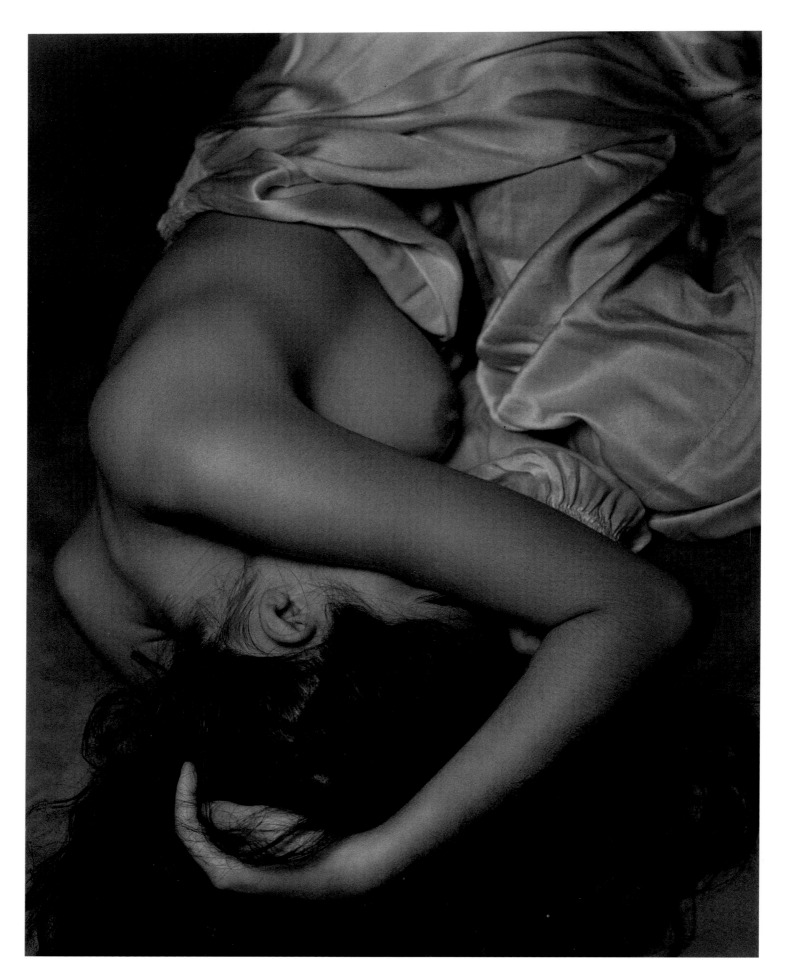

42

ALBERT WATSON, *Amira, Paris, February 1988*

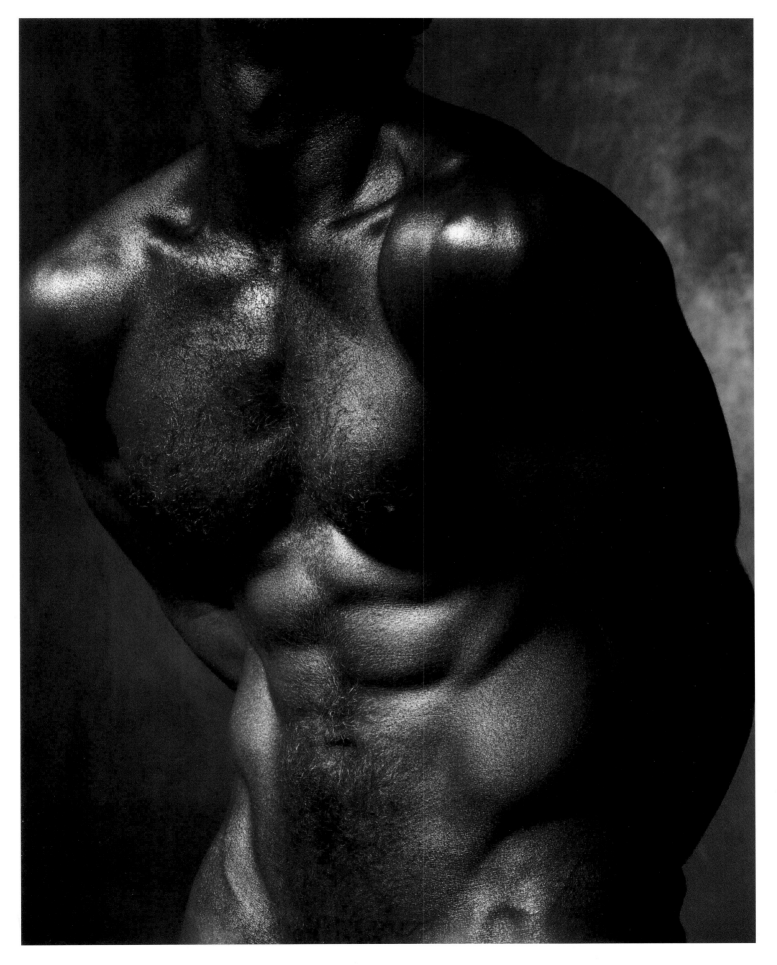

43

ALBERT WATSON, *Laurent, Torso, NYC, September 1992*

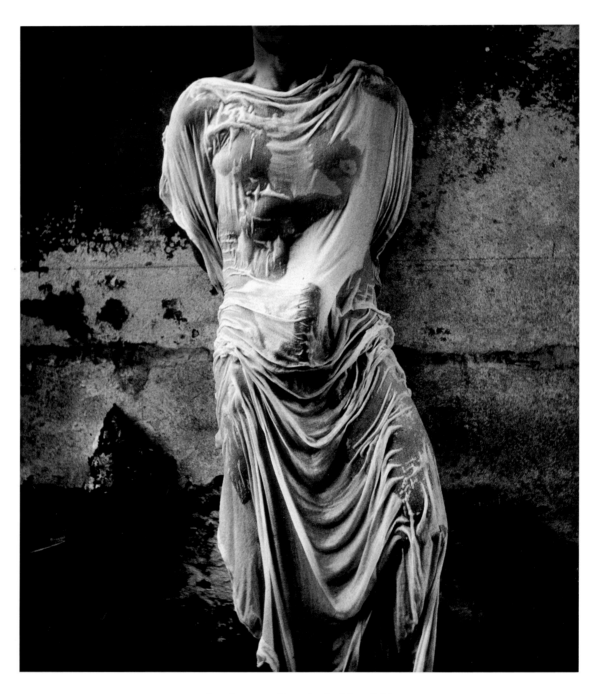

44

Jan Saudek, *Portrait of a Man*, 1984

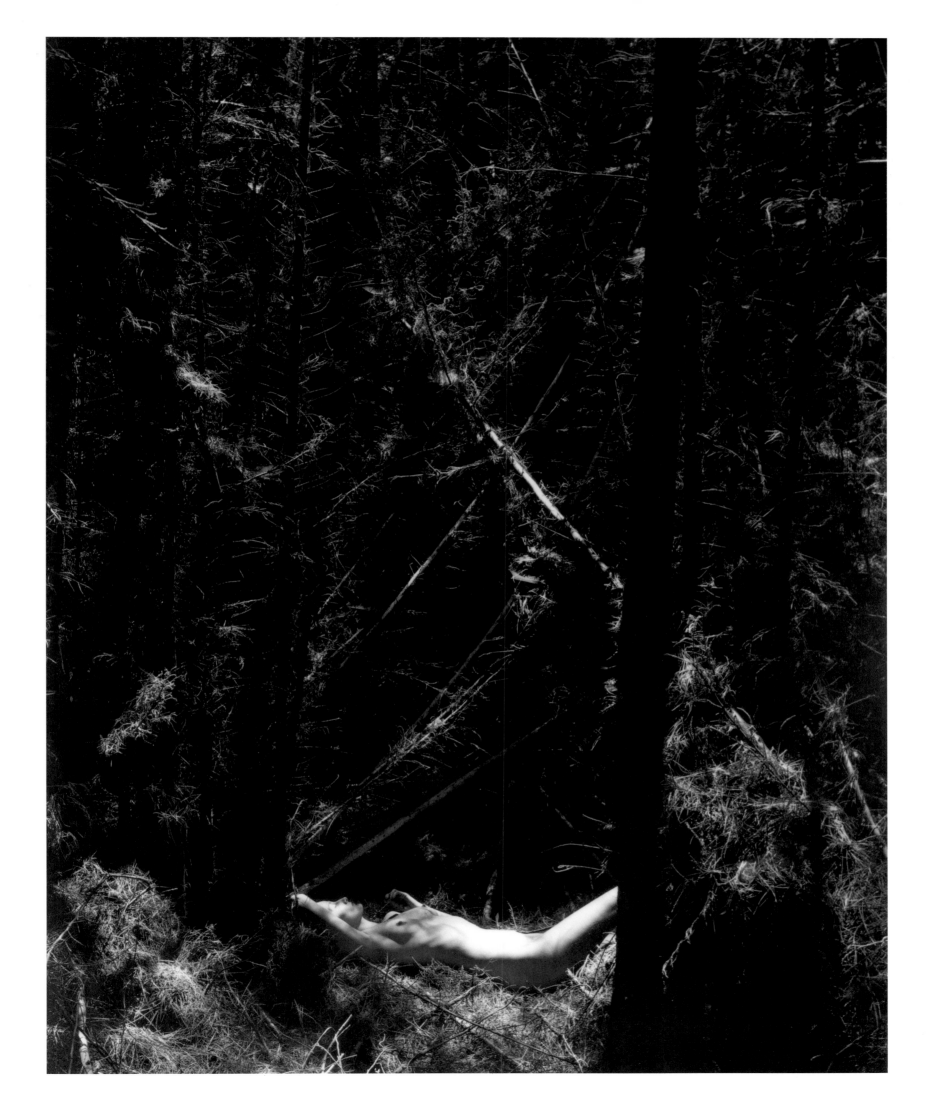

Help me
with
the buttons.

My body
is
the only clothing
I can possibly
wear.

—SIV CEDERING, *Help Me With the Buttons*

ELLEN VON UNWERTH, *Stephanie Seymour from SNAPS*, 1992

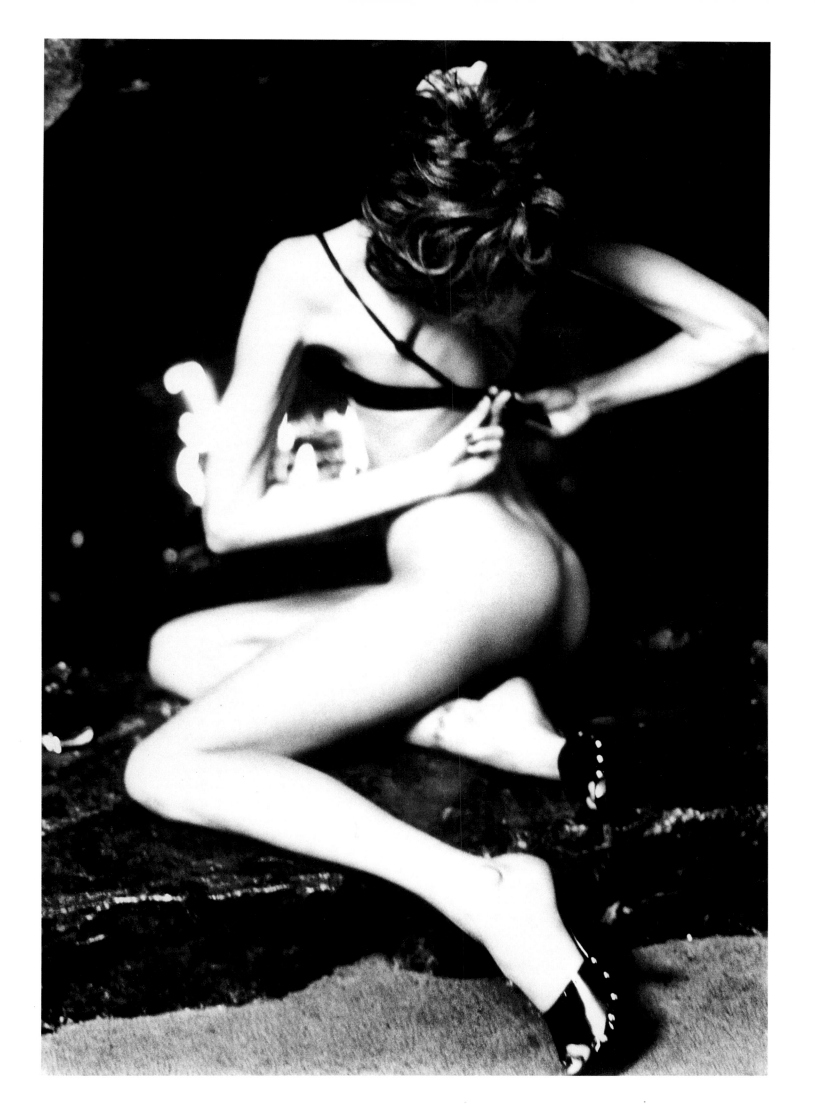

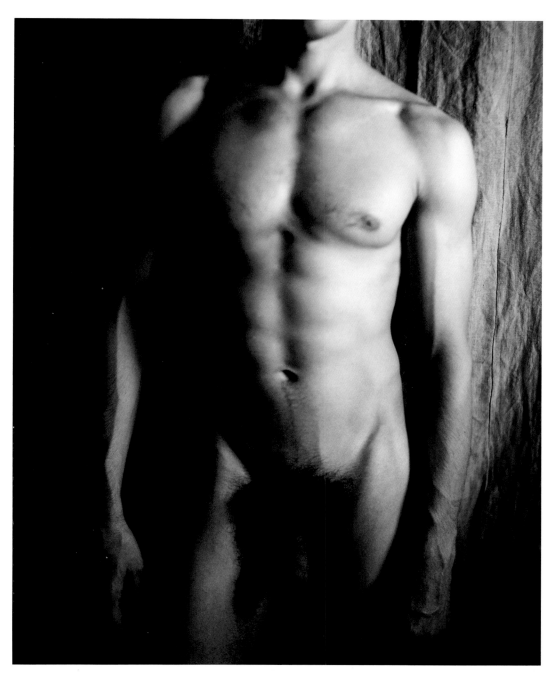

JOHN DUGDALE, *Greek Youth*, 1995

LILLIAN BASSMAN, *Untitled*, 1950s

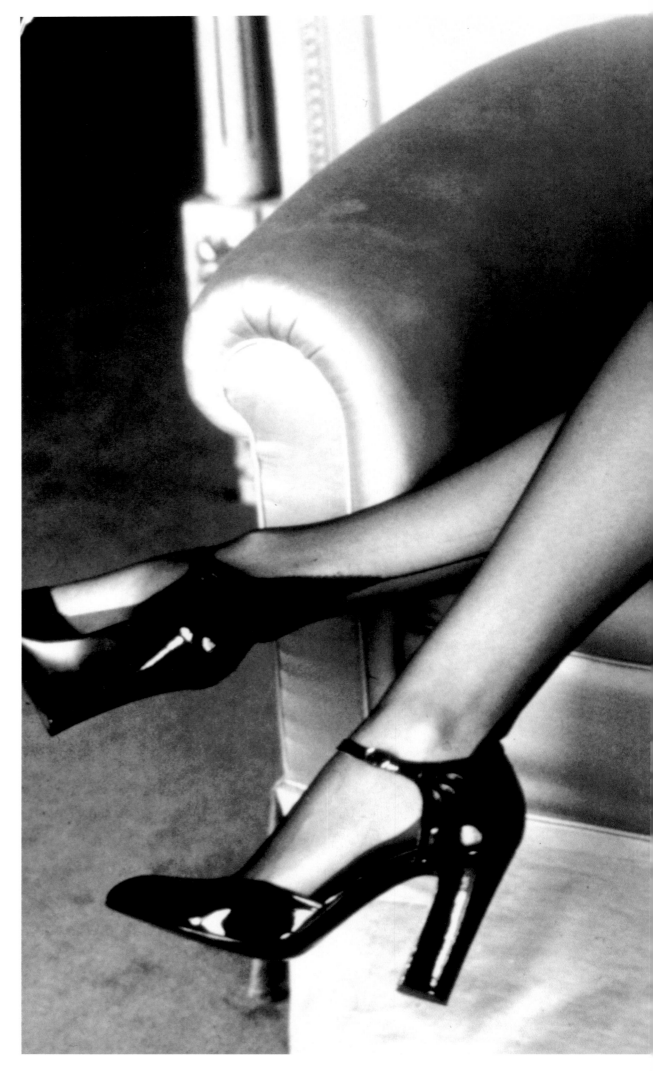

Helmut Newton, Cover of *White Women*, 1975

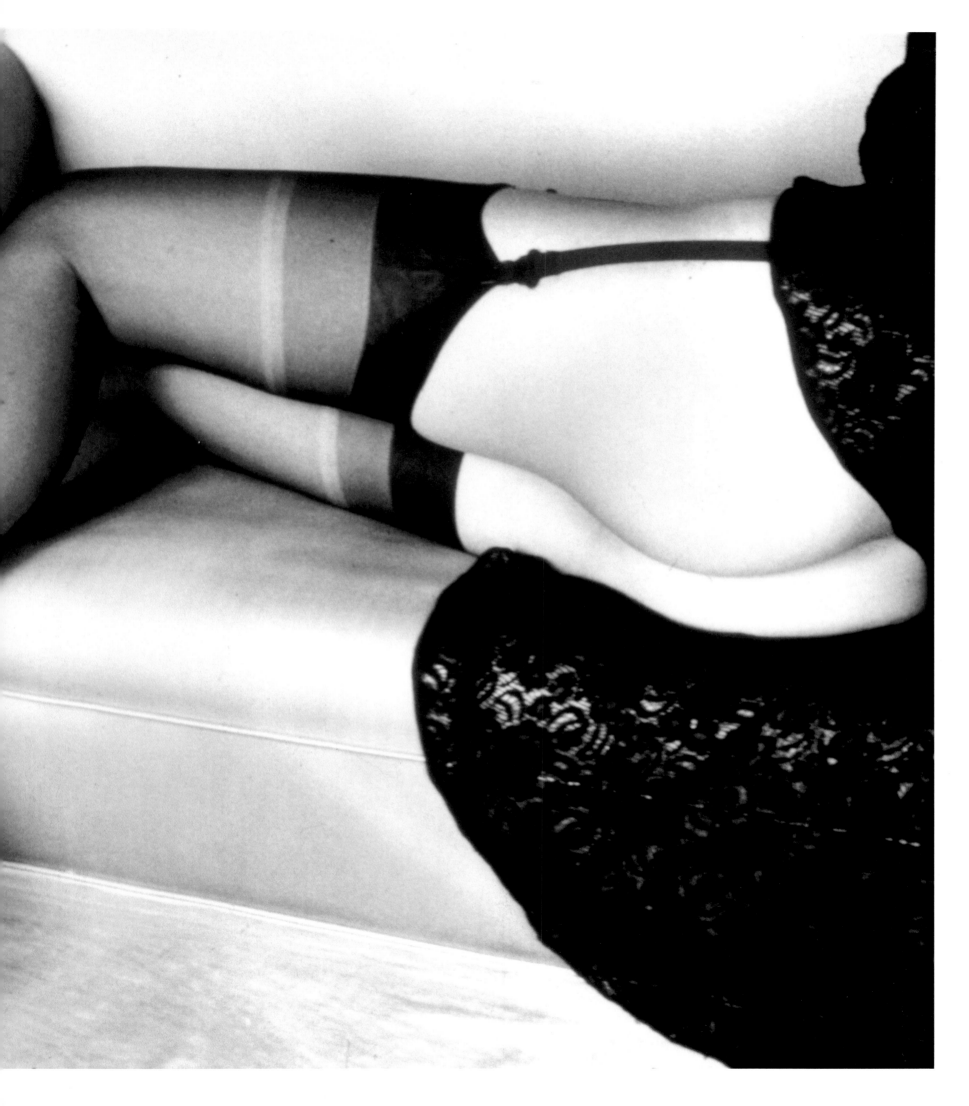

51

52

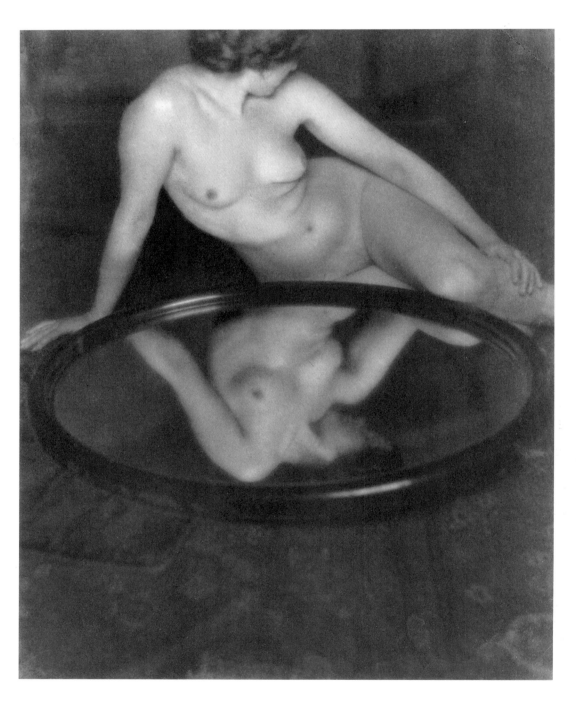

Clarence H. White, *The Mirror*, 1909

Anthony E. Friedkin, *Annie's Blue Dream*, 1976

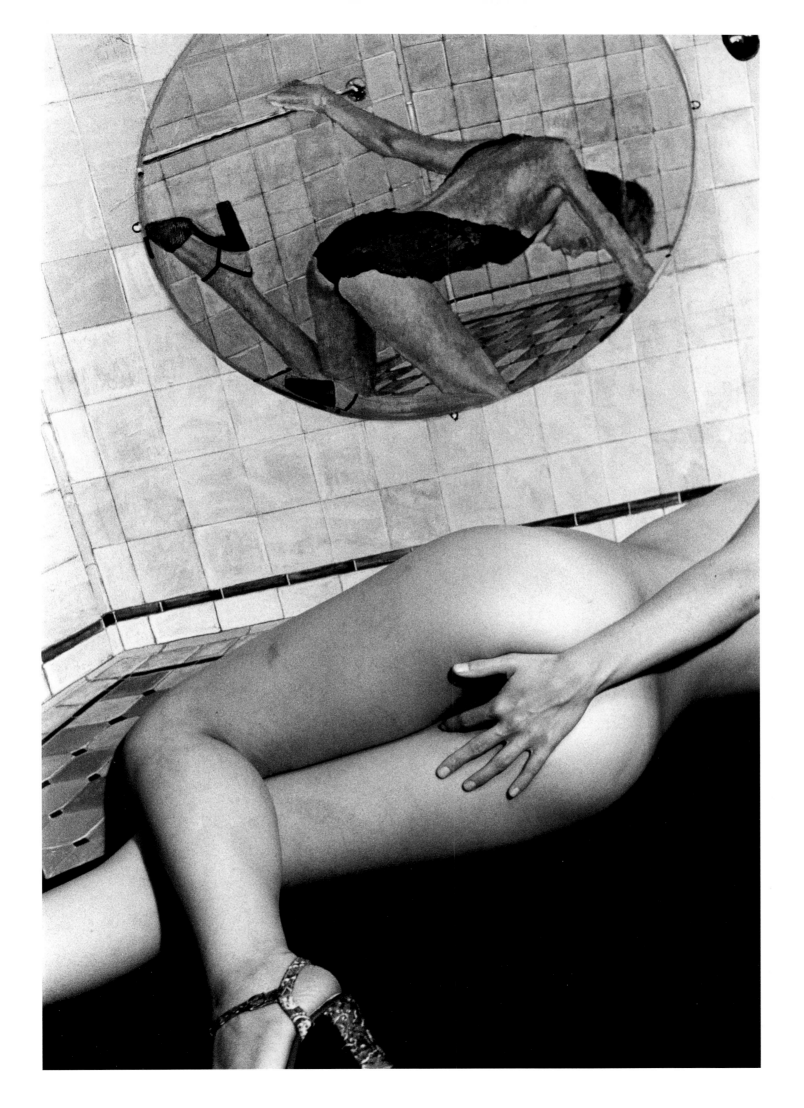

This is the female form,

A divine nimbus exhales from it from head to foot,

It attracts with fierce undeniable attraction,

I am drawn by its breath as if I were no more than a

 helpless vapor,

all falls aside but myself and it,

Books, art, religion, time, the visible and solid earth,

 and what was expected of heaven or fear'd of hell,

 are now consumed,

Mad filaments, ungovernable shoots play out of it, the

 response

likewise ungovernable,

Hair, bosom, hips, bend of legs, negligent falling hands

 all diffused,

mine too diffused,

Ebb stung by the flow and flow stung by the ebb, love-

 flesh swelling

and deliciously aching,

Limitless limpid jets of love hot and enormous, quiver-

 ing jelly of

love, white-blow and delirious juice,

Bridegroom night of love working surely and softly into

 the prostrate

dawn,

Undulating into the willing and yielding day,

Lost in the cleave of the clasping and sweet-flesh'd day.

—WALT WHITMAN

BARBARA BORDNICK, *Nude I*, 1982

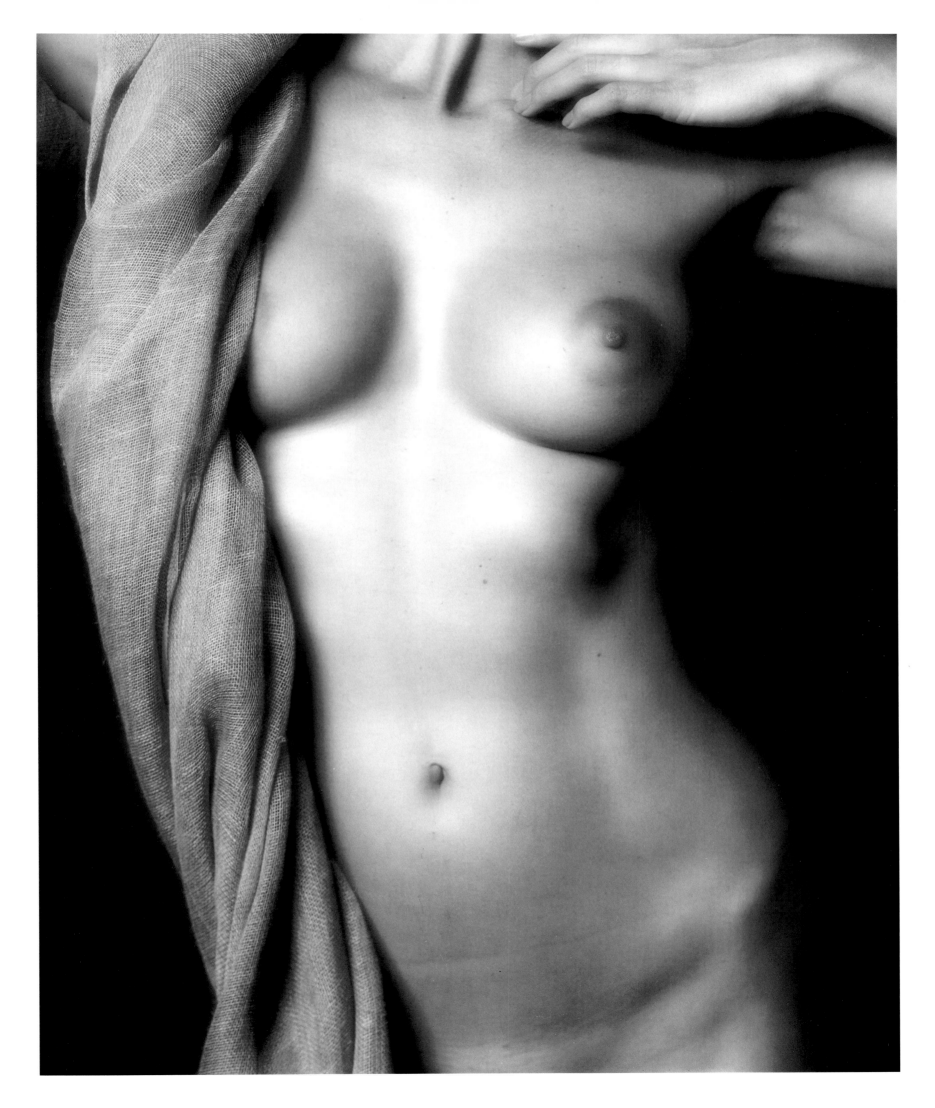

DAVID SEIDNER, *Violeta Sanchez*, 1979

58

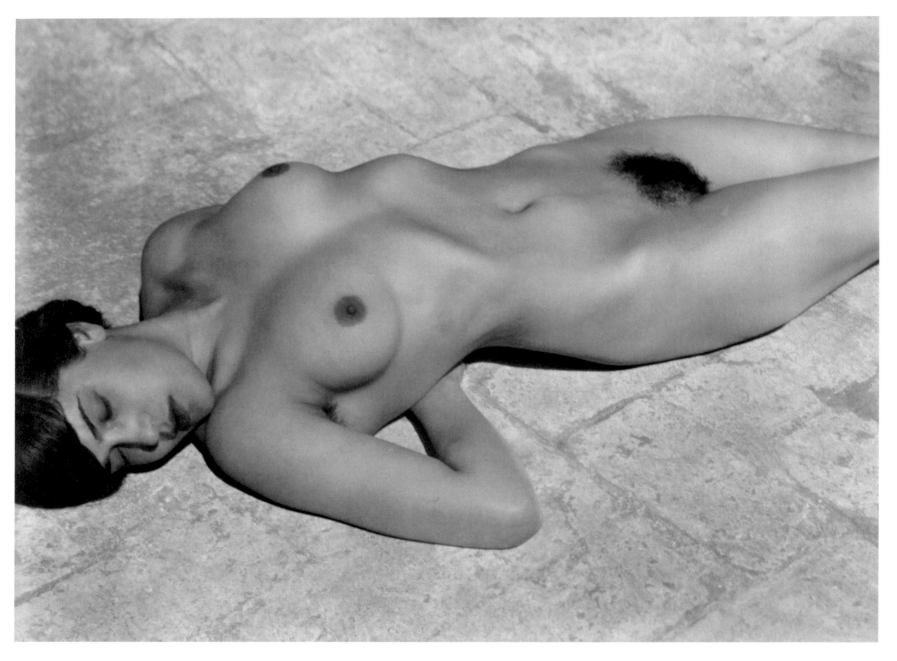

Edward Weston, *Tina on the Azotea*, 1923

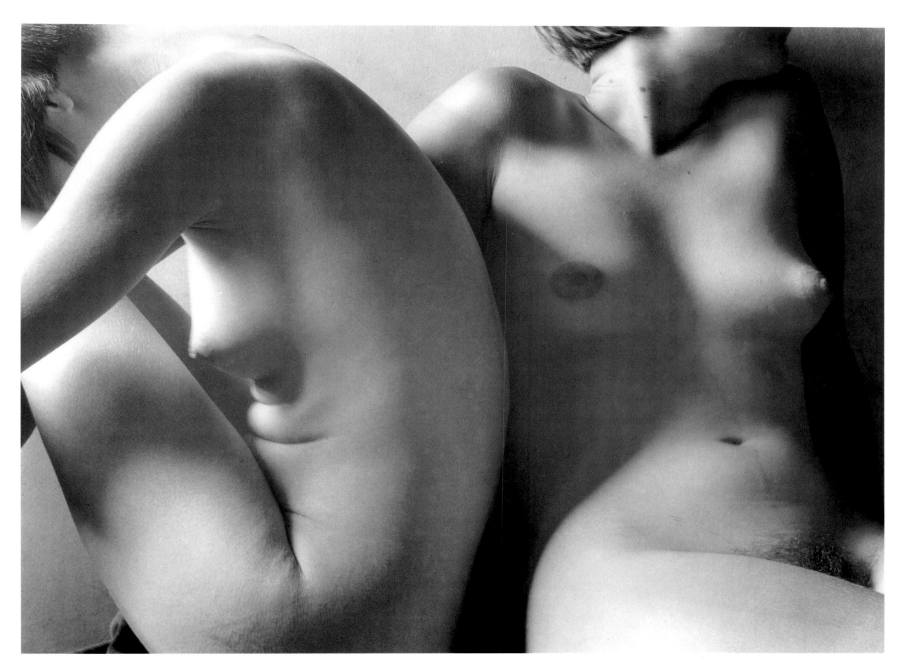

59

IMOGEN CUNNINGHAM, *Two Sisters*, 1928

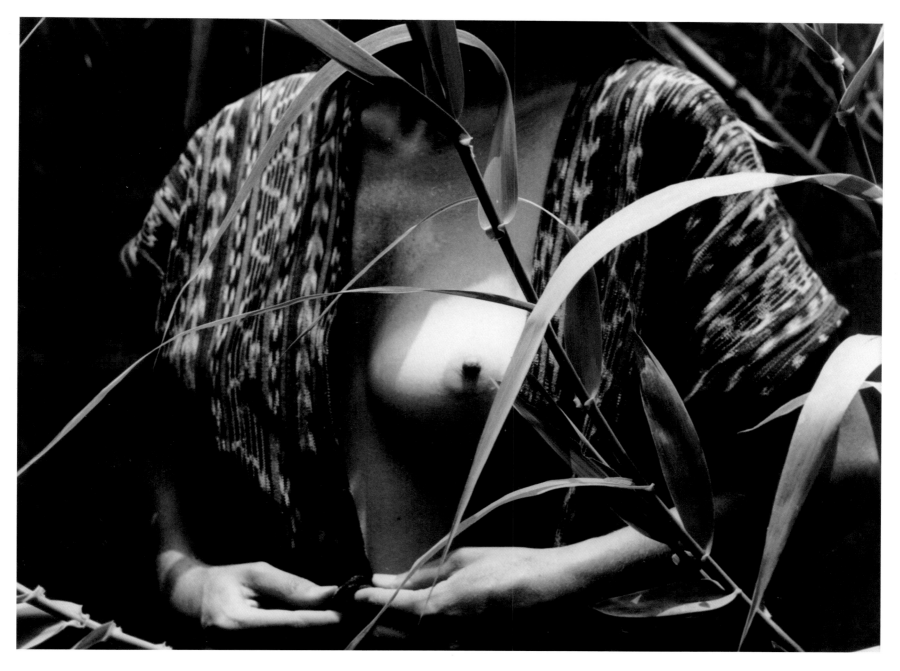

MANUEL ALVAREZ BRAVO, *Fruta prohibida*, 1976

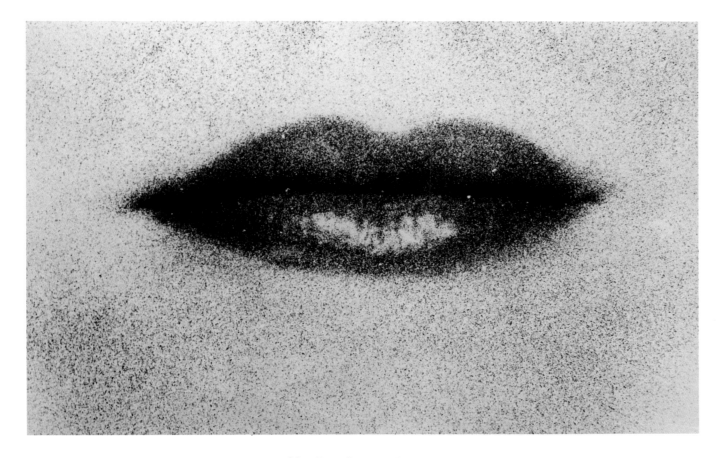

MAN RAY, *Lèvres de Kiki*, 1929

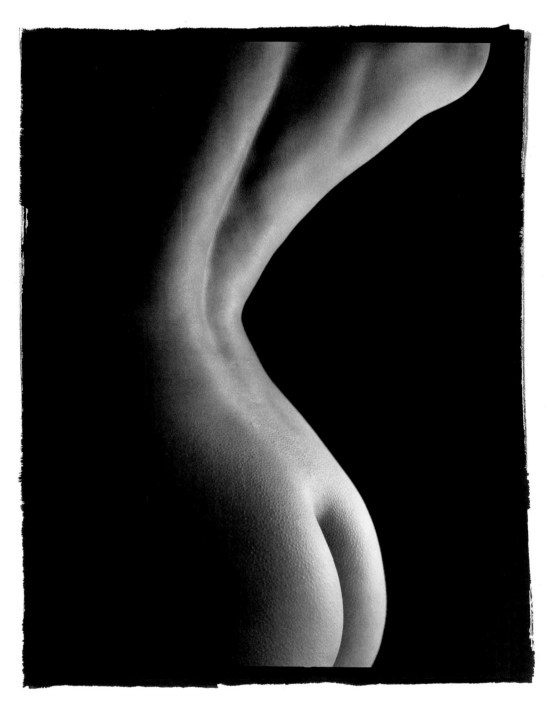

KENRO IZU, *Still Life #467*, 1994

ANDREW BRUCKER, *Lorelei–Hotel Belle Claire*, 1993

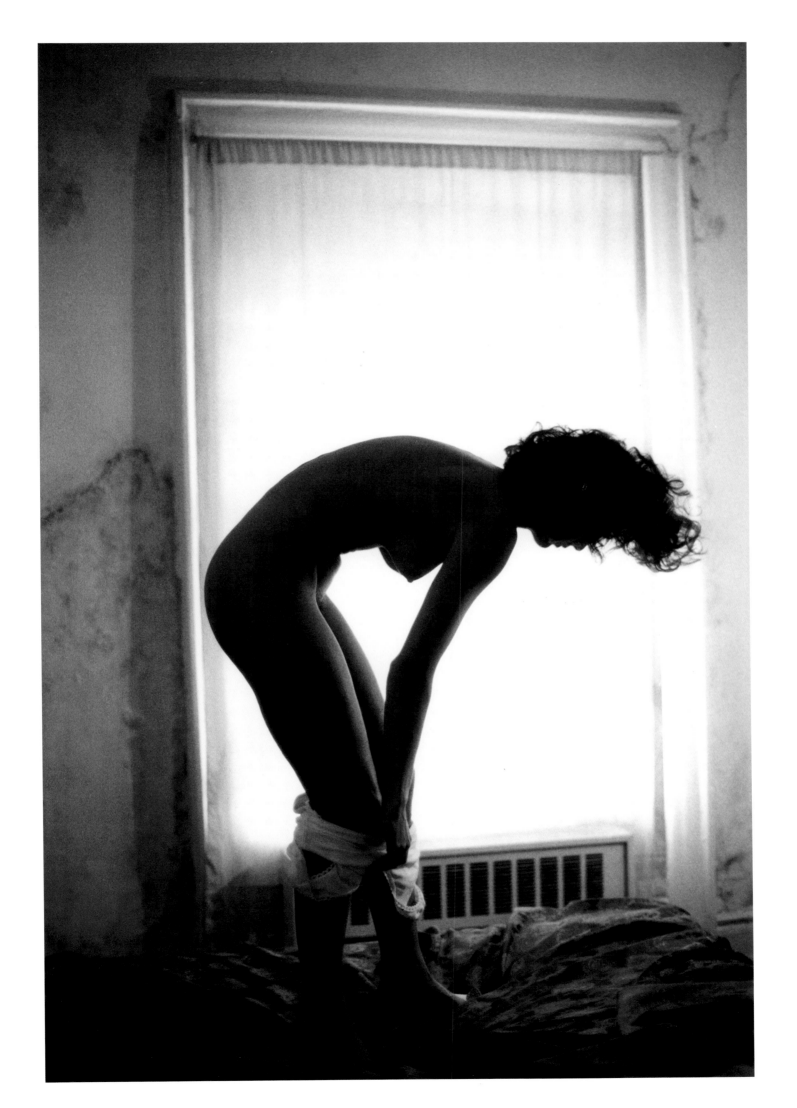

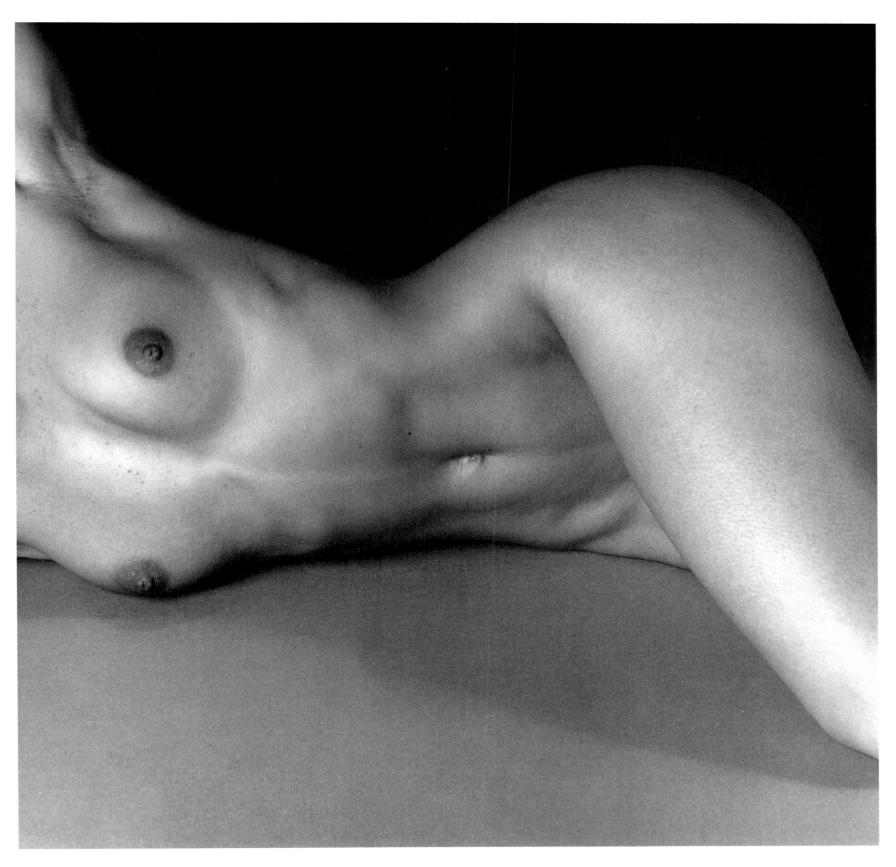

67

ROBERT MAPPLETHORPE, *Lydia*, 1987

Before every church festival there was a good deal of practice with the organist, and girls from neighboring houses joined in our classes. One girl alone sang alto and she and I were separated from the other boys and girls; the upright piano was put across the corner of the room and we two sat or stood behind it, almost out of sight of all the other singers, the organist, of course, being seated in front of the piano. The girl E. . . . , who sang alto with me, was about my own age; she was very pretty, or seemed so to me, with golden hair and blue eyes, and I always made up to her as well as I could, in my boyish way. One day while the organist was explaining something, E. . . . stood up on the chair and leant over the back of the piano to hear better or see more. Seated in my chair behind her, I caught sight of her legs, for her dress rucked up behind as she leaned over; at once my breath stuck in my throat. Her legs were lovely, I thought, and the temptation came to touch them; for no one could see.

I got up immediately and stood by the chair she was standing on. Casually I let my hand fall against her left leg. She didn't draw her leg away or seem to feel my hand, so I touched her more boldly. She never moved, though now I knew she must have felt my hand. I began to slide my hand up her leg and suddenly my fingers felt the warm flesh on her thigh where the stocking ended above the knee. The feel of her warm flesh made me literally choke with emotion: my hand went on up, warmer and warmer, when suddenly I touched her sex; there was soft down on it. The heart-pulse throbbed in my throat. I have no words to describe the intensity of my sensations.

Thank God, E. . . . did not move or show any sign of distaste. Curiosity was stronger even than desire in me and I felt her sex all over, and at once the idea came into my head that it was like a fig (the Italians, I learned later, called it familiarly *fica*); it opened at my touches and I inserted my finger gently . . . still E. . . . did not move. Gently I rubbed the front part of her sex with my finger. I could have kissed her a thousand times out of gratitude.

Suddenly, as I went on, I felt her move, and then again; plainly she was showing me where my touch gave her most pleasure: I could have died for her in thanks; again she moved and I could feel a little mound or small button of flesh right in the front of her sex, above the junction of the inner lips; of course it was her clitoris. I had forgotten all the old Methodist doctor's books till that moment; this fragment of long forgotten knowledge came back to me: gently I rubbed the clitoris and at once she pressed down on my finger for a moment or two. I tried to insert my finger into the vagina; but she drew away at once and quickly, closing her sex as if hurt, so I went back to caressing her tickler.

Suddenly the miracle ceased. The cursed organist had finished his explanation of the new plain chant, and as he touched the first notes on the piano, E. . . . drew her legs together; I took away my hand and she stepped down from the chair. "You darling, darling," I whispered, but she frowned, and then just gave me a smile out of the corner of her eye to show me she was not displeased.

Ah, how lovely, how seductive she seemed to me now, a thousand times lovelier and more desirable than ever before. As we stood up to sing again, I whispered to her: "I love you, love you, dear, dear!"

I can never express the passion of gratitude I felt to her for her goodness, her sweetness in letting me touch her sex. E. . . . it was who opened the Gates of Paradise to me and let me first taste the hidden mysteries of sexual delight. Still after more than fifty years I feel the thrill of the joy she gave me by her response, and the passionate reverence of my gratitude is still alive in me.

This experience with E. . . . had the most important and unlooked for results. The mere fact that girls could feel sex-pleasure "just as boys do" increased my liking for them and lifted the whole sexual intercourse to a higher plane in my thought. The excitement and pleasure were so much more intense than anything I had experienced before that I resolved to keep myself for this higher joy. No more self-abuse for me; I knew something infinitely better. One kiss was better, one touch of a girl's sex.

—FRANK HARRIS, from *My Life and Loves*

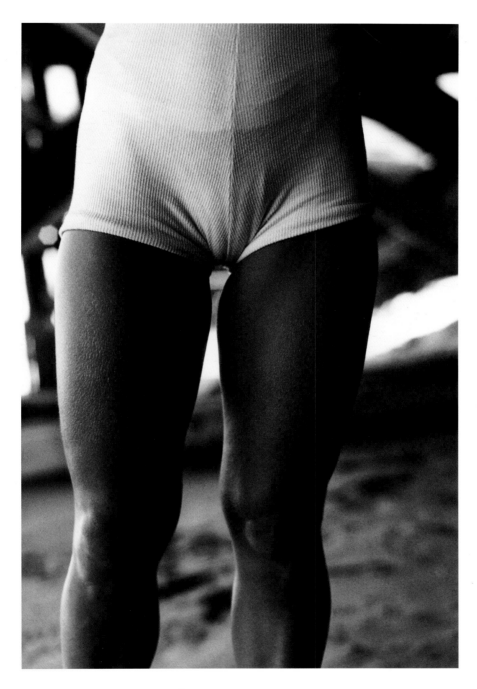

ANDREW BRUCKER, *Harper–Malibu*, 1994

Franco Salmoiraghi, *Torso with Hands*, 1990

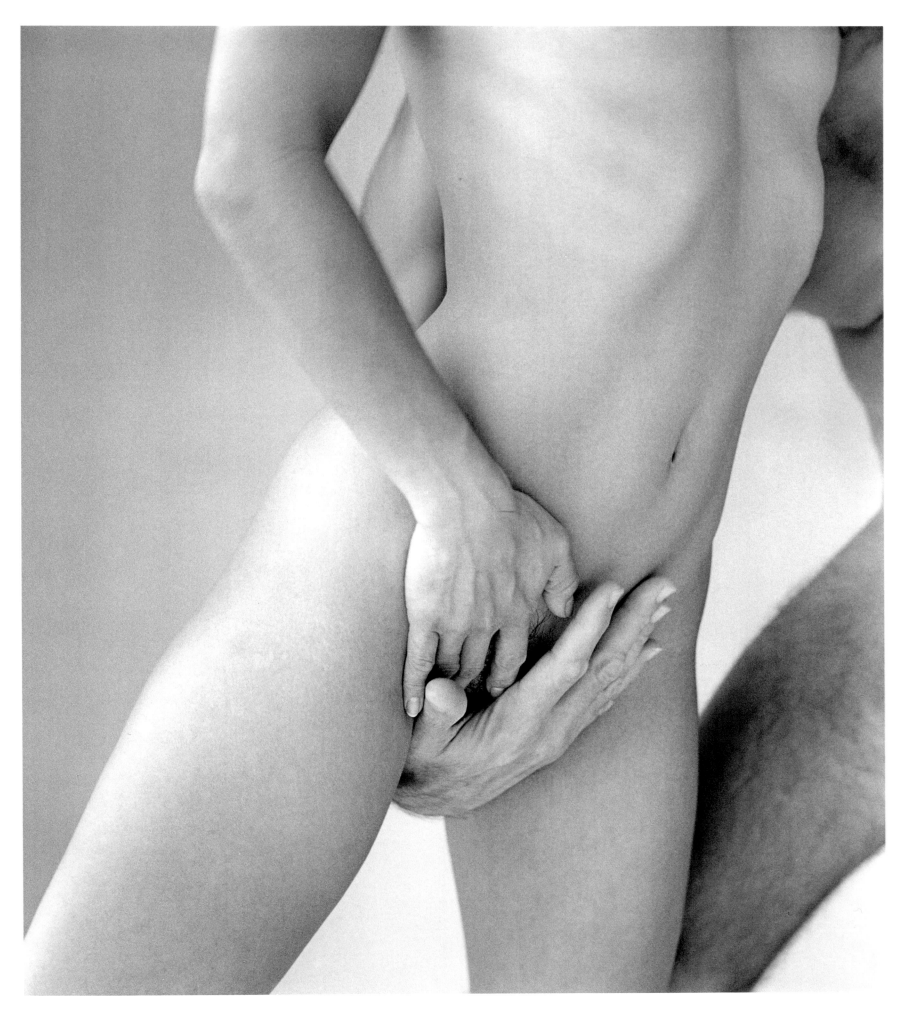

Your perfume, or odor—

All measure gone I remember it, my body

Remembers it, my body when dead will remember it

In its bones, and when after incineration

The bones themselves are pulverized and dispersed

 upon the air

As tiny motes of ash, they too will remember

(Dancing in sunlight, jostled by larger molecules)

Your odor without a name.

—MICHAEL FRIED, *Odor*

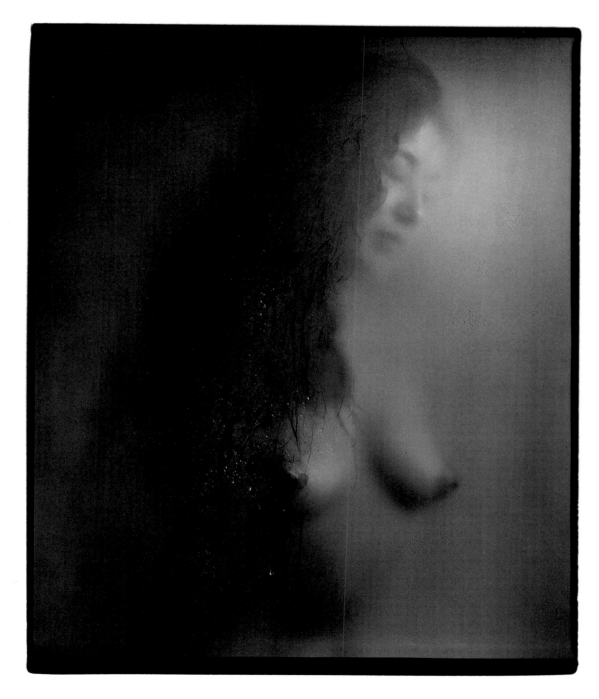

HIROSHI OSAKA, *Syzygy #108-B, March 1987*

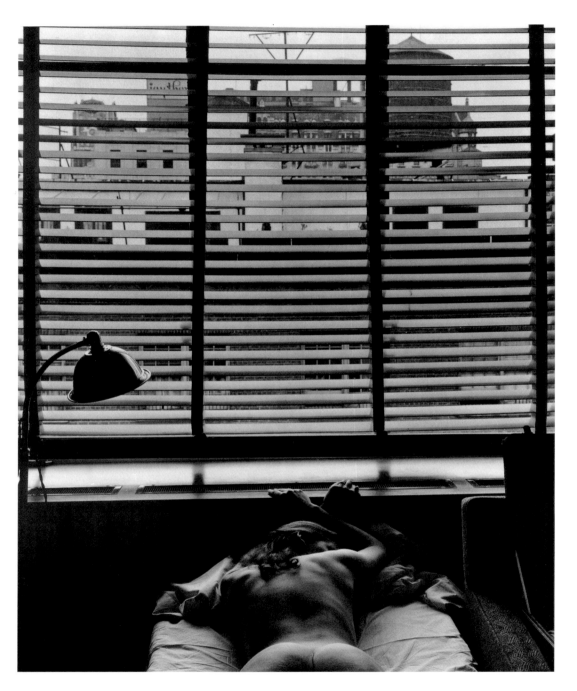

Edward Weston, *Nude, New York City*, 1941

Robert Mapplethorpe, *Derrick Cross*, 1983

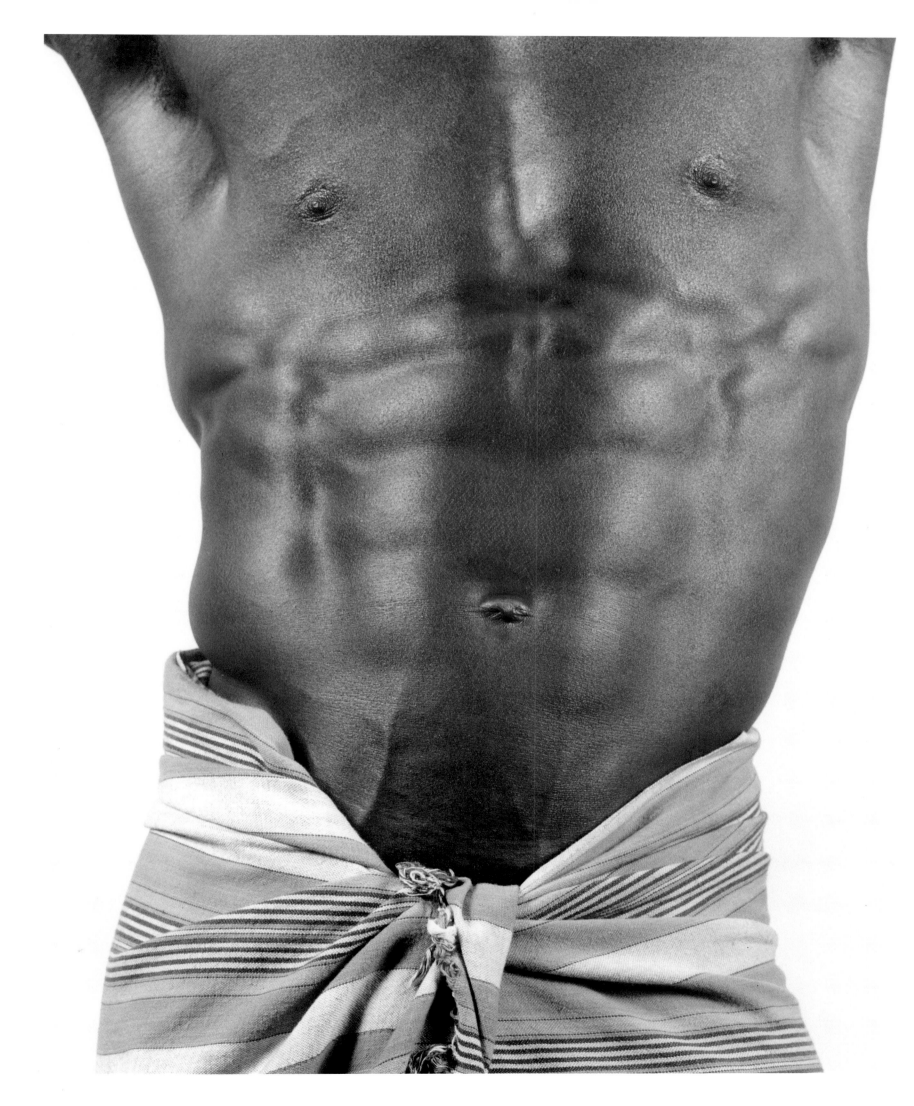

WYNN BULLOCK, *Nude Behind Cobwebbed Window*, 1955

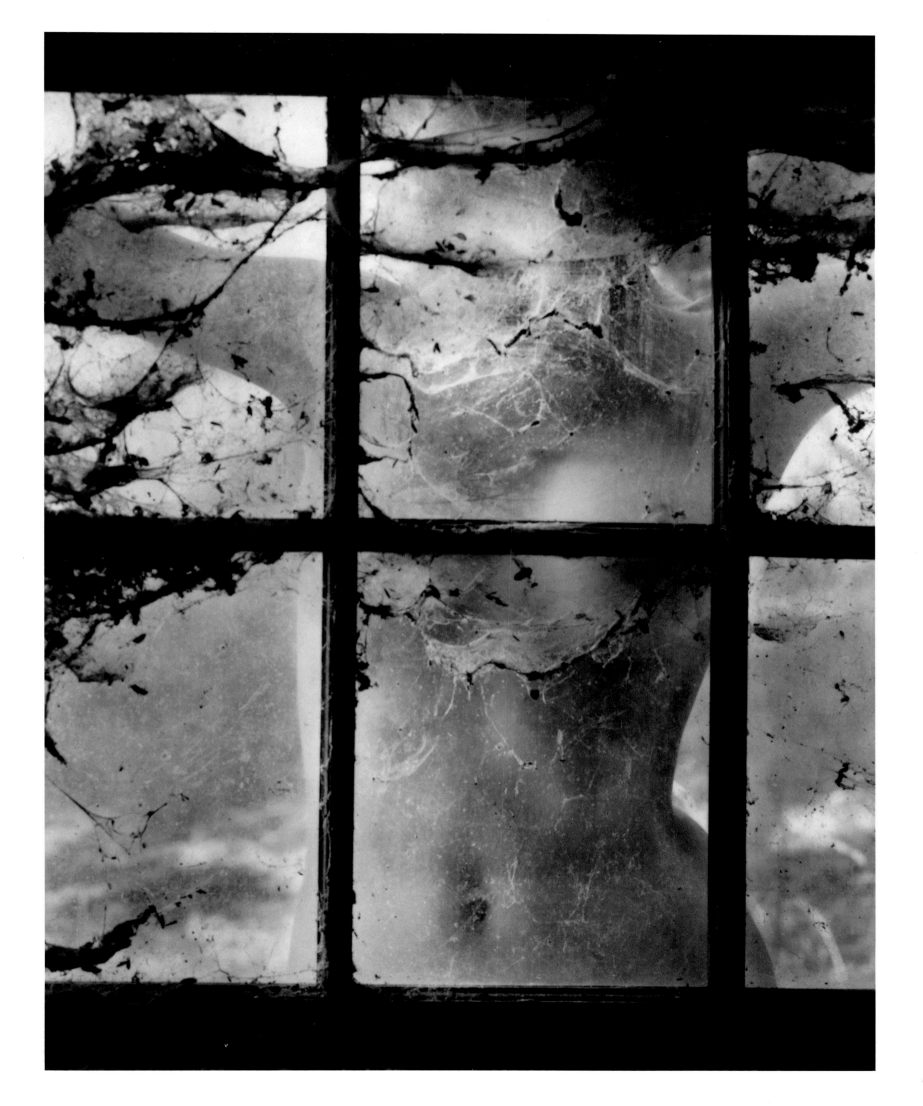

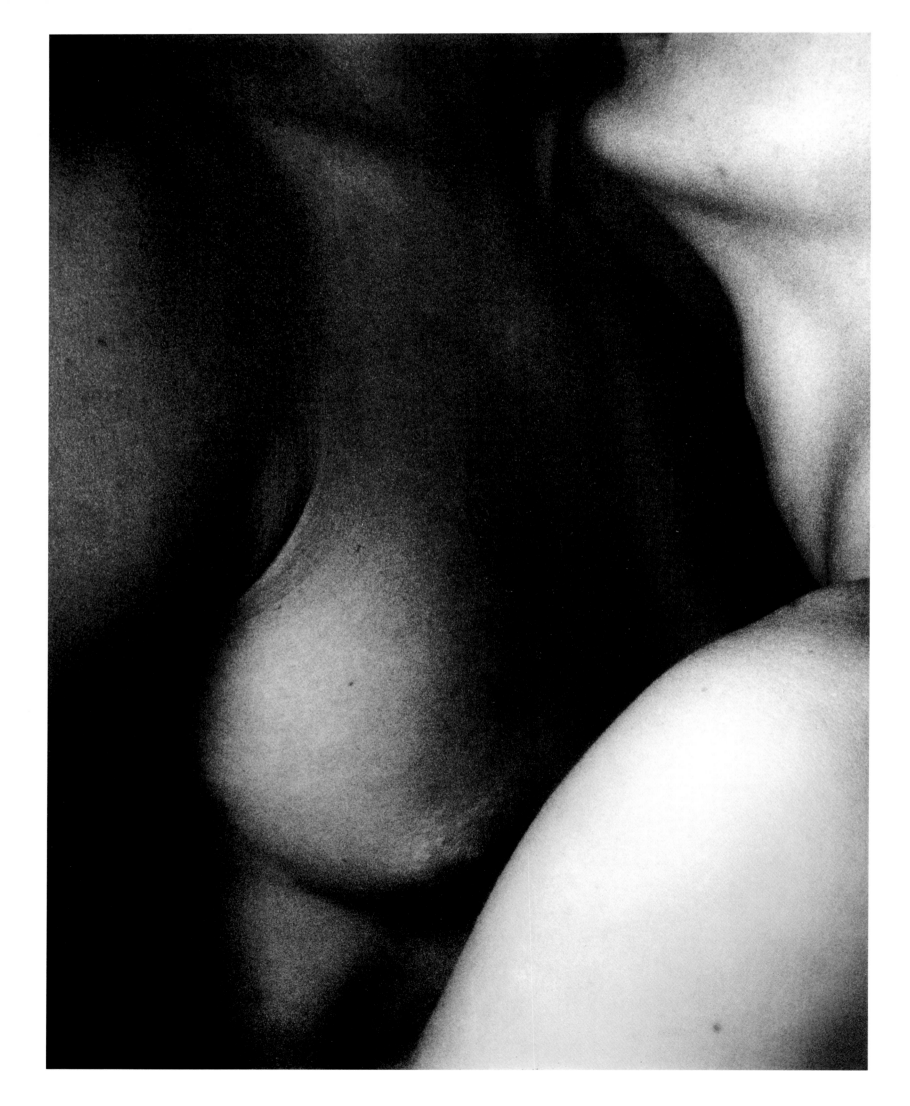

78

I cannot think of the double curve lithe and flowing with movement as a bony ridge, I think of it as the musical instrument that bears the same root. Clavis. Key. Clavichord. The first stringed instrument with a keyboard. Your clavicle is both keyboard and key. If I push my fingers into the recesses behind the bone I find you like a soft shell crab. I find the openings between the springs of muscle where I can press myself into the chords of your neck. The bone runs in perfect scale from sternum to scapula. It feels lathe-turned. Why should a bone be balletic?

You have a dress with a décolletage to emphasize your breasts. I suppose the cleavage is the proper focus but what I wanted to do was to fasten my index finger and thumb at the bolts of your collar bone, push out, spreading the web of my hand until caught against your throat. You asked me if I wanted to strangle you. No, I wanted to fit you, not just in the obvious ways but in so many indentations.

It was a game, fitting bone on bone. I thought difference was rated to be the largest part of sexual attraction but there are so many things about us that are the same.

Bone of my bone. Flesh of my flesh. To remember you it's my own body I touch. Thus she was, here and here. The physical memory blunders through the doors the mind has tried to seal. A skeleton key to Bluebeard's chamber. The bloody key that unlocks pain. Wisdom says forget, the body howls. The bolts of your collar bone undo me. Thus she was, here and here.

—Jeanette Winterson, from *Written on the Body*

Andrew Eccles, *Couple Embracing 4*, 1994

Oh! could I paint his figure as I see it now still present to my transported imagination! A whole length of an all-perfect manly beauty in full view. Think of a face without a fault, glowing with all the opening bloom and vernal freshness of an age in which beauty is of either sex, and which the first down over his upper-lip scarce began to distinguish.

The parting of the double ruby pout of his lips seemed to exhale an air sweeter and purer than what it drew in: ah! what violence did it not cost me to refrain the so tempted kiss!

Then a neck exquisitely turned, graced behind and on the sides with his hair playing freely in natural ringlets, connected his head to a body of the most perfect form, and of the most vigorous contexture, in which all the strength of manhood was concealed and softened to appearance by the delicacy of his complexion, the smoothness of his skin, and the plumpness of his flesh.

The platform of his snow-white bosom, that was laid out in a manly proportion, presented, on the vermillion summit of each pap, the idea of a rose about to blow.

Nor did his shirt hinder from observing that symmetry of his limbs, that exactness of shape, in the fall of it towards the loins, where the waist ends and the rounding swell of the hips commences, where the skin, sleek, smooth, and dazzling white, burnishes on the stretch over firm, plump-ripe flesh, that crimped and run into dimples at the least pressure, or that the touch could not rest upon, but slid over as on the surface of the most polished ivory.

His thighs finely fashioned, and with a florid glossy roundness gradually tapering away to the knees, seemed pillars worthy to support that beauteous frame, at the bottom of which I could not, without some remains of terror, some tender emotions too, fix my eyes on that terrible spitfire machine, which had, not so long before, with such fury broke into, torn, and almost ruined those soft tender parts of mine, which had not yet done smarting with the effects of its rage; but behold it now! crest-fallen, reclining its half-capped vermillion head over one of his thighs, quiet, pliant, and to all appearance incapable of the mischiefs and cruelty it had committed. Then the beautiful growth of the hair, in short and soft curls round its root, its whiteness, branched veins, the supple softness of the shaft, as it lay foreshortened, rolled and shrunk up into a squob thickness, languid, and born up from between the thighs by its globular appendage, that wondrous treasure-bag of nature's sweets, which, rivelled round and pursed up in the only wrinkles that are known to please, perfected the prospect, and all together formed the most interesting moving picture in nature, and surely infinitely superior to those nudities furnished by the painters, statuaries, or any art, which are purchased at immense prices, whilst the sight of them in actual life is scarce sovereignly tasted by any but the few whom nature has endowed with a fire of imagination, warmly pointed by a truth of judgment to the spring-head, the originals of beauty of nature's unequalled composition, above all the imitations of art, or the reach of wealth to pay their price.

—JOHN CLELAND, from *Fanny Hill*

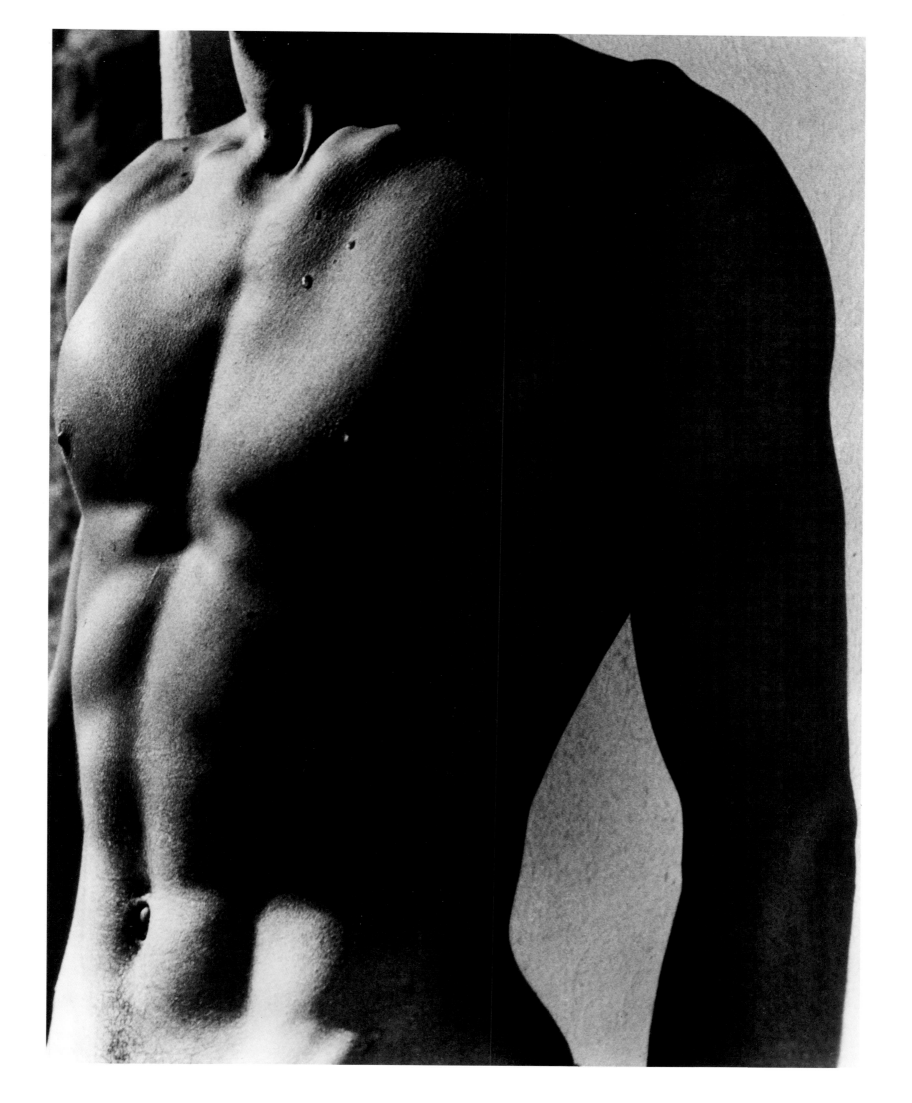

HOW NICE TO WATCH YOU TAKE A BATH

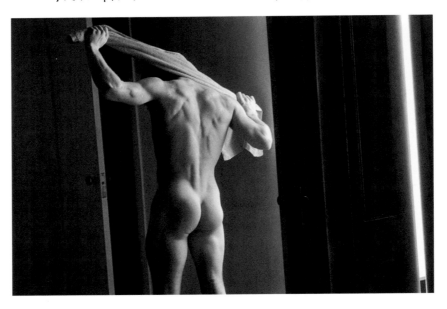

Duane Michals, *How Nice to Watch You Take a Bath*, 1992

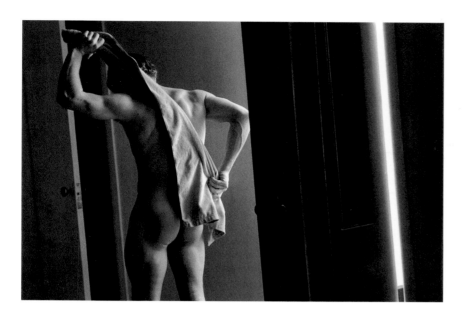

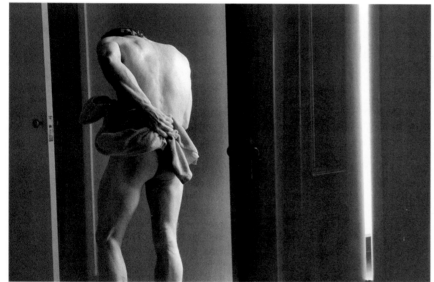

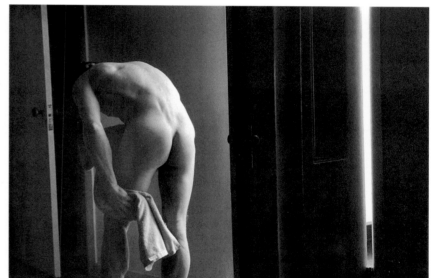

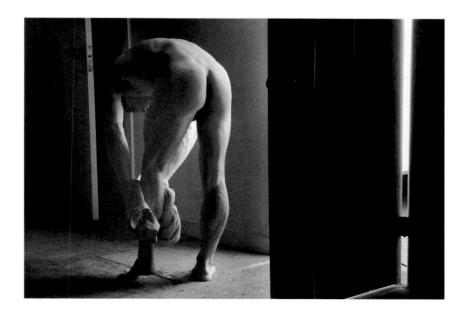

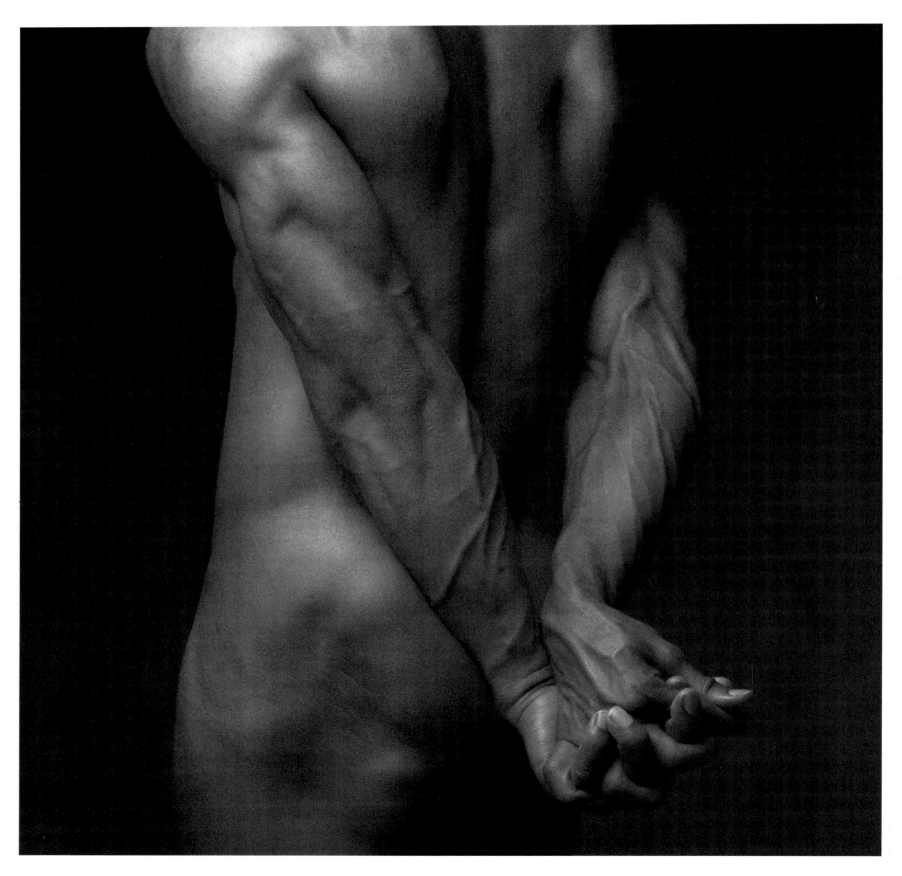

BARBARA BORDNICK, *Nude Waiting*, 1996

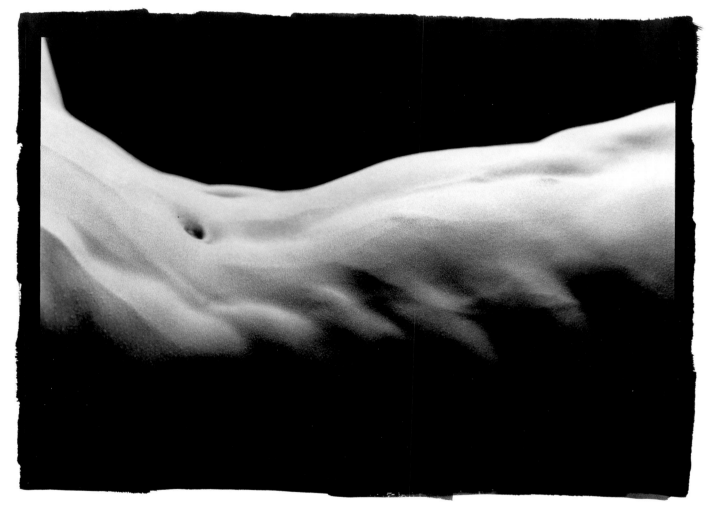

KENRO IZU, *Still Life #475*, 1996

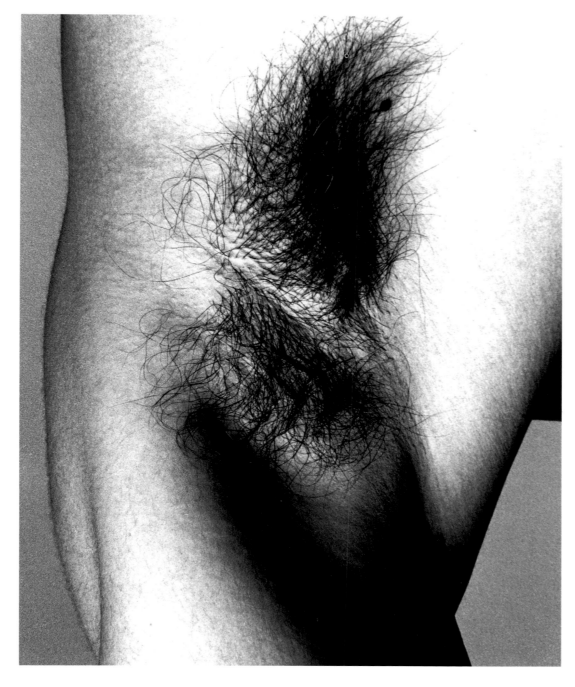

HIRO, *Untitled*, 1993

Minor White, *Untitled*, from the sequence *The Temptation of St. Anthony is Mirrors*, 1948

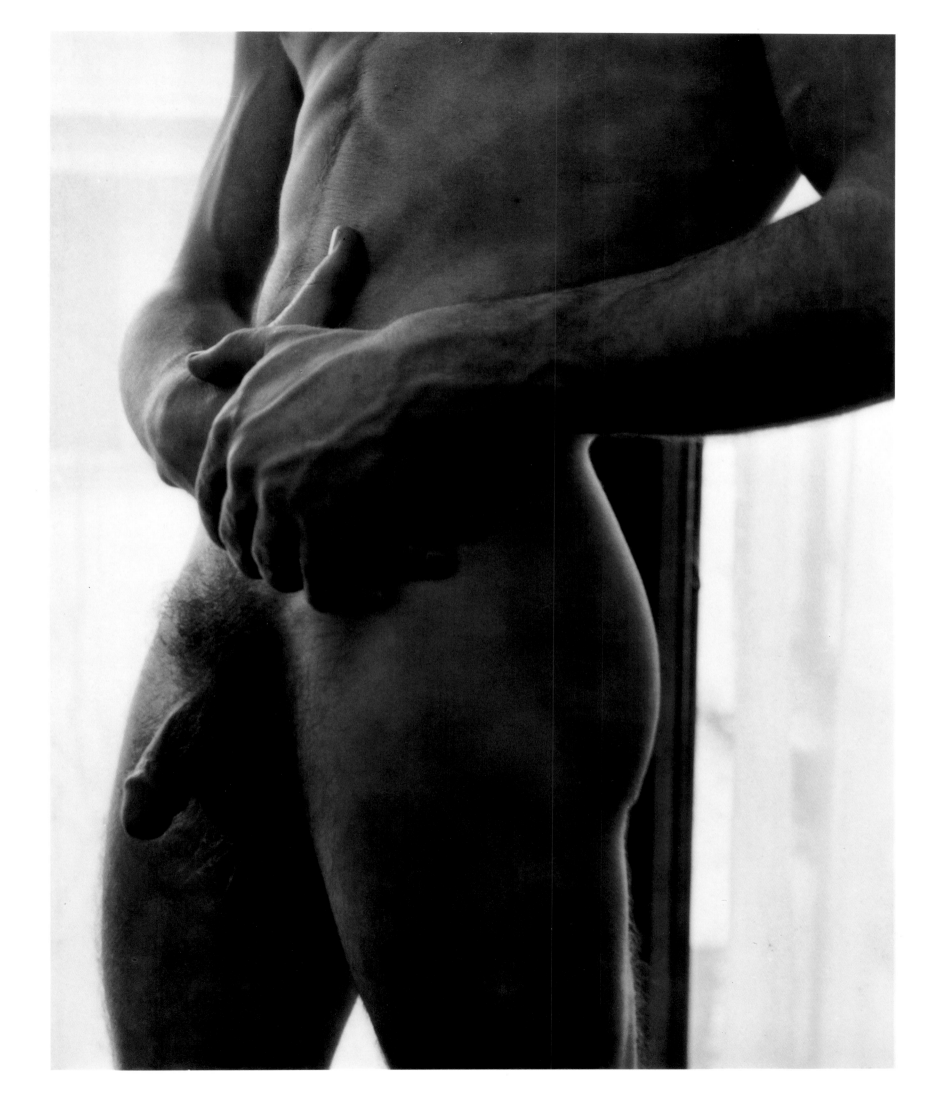

89

I had just got to my feet when Louise strode through the door, her hair piled up on her head and pinned with a tortoiseshell bar. I could smell the steam on her from the bath and the scent of a rough woody soap. She held out her arms, her face softening with love, I took her two hands to my mouth and kissed each slowly so that I could memorize the shape of her knuckles. I didn't only want Louise's flesh, I wanted her bones, her blood, her tissues, the sinews that bound her together. I would have held her to me though time had stripped away the tones and textures of her skin. I could have held her for a thousand years until the skeleton itself rubbed away to dust. What are you that makes me feel thus? Who are you for whom time has no meaning?

In the heat of her hands I thought, This is the campfire that mocks the sun. This place will warm me, feed me and care for me. I will hold on to this pulse against other rhythms. The world will come and go in the tide of a day but here is her hand with my future in its palm.

She said, "Come upstairs."

—JEANETTE WINTERSON, from *Written on the Body*

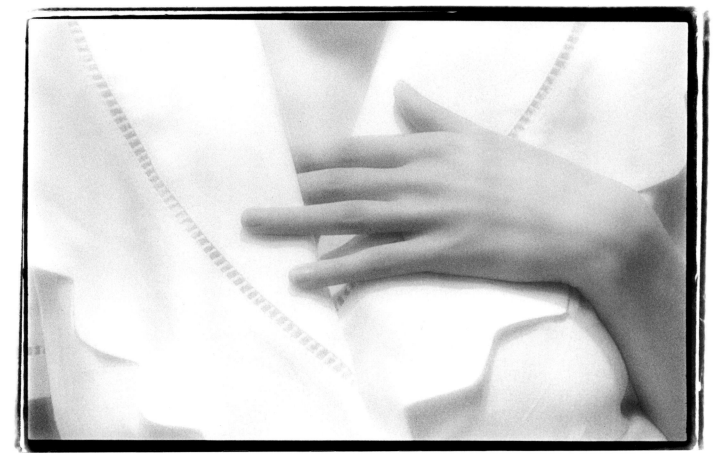

Barbara Bordnick, *Untitled*, 1986

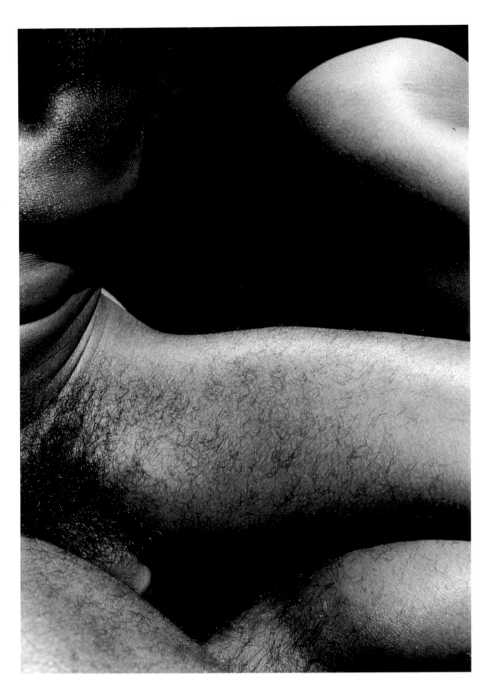

Ernestine Ruben, *Male Nude*, 1984

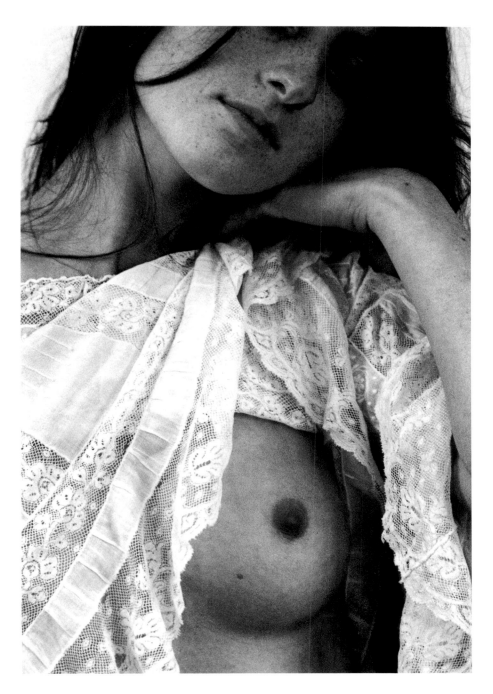

FRÉDÉRIC BARZILAY, *Margarete*, 1966

Robert Mapplethorpe, *Lisa Lyon*, 1981

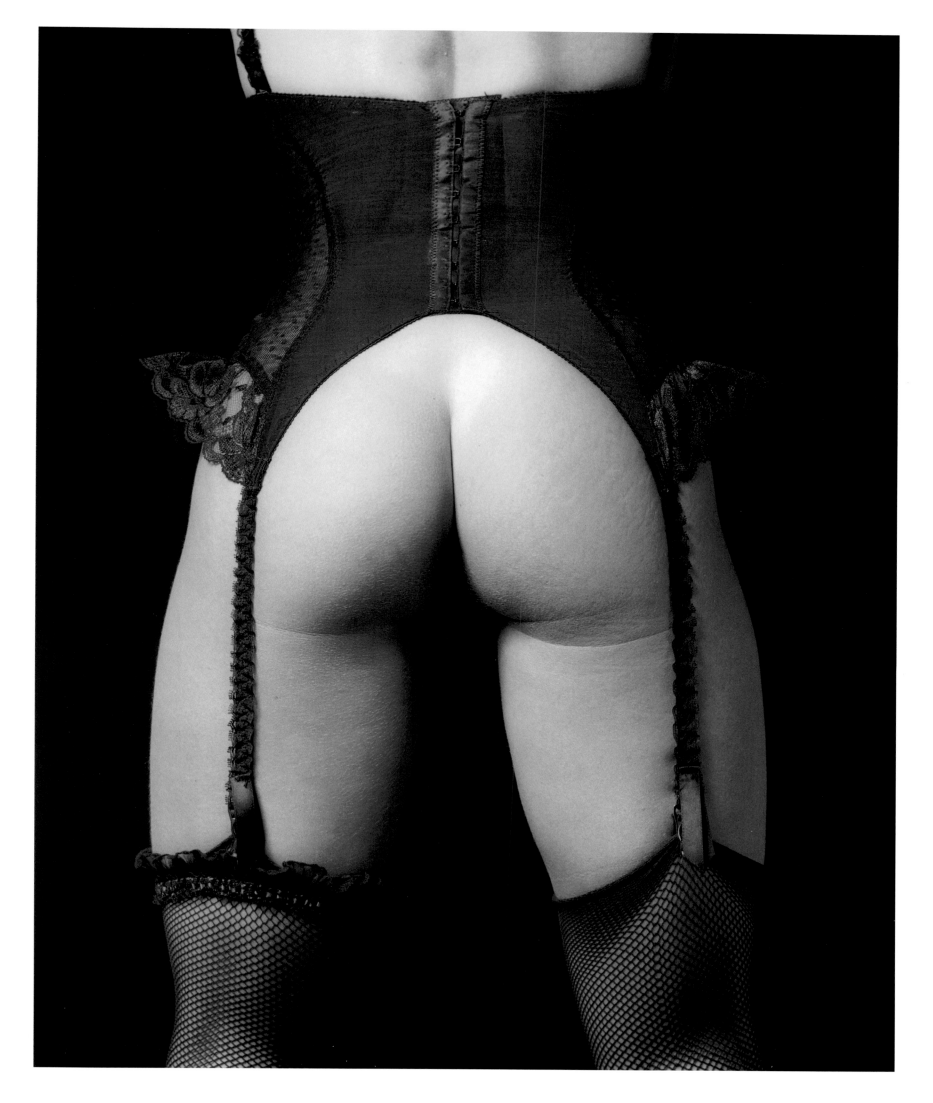

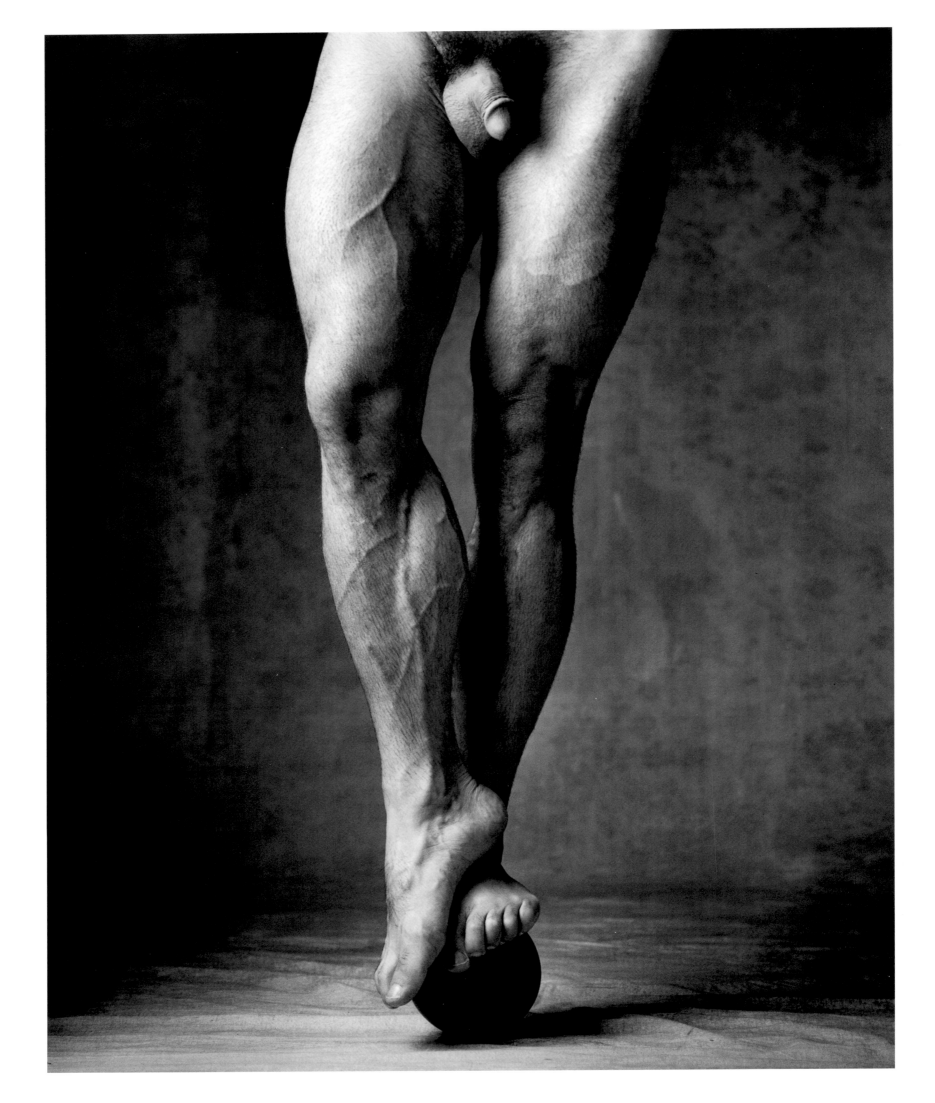

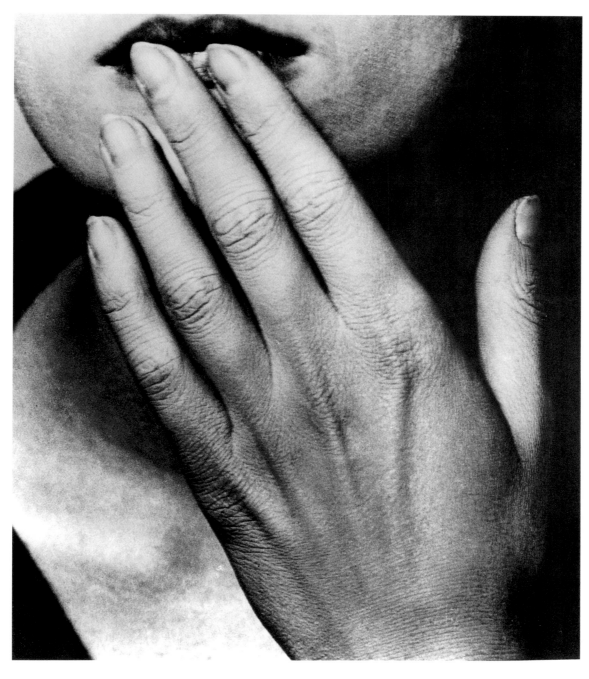

MAN RAY, *Main sur lèvres*, 1929

BLAKE LITTLE, *The Balance*, 1992

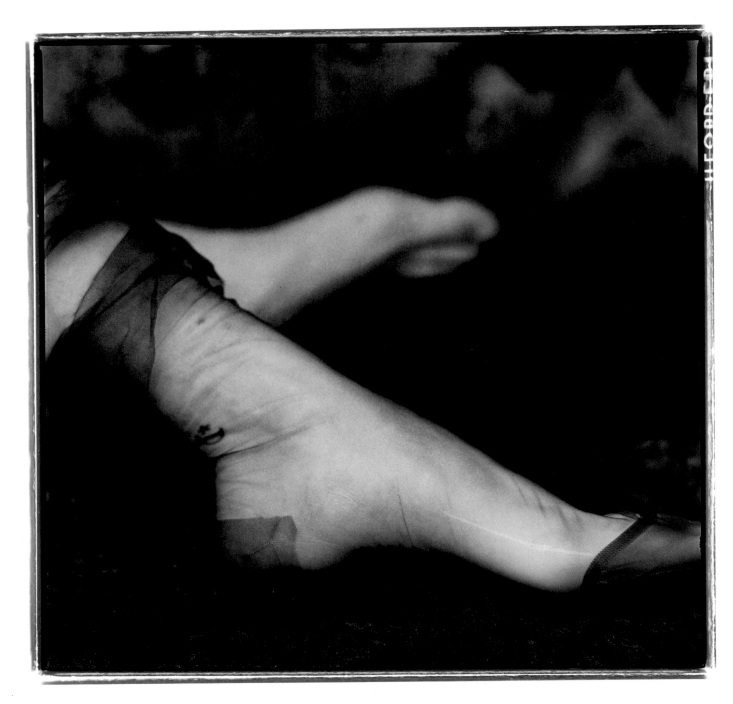

98

KEITH CARTER, *Moon and Star*, 1989

JEANLOUP SIEFF, *Nu montant un escalier*, 1976

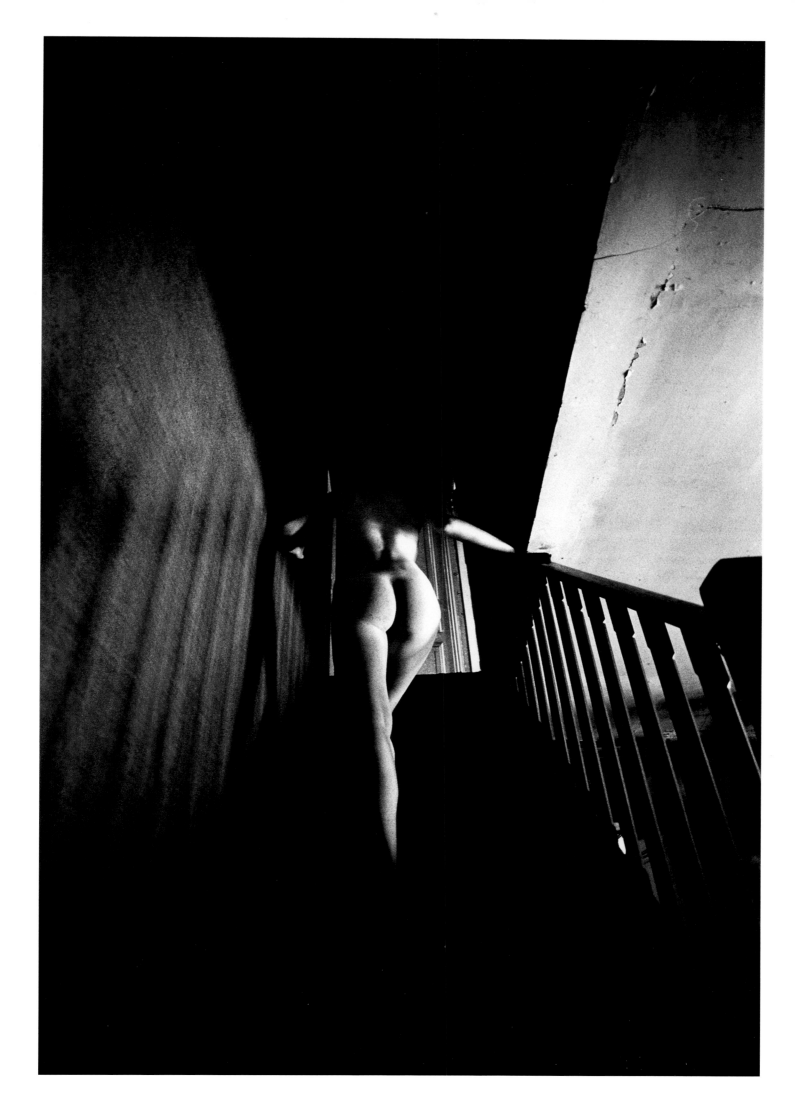

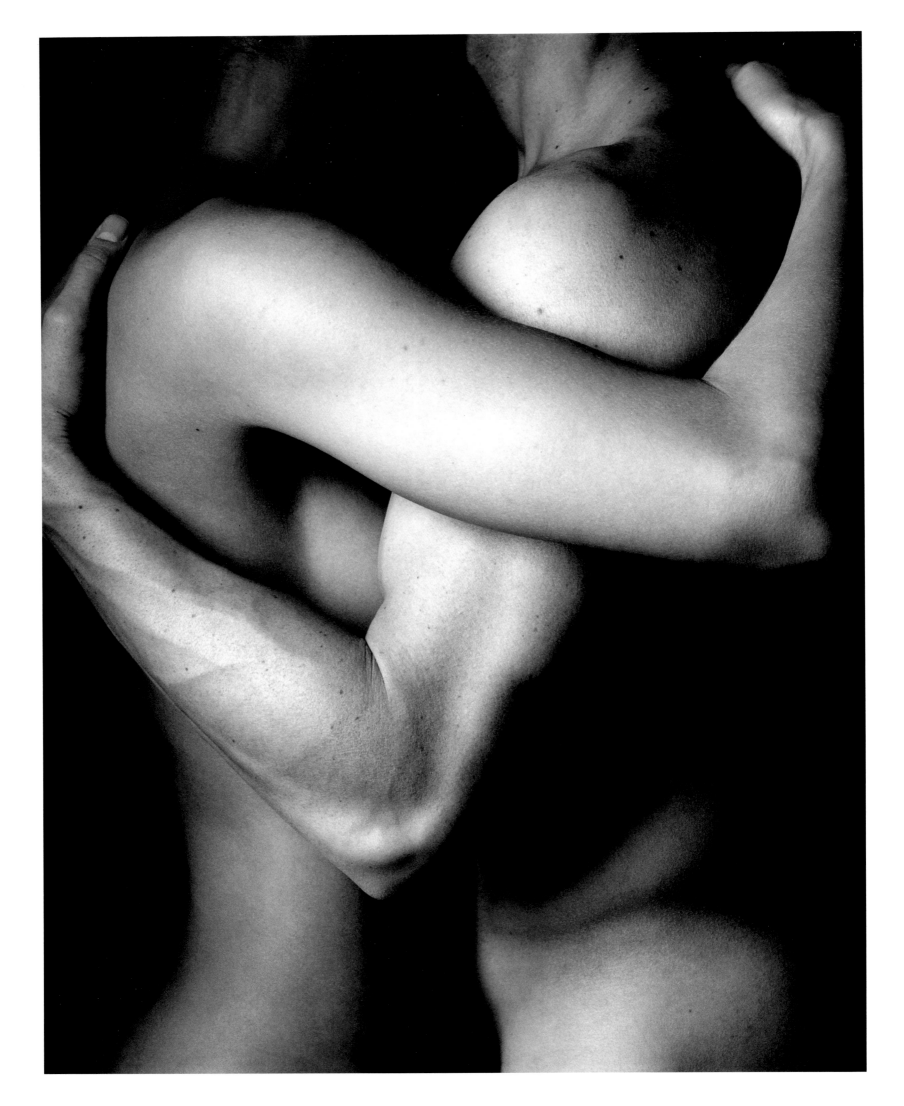

i like my body when it is with your

body. It is so quite new a thing.

Muscles better and nerves more.

i like your body. i like what it does,

i like its hows. i like to feel the spine

of your body and its bones,and the trembling

-firm-smooth ness and which i will

again and again and again

kiss, i like kissing this and that of you,

i like,slowly stroking the,shocking fuzz

of your electric fur,and what-is-it comes

over parting flesh....And eyes big love-crumbs,

and possibly i like the thrill

of under me you so quite new

<p style="text-align:right">—E. E. CUMMINGS, Sonnets–Actualities, VII, from & [AND]</p>

ANDREW ECCLES, Couple Embracing 3, 1994

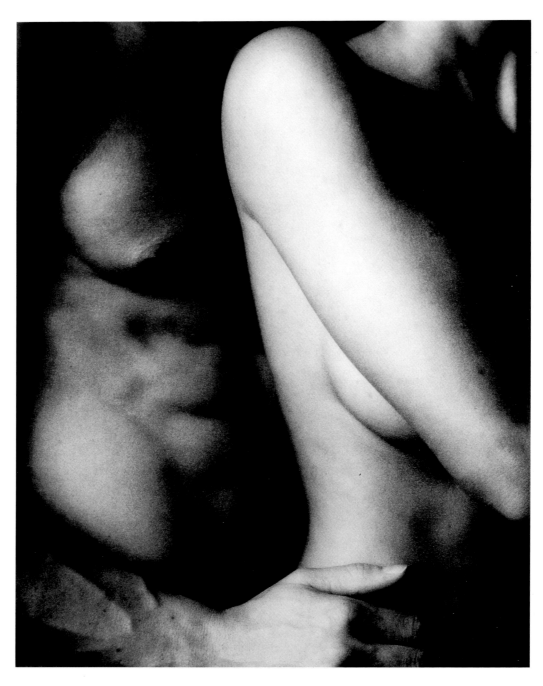

ANDREW ECCLES, *Couple Embracing 1*, 1994

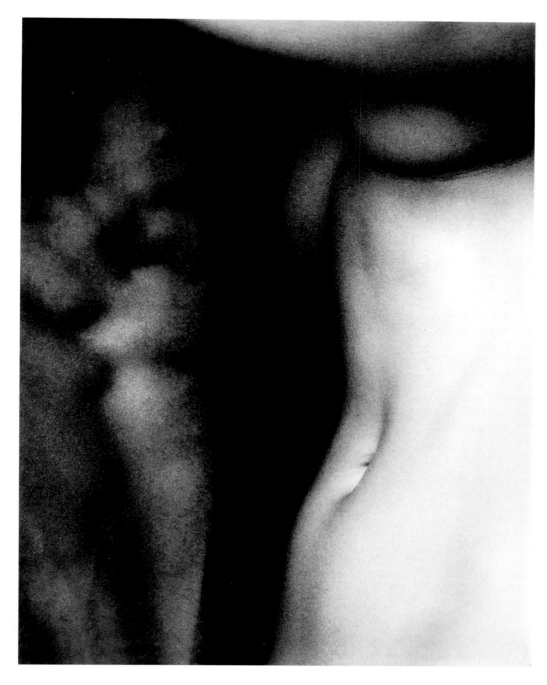

ANDREW ECCLES, *Couple Embracing 2*, 1994

The triangle of a man's shoulders, back, and hips, moving as he moves, gliding, turning. The delicate hollow at the base of a woman's neck, that pulsating depression, the gentle U of bone, the plain of soft skin below. And the fetish goes on, enlarging, clarifying. A falling corner of clothing, the slither of sheets. Acts are like this, too, so fraught with erotic potential, they take on the characteristics of objects: to *do* a certain thing, to slip a hand between the buttons on a lover's shirt. The act is infinitely variable, infinitely repeatable, the way an object is always new and always there.

—SALLIE TISDALE, from *Talk Dirty to Me*

MANUEL ALVAREZ BRAVO, *El trapo negro*, 1986

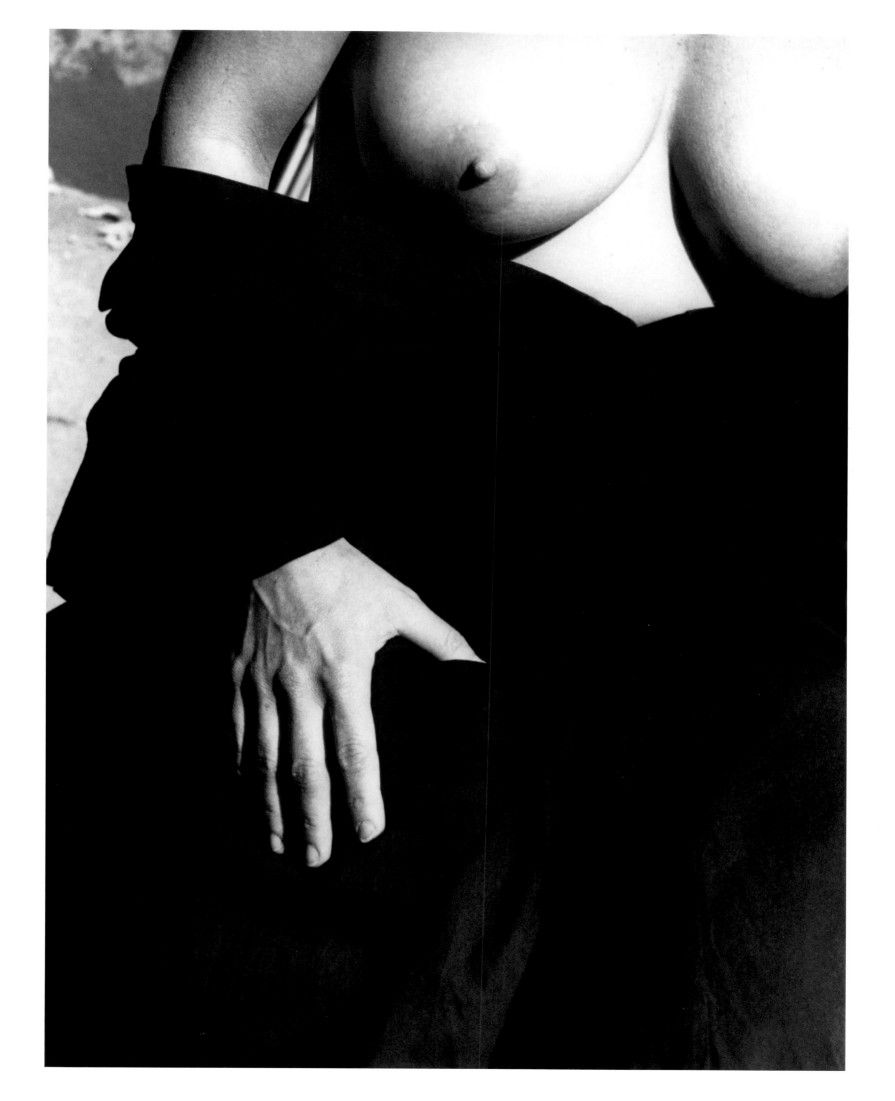

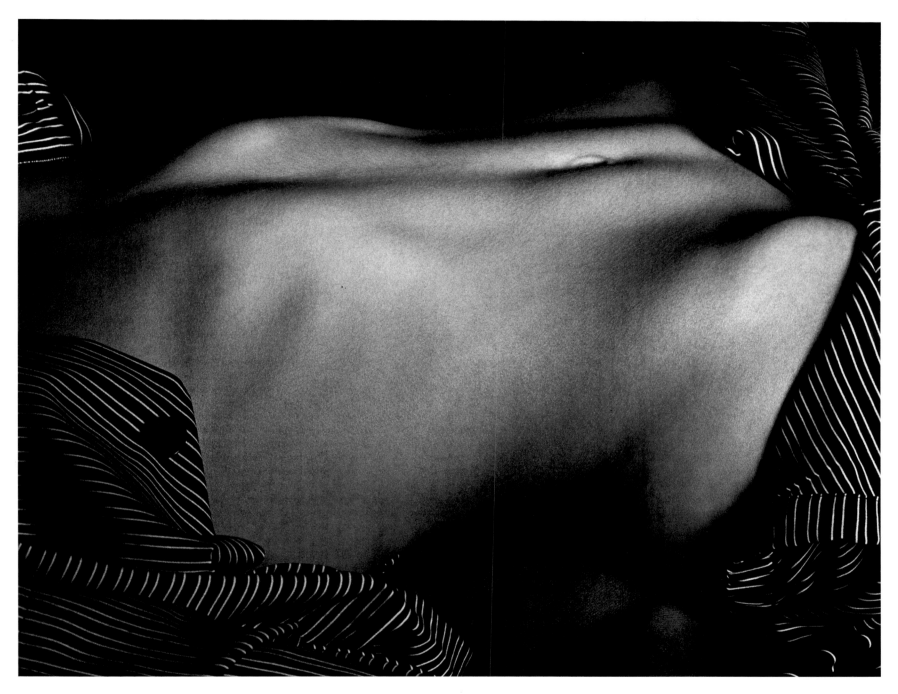

ALBERT WATSON, *Charlotte, Torso, NYC, July 26, 1988*

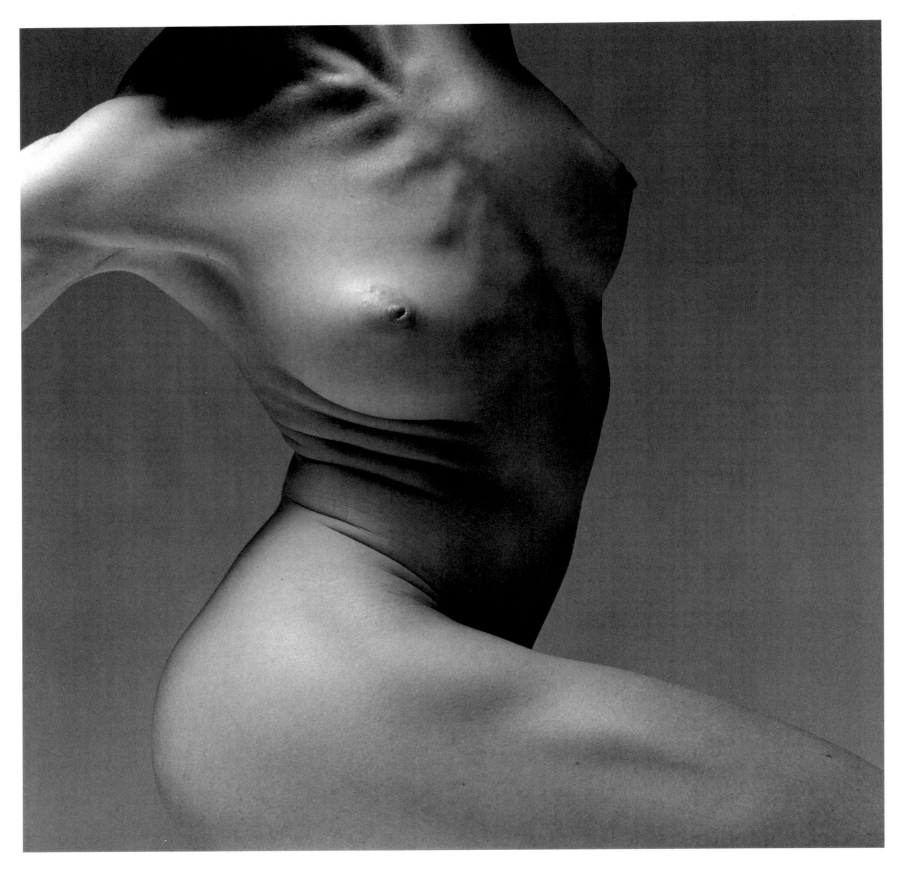

108

HOWARD SCHATZ, *Torso*, 1995

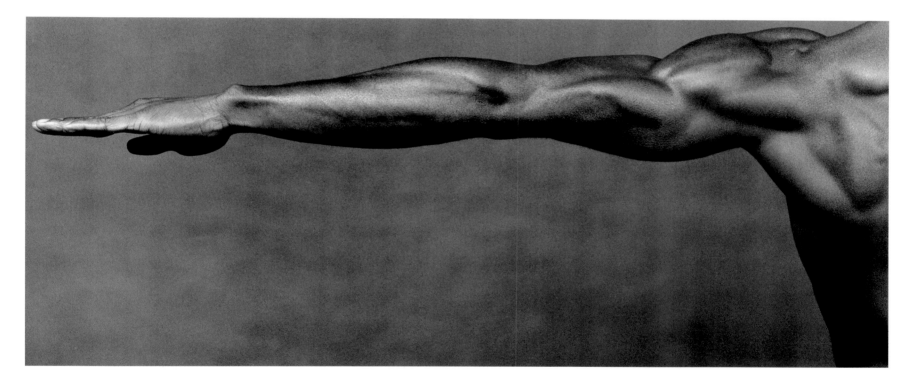

Robert Mapplethorpe, *Derrick Cross*, 1982

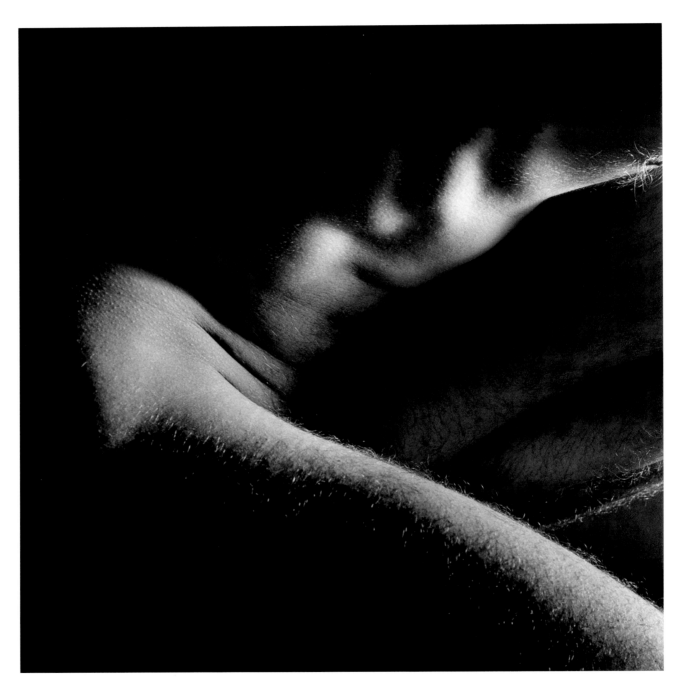

KARIN ROSENTHAL, *Untitled*, 1983

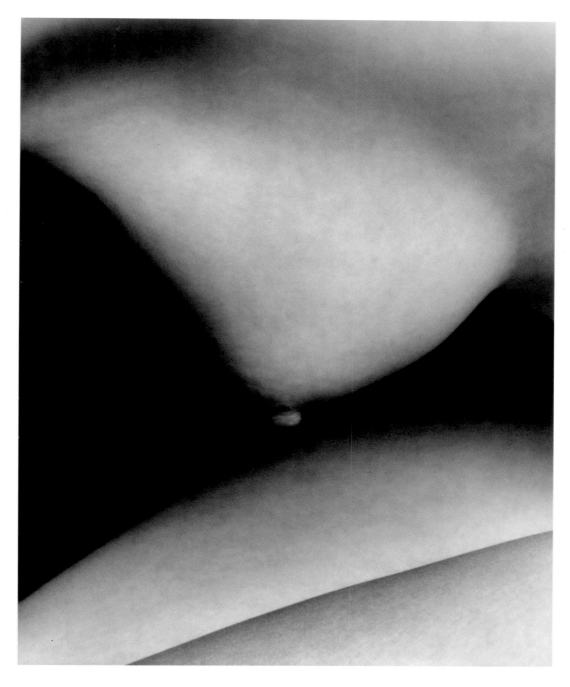

EDWARD WESTON, *Nude*, 1934

112

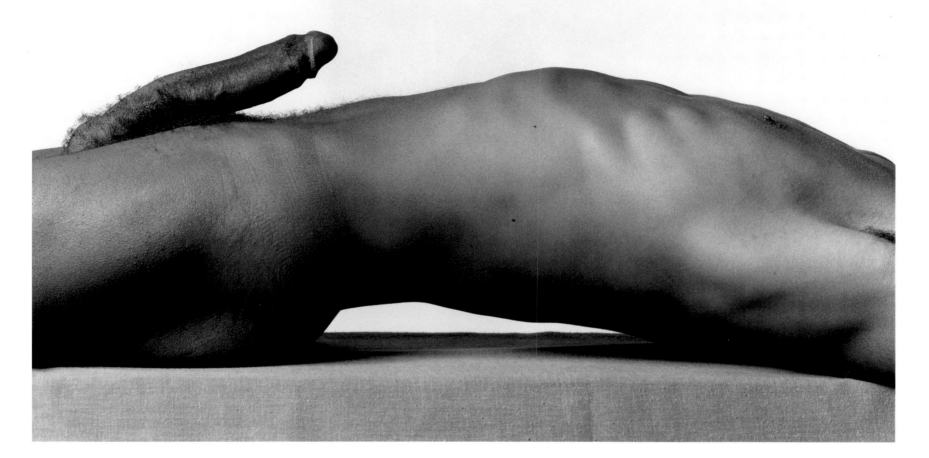

ROBERT MAPPLETHORPE, *Christopher Holly*, 1980

114

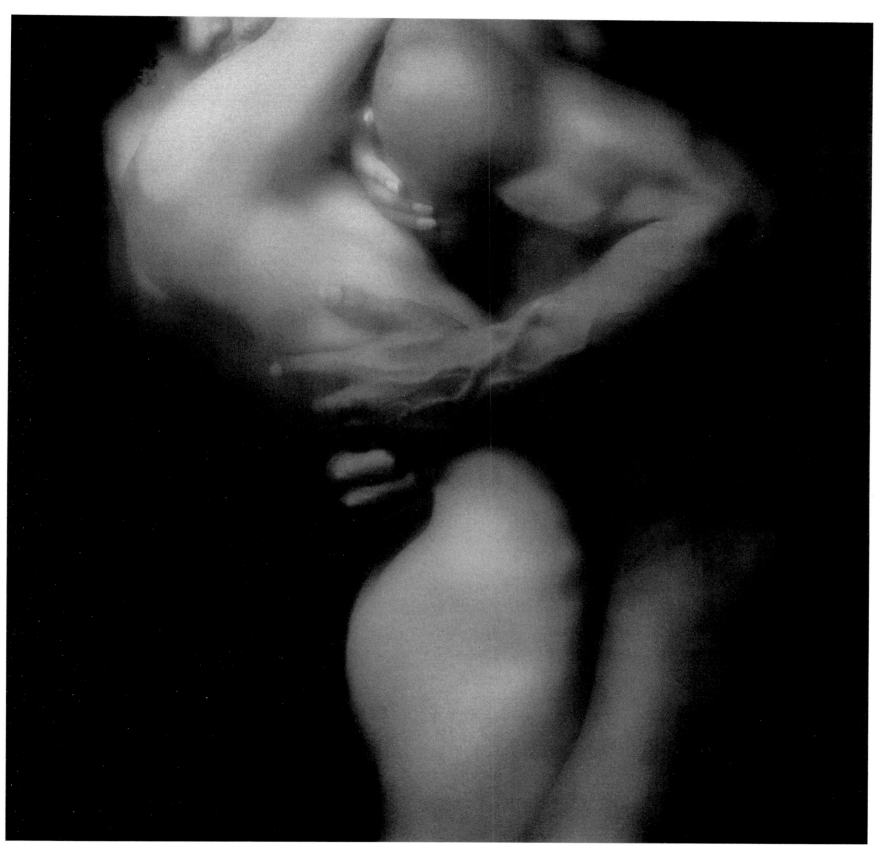

BARBARA BORDNICK, *Nude: Blurred Embrace*, 1996

In Grandma's basement, let's fuck
on something that doesn't squeak,

cuz she's not snoring like she'd
snore if she weren't listening.

(Grandpa we won't think about.
Even if I hollered when we

came instead of biting at
the pillow Grandma made, he

wouldn't dismount from his dreams.)
When we don't go to town with them

to eat prime rib, I'll holler until
the horses bolt, and the hawks kick

the fattest chick out of the nest,
and the brahma bull comes bawling

home, and the greyhounds leave the cats
alone, and the mice spill out of

the loaves of hay, and the wind blows
and blows and blows us all away.

—RICK KEMPA, *Because I Am Tactful and Lewd*

JOHN SCHLESINGER, *Untitled*, 1994-5

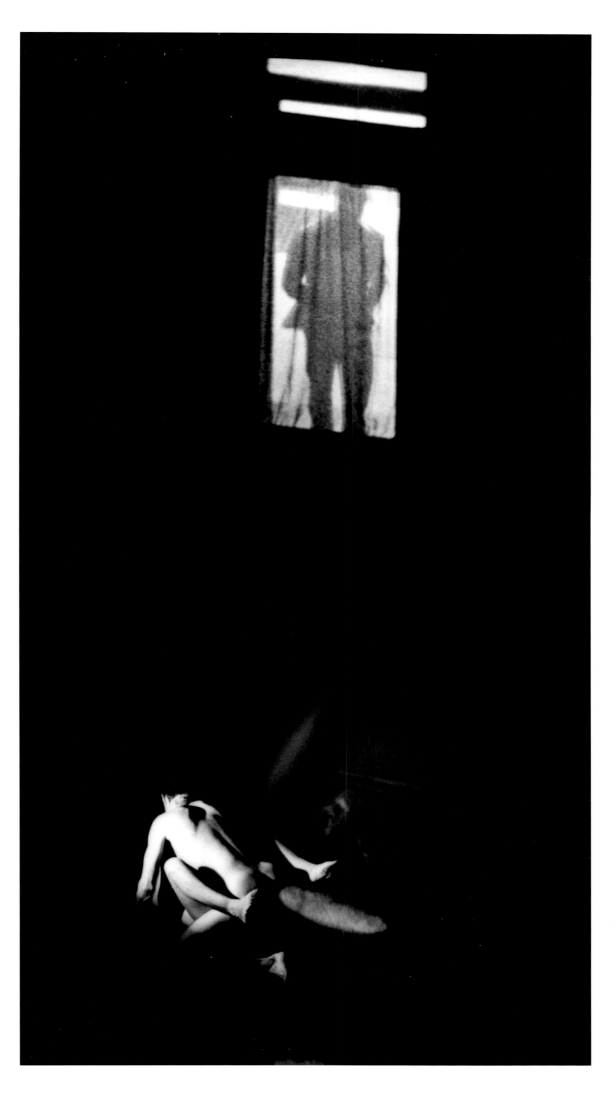

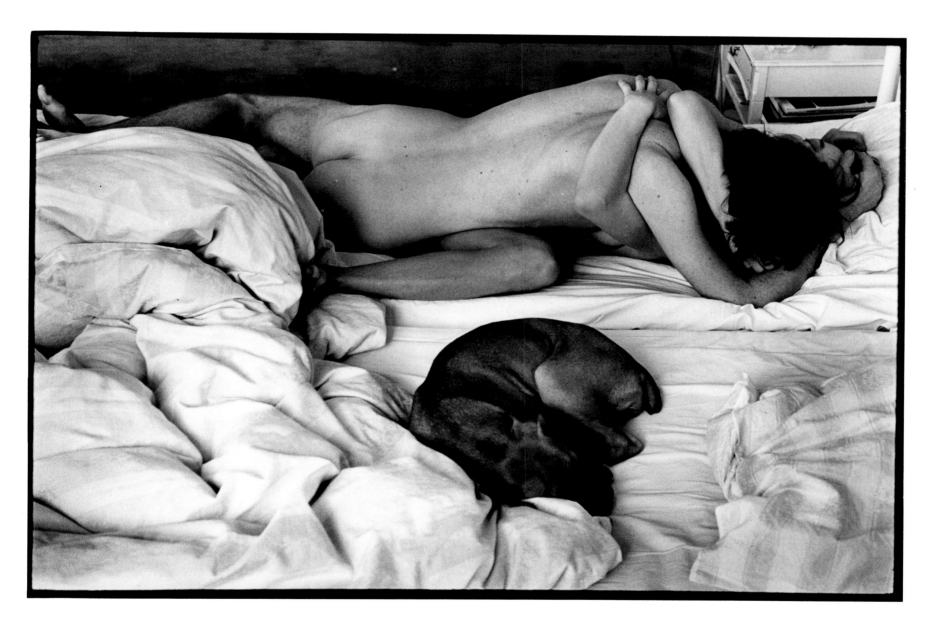

119

LEONARD FREED, *Lovers in a Bed*, 1971

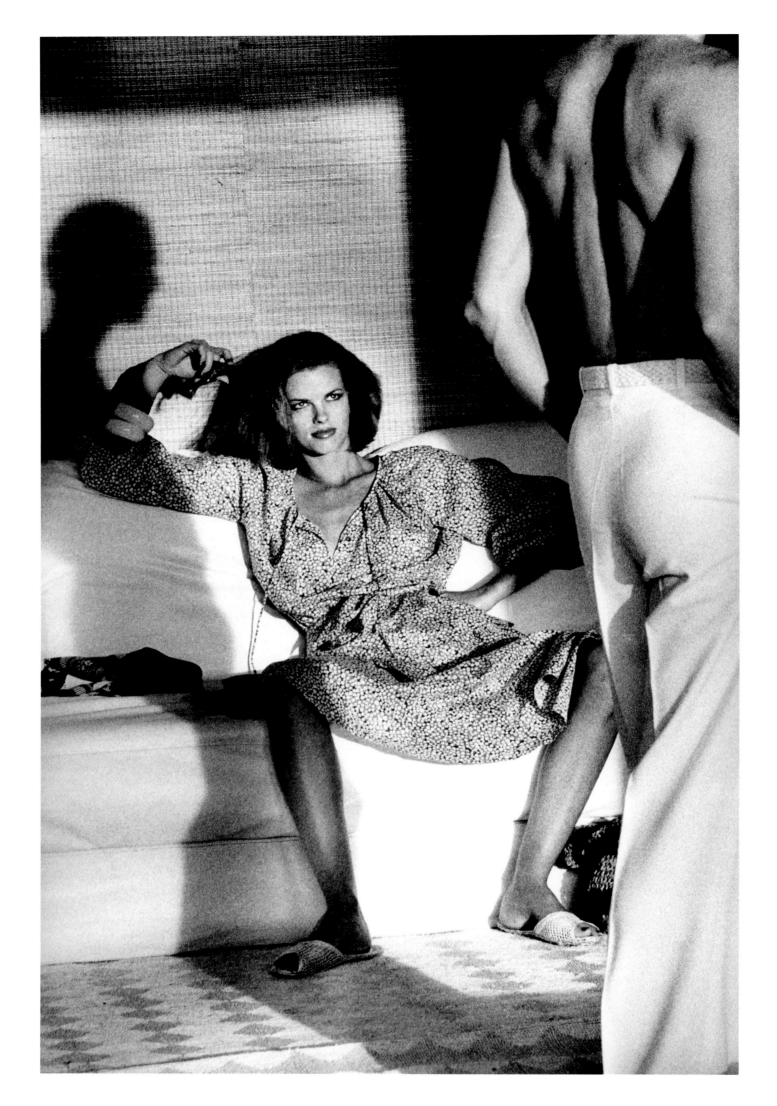

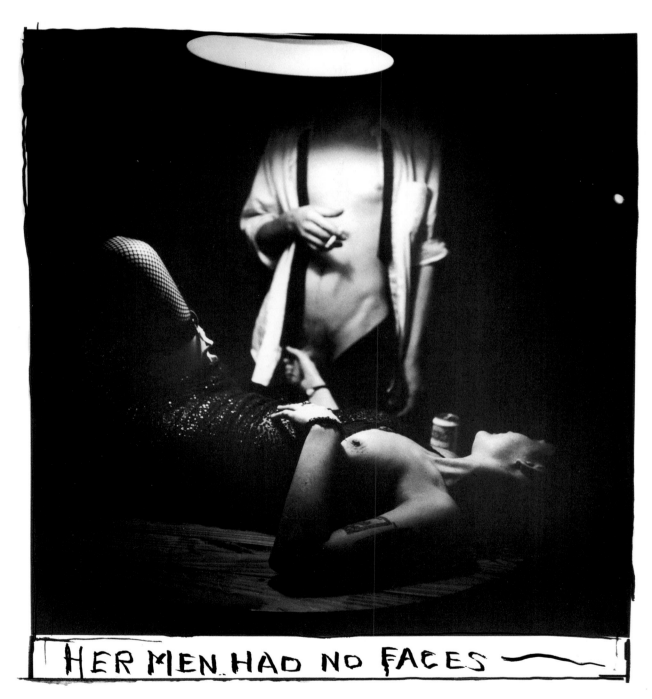

HER MEN HAD NO FACES

DAVID SELTZER, *Her Men Had No Faces*, 1989

HELMUT NEWTON, *Woman Examining Man*, 1975

Helmut Newton, *Office Love*, 1976

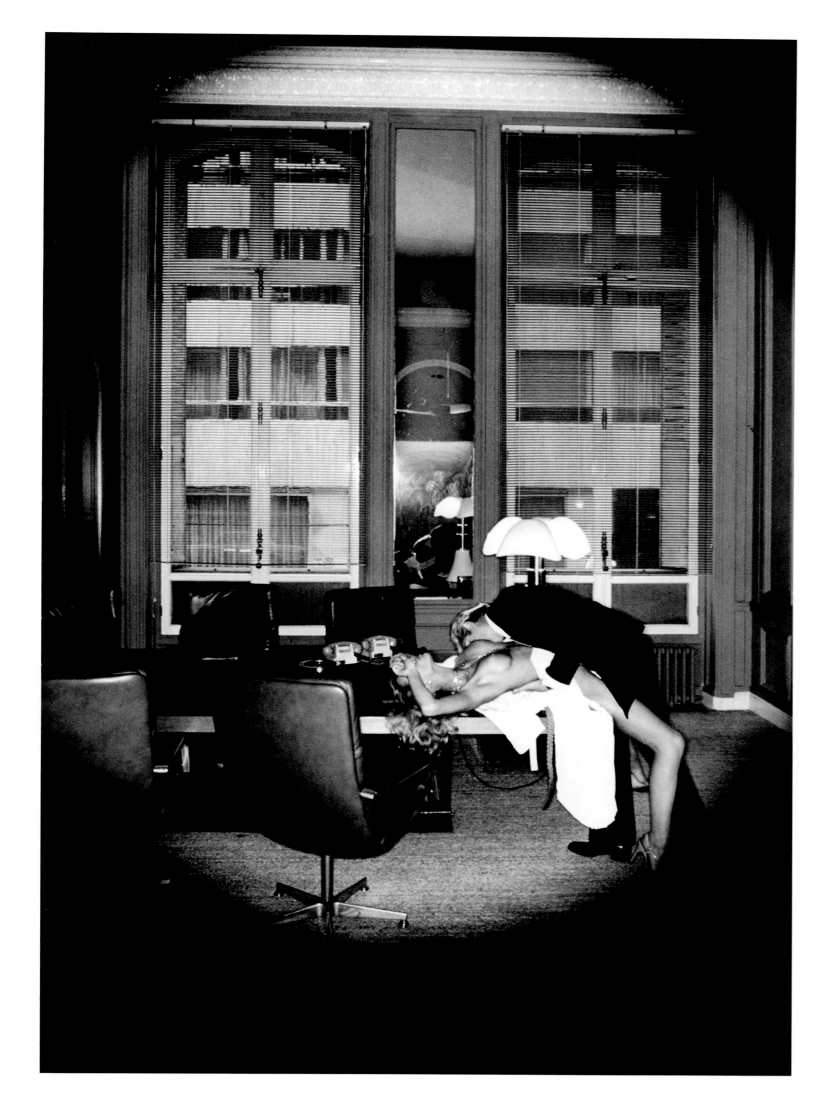

She being Brand

-new;and you
know consequently a
little stiff i was
careful of her and(having

thoroughly oiled the universal
joint tested my gas felt of
her radiator made sure her springs were O.

K.)i went right to it flooded-the-carburetor cranked her

up,slipped the
clutch(and then somehow got into reverse she
kicked what
the hell)next
minute i was back in neutral tried and

again slo-wly;bare,ly nudg. ing(my

lev-er Right-
oh and her gears being in
A 1 shape passed
from low through
second-in-to-high like
greasedlightning)just as we turned the corner of Divinity

avenue i touched the accelerator and give

her the juice,good

 (it

was the first ride and believe i we was
happy to see how nice she acted right up to
the last minute coming back down by the Public
Gardens i slammed on

the
internalexpanding
&
externalcontracting
brakes Bothatonce and

brought allofher tremB
-ling
to a:dead.

stand-
;Still)

—E. E. Cummings, *One, XIX,* from *is 5*

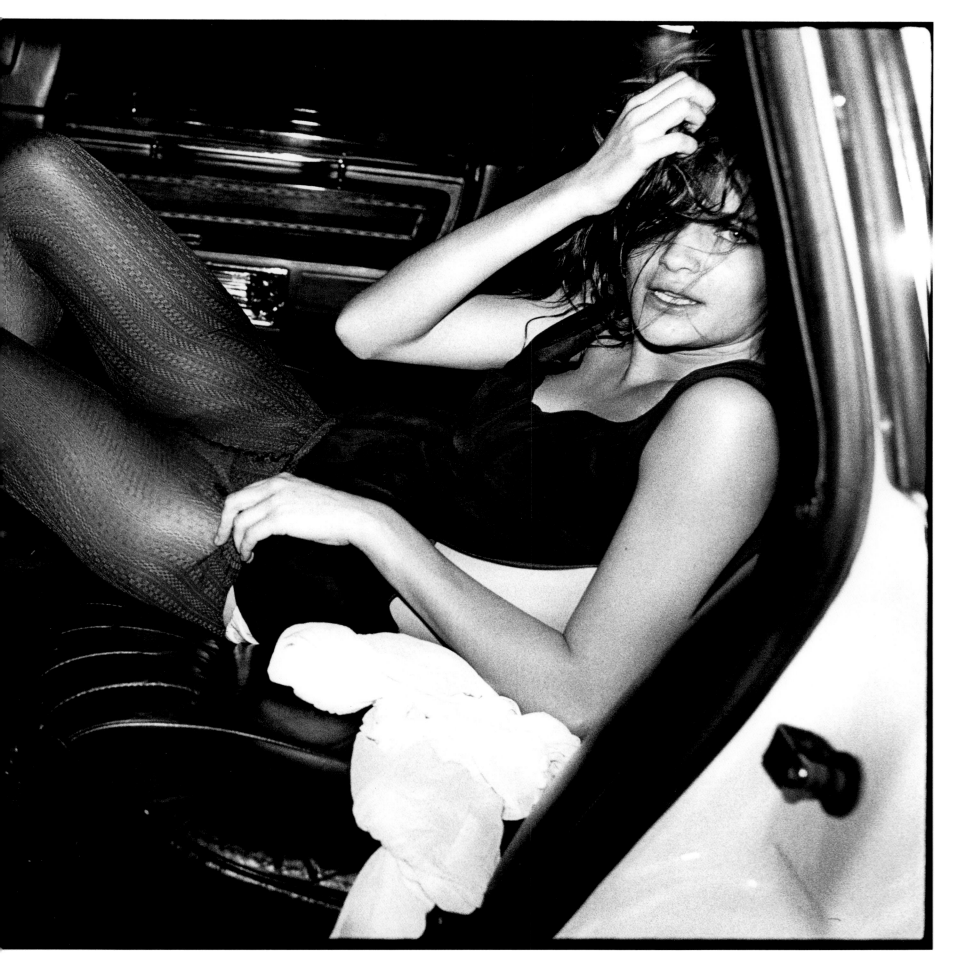

ARTHUR ELGORT, *Helena in Limousine, Los Angeles,* 1990

Girlfriend, I don't believe in spendin no whole lotta money on no shoes. And even if I did, that ain't no reason to keep 'em locked up. So what am I doin with this here box? See, I got to explain how it is with me and Russell.

I had been knowin him for a long time. Always did like him. Not like that. I just liked to keep his company. Russell had somethin about him that drawed me to him. He one of these men that like women. I mean, really like 'em, not just for foolin with, but to be friends with and joke around and laugh with. Russell and me went out lots of times and spent the whole night laughin bout one thang and then anotha. Couldn't remember the next day bout what, just that we had a good time.

Well, one night I was up to Marguerite's. You know that place where Gilbert's band plays. Gilbert was wailin on his sax and, girl, we was ballin. Everybody was all dressed up. I had on my purple dress with the gold threads and the turquoise flowers. You know, the one with the ruffles around the hem and the back out. Lookin good. All the mens was posin around like peacocks and all the women was flouncin round like peahens tryin to be noticed.

You know I thought I was too cute to be standin around with the rest of those heffas. I mean those mens' heads was big enough without me addin to they adoration. So I took to standin by myself at the bar facin the door so I could see whoever was comin in. That's how I happened to see Russell.

Now, in all the time I spent with him, I never thought of Russell in any way more than as a friend. So you know I was not ready for what happened next. And while I know why I stay with him, for the life of me, I cain't figure out what made me get started. I mean he ain't much to look at, bald and short, but that night, I'm here to tell you, that man was fine!!

It was hot outside and he had his jacket slung over his shoulder when he walked in so I could see everythang he had. His shirt was fittin him real close, and I could see every muscle in his chest. When he turned around, I could see how his pants cupped his behind. And, right off, I knew just how it would feel if it was my hands on his naked behind 'stead of his draws. Just thinkin about it gave me a thrill that started in my coochee and spread up and out so far he must have felt it too. Cause he looked up, and, girl, our eyes met, and right then we both knew that we was gon' get it on.

Now, don't get me wrong, we didn't just like that run off and do it. We worked up to it. First he had to pretend he didn't see me. And so did I. But you know I knew where he was every minute of the time. I saw him talkin to Rosalee and the way she was rubbin his thigh. I saw how that huzzy Greta Mae was lettin her titties brush up on him tryin to pretend she didn't know it was happenin. All the women was flockin to him. It was like he was a chocolate ice cream cone and they all wanted a lick. That's all right, I said to myself. They was just warmin him up for me.

He finally worked his way round to me and asked me to dance. The band was playin somethin whiney and slow and we pulled up real close to each other and started grindin. Chile, I hadn't done no grindin since I was in high school. I had forgot how good it felt. He had his thigh rubbin between my legs, rubbin and rubbin in time to the music. I could feel his thang get hard and his

breath hot on my neck. Breath hot and soundin like he had asthma or somethin. I like that. Listenin to a man breathe hard and knowin he's doin it 'cause of the way I make him feel. Makes me hot.

His hands was strokin the middle of my bare back and I was holdin tight onto his shoulders trying to keep myself from grabbin his behind and everythang else 'cause after all I was in public and I don't do that stuff where folks can see me. Girl, that man was gettin to me.

Now, that's how we got started. And we gon' stay together, too. Cause we know just what the other one likes. Russell know how to touch me. He got hands that know when to be rough and when to be soft. He knows I like him to grab my behind real firm and make it move so the stroke is right. He know how to touch my nipples just so, makin me want to scream out his name. But I don't, 'cause his mouth, his lips sweet like candy, is over mine, and for me to scream out, he'd have to move 'em. So I moan. Only real low, so I can hear him breathe. I love to hear him breathe.

And I know what he likes. Russell likes me to wear shoes. Not just any shoes. He likes me to wear mules. You know, those shoes with the toe out, and no straps, and four-inch heels. I remember how I found out. He gave me some money and told me to buy a pair of shoes. I went out and bought this pair of black pumps I had been eyein for about a month. When he saw 'em, he was mad. He grabbed me up, took me to the store, picked up a pair of mules and told me that the next time he sent me to buy some shoes these were what I was supposed to come back with. Now, sometimes he sends me and sometimes he comes home with a pair. I got 'em in every color. You can look over there in the closet and see 'em if you want to.

Anyway, we bought those shoes, went home, and he showed me what to do. I got all dressed up, shoes and all. And then I stripped til I didn't have on nothin but those shoes. Russell watched the whole time, his thang gettin stiff as a baseball bat and him breathin heavy. That was some of the best lovin I ever had.

Now, any time I see him with a pair, I know what to expect. I know we gon' do us some real good lovin, that he gon' last a real long time. I put on those shoes and nothin else. Parade around, throwin my hips everywhichway while Russell lays on the bed watchin me. All the time I watch him out the corner of my eye, likin to see his thang jumpin up and down and hearin him breathe.

But you didn't ask me bout all that. You want to know about this here pair of shoes and this lockbox. I already said I don't pay no money for no shoes, but one Easter I saw this pretty pair of white slingback pumps with the toe out that was just what I needed to go with my new suit. They cost way more than I usually pay, but they was so pretty, I bought 'em anyway. Come the day I wanted to wear 'em, I couldn't find 'em nowhere. Somethin told me to check the closet where we keep my special shoes, and there they were. No longer fit to wear to except in the privacy of my bedroom. That man had cut the straps off!!

So now when I buy toe-out, slingback pumps, I lock 'em up in this here box. That way, girlfriend, I keeps my shoes and my lovin in good shape.

—LAWANDA POWELL, *Shoes*

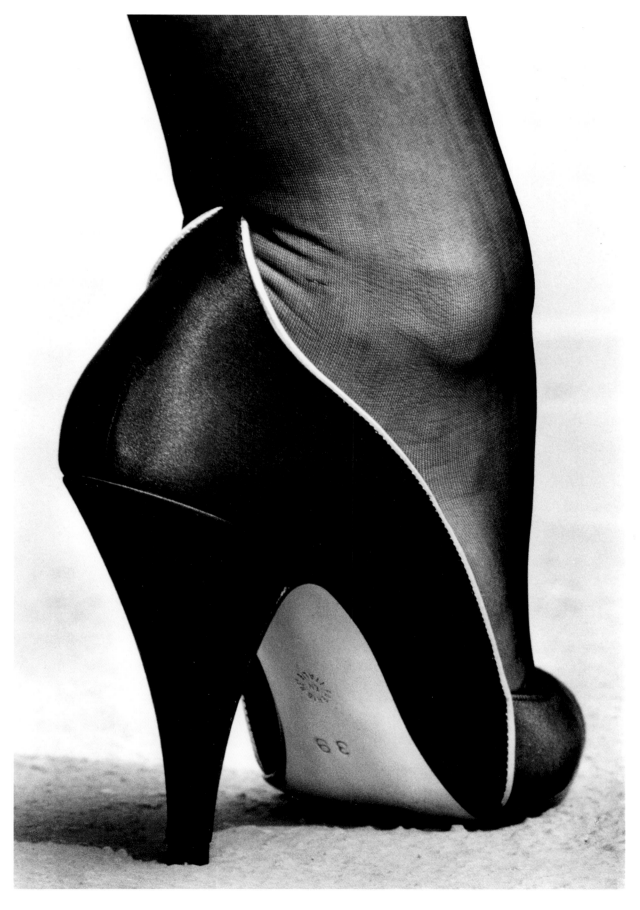

HELMUT NEWTON, *The Shoe*, 1983

There was a contest

once

for the best picture

of a peach

in China

Madame Ling

or was it Ching

sat in some yellow

pollen

then

carefully, again

she sat

upon

a piece of white

paper

—SIV CEDERING, *Peaches*

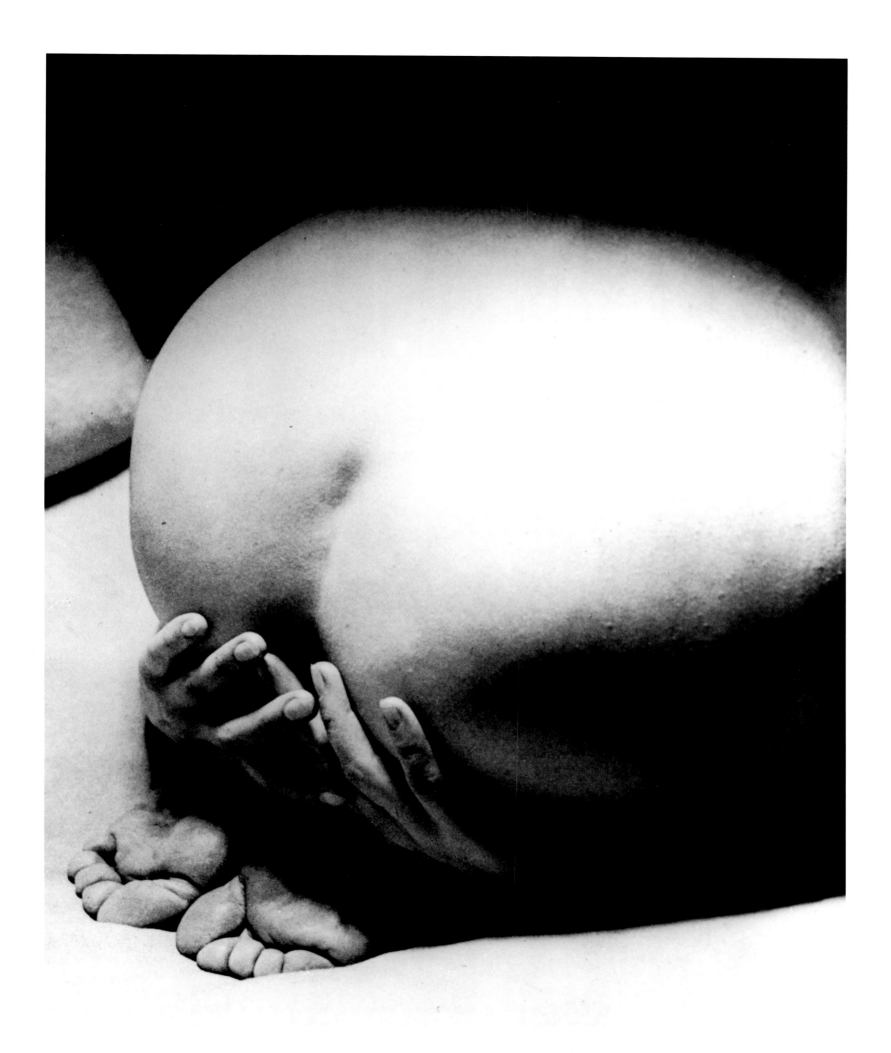

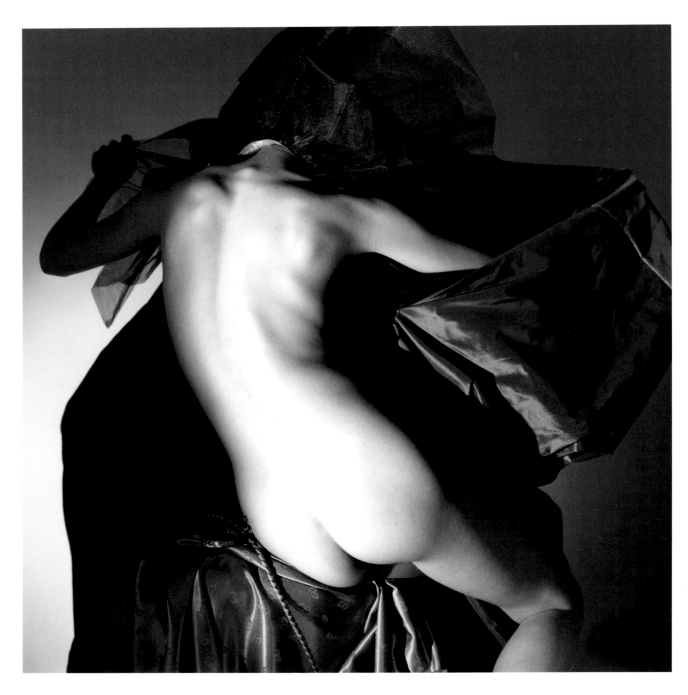

HORST, *American Nude I, NY*, 1982

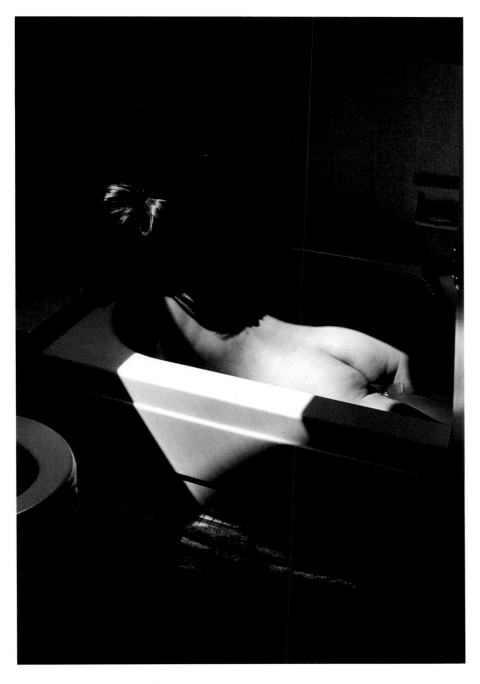

133

TOMAS SENNETT, *Untitled*, 1982

When people say "eros," I know what they mean—though they may not. And when I need my fantasy to evoke the most passion a woman can bear, this is my reference point.

I was unmarried at the time—somewhere between my third and fourth marriage—and I had fallen in love with a man who looked to me like Pan, smelled brownly of summer and sex, and sailed his sloop in the lagoon of Venice and on the Adriatic Sea.

Our affair had begun a year before—we fell in love on his boat, waited a full year in anticipation, and then, when I came back to Venice the following summer, snatched perfect hours in the house he shared with the woman in his life. We continued by phone and fax for years after that—meeting as often as we could. I wore two watches so I always knew what time it was in Venice, and we had lovers' phone dates when we put each other to sleep describing what we would do, had done, to each other.

"I am exploding, full of stars…" he would say (in Italian), coming. Everything was planetary metaphor. Sex was cosmic—by optical fiber.

I would go to Venice and stay in a beautiful suite in the Gritti (where the water rippled on the ceiling) and he would come to visit morning and evening.

But one summer (was it the second or the third? I can't remember), I decided to rent the piano nobile of a palazzo for three months—to give us unlimited time to explore this connection and see if it could become permanent. What I learned was eros is never permanent, or rather the conditions of its permanence are impermanence.

I arrived alone at the end of June, settled into my rented palazzo—with its windows overlooking the Guidecca canal, boats with Cyrillic lettering sliding past, its walled garden filled with old roses and one amazingly fruitful pear tree (*pero*) in the center, which was heavy with ripening pears.

Piero (let us call him) came at eleven o'clock the first morning to say hello ("*per salutarti*"), he said. He said hello to my nipples, my neck, my lips, my tongue, took me by the hand and walked me into the bedroom, where he uncovered by body slowly, exclaiming at the beauty of each part, and entered me on the bed, holding firm inside me for what seemed like forever, while I filled with juice like the pears on the peartree and began to throb as if a storm were shaking them onto the ground.

Filled by his smell, his words, his tongue, his incredibly unhurried penis, all of me rose up to him as if the cells of my body were being taken apart and put back together. It was sort of transubstantiation—blood and body becoming bread and wine instead of the other way around. I looked up at his faunlike brown eyes, his curly reddish gold hair and said, "*Mio dio del bosco*"—my forest god—for that was how it felt. It was like being possessed by a very gentle grandmaster of the coven, a stagman, a horned god, the god of the witches, the greenman. It was like being possessed by all of nature, giving up my intellectuality, my will, my separateness to the green fuse that drives the flower.

The sun shone in squares on the bed, the canal water rippled on the painted ceiling (with its figures of Hera, Venus, Persephone, and assorted sibyls), motorboats puttered by, and in the wake of my oneness with the forest and the sea, I saw clearly what the life of a man and a woman was meant to be like, two halves fitting into each other, out of time, for eternity. I knew that people took drugs trying to simulate this, pursued money and power for this, tried to destroy it in others when they could not have it themselves. It was a very simple gift—but no less elusive for its simplicity—and most people had never known it. All their thrashing around was in its pursuit.

"I must go," he said, and I followed him into the bathroom—laughing, literally jumping for joy—while he washed under his arms and his crotch, put on his clothes, and fluttered a kiss between my breasts.

"I will call for you at five," he said.

And I sat down to the day's writing, with his sap between my thighs, and his smell on my fingers and mouth.

I wrote till three, dressed in a bathing suit under a sundress, and walked the length of the Fondamenta to the swimming pool where I swam laps in the sunlight, feeling my limbs heavy as water, bright as the air. Then I had something to eat and walked back down the Fondamenta, seeming to float over the stones.

At five he called. "*Siete sola?*" (Are you alone?) he asked.

Of course I was alone. And then we were back in bed, with the afternoon light, not the morning light, playing on the ceiling, with his rod and staff comforting me, with his salty kisses turning my mouth into the lagoon drowning the fiery pink sun.

Sometimes we'd walk together on the Fondamenta or stop for a glass of wine at Harry's Dolci—and then he was gone to his other life and I to my dinners with friends, concerts, operas, long walks in the city.

Sometimes, I'd see him puttering through the lagoon squiring his other lady. Sometimes I'd wonder where he was. But always with pleasure, not pain.

This went on for eight days. And on the evening of the eighth day he vanished without a word. He was at sea with people I did not know. He was gone and I had no idea if he would ever return.

The days grew long. A suitor from home showed up, and later, one from Paris. They failed to banish him from my bed. Eventually my daughter came and my assistant, and I crammed the day with motherhood and work.

I was enraged with Piero, not for going, but for going without a word and I vowed never to see him again. The summer dragged on, hot, humid, useless. Venice was like a cruise ship where I knew and was bored by all the people. Eventually my daughter had to see her father and my assistant had to see her lover. Friends arrived and took me on an endless round of parties—and then one morning, he rang as if nothing had happened.

"*Siete sola?*" he asked.

"*Cretino!*" I shouted. "Idiot!"

"I have to go to Murano in the boat—will you come?"

I flew out of the house to tear his eyes out.

In the boat, I hammered my fists at his chest.

"How could you leave me when I came here to be with you?"

"I had no choice—I *had* to."

And his mouth was on my mouth, silencing me.

In a little while, we were parked behind a mud bank, thick with rushes, making love. And the boat rocked with us and the sun shone.

My houseguests were amused as I cursed him, then ran to him, then cursed him again. We would meet in the secret little studio near my walled garden whose roses were over but whose pear tree still dropped fruit. We would make love morning and night and then he would flee.

I forgave him because I had to. When he entered me, I felt complete. Yet when he left, I did not trust him to return.

There is no end to this story. If he appeared here today and touched me I would be drawn back into that forest, that lagoon, that whirling sabbath dance.

The sense of impermanence made his hold on me permanent and his unreality also made him real. Some nights I go to sleep thinking I will wake up in that other country with that other husband. He is my husband on the moon and when it is full, I think of him. He populates my dreams.

When people say "sex," I think of him.

What would have happened if I joined my life with his?

I can only speculate. He claims he does not make love with the lady he lives with and maybe this is true, maybe not. I only know that I would rather be the one he runs to than the one he escapes from, and somehow I have insured that situation by not sticking around. I would rather keep sex alive in my fantasy life than kill it by marrying it. But maybe I am deluding myself. Could I have lived with the god of the woods? Only part time. He was not willing to be there *except* part time. And I accepted his conditions and went on with my life.

—ERICA JONG, from *Fear of Fifty*

135

Judy Dater, *Lovers #2*, 1964

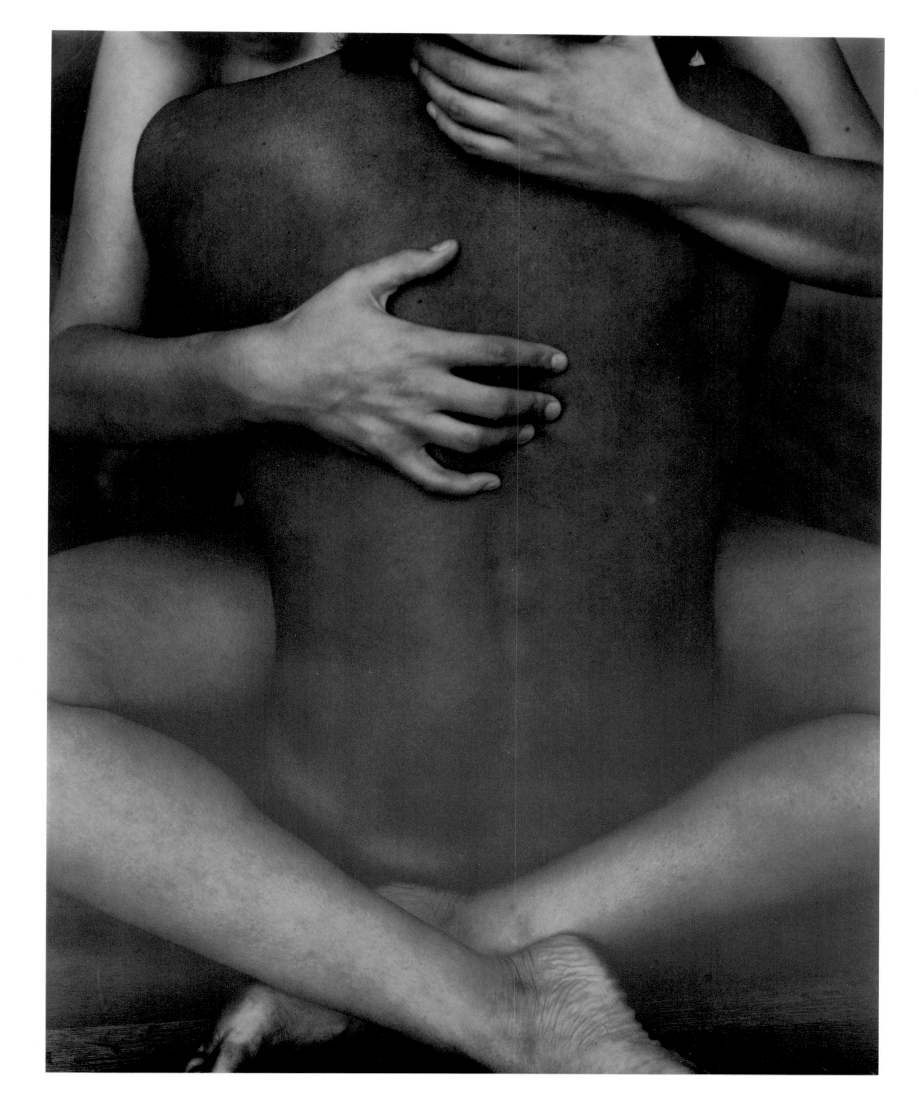

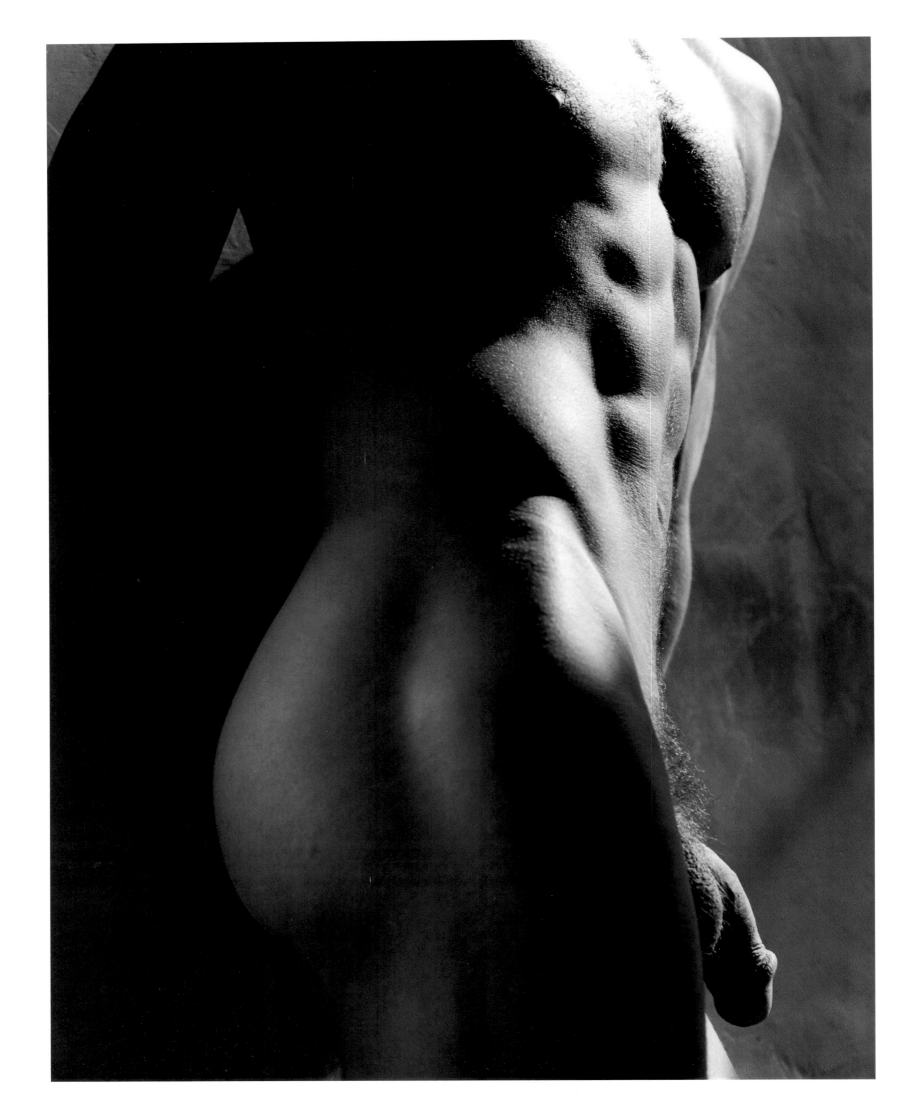

138

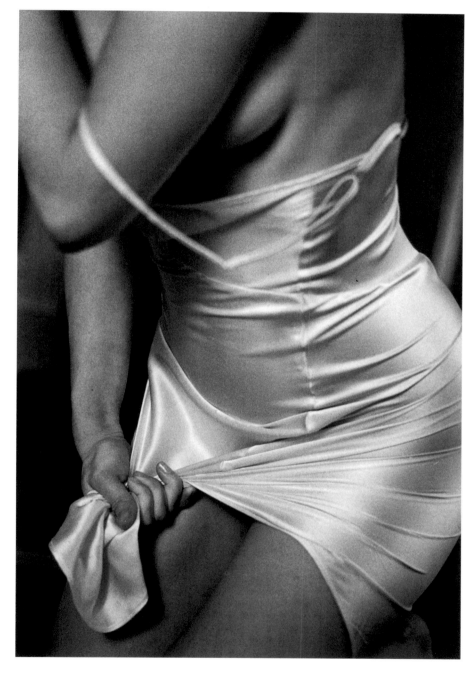

WAYNE MASER, *Untitled*

GREG GORMAN, *Male Torso*, 1988

DAVID LEVINTHAL, *Untitled,* from the series *Desire,* 1991

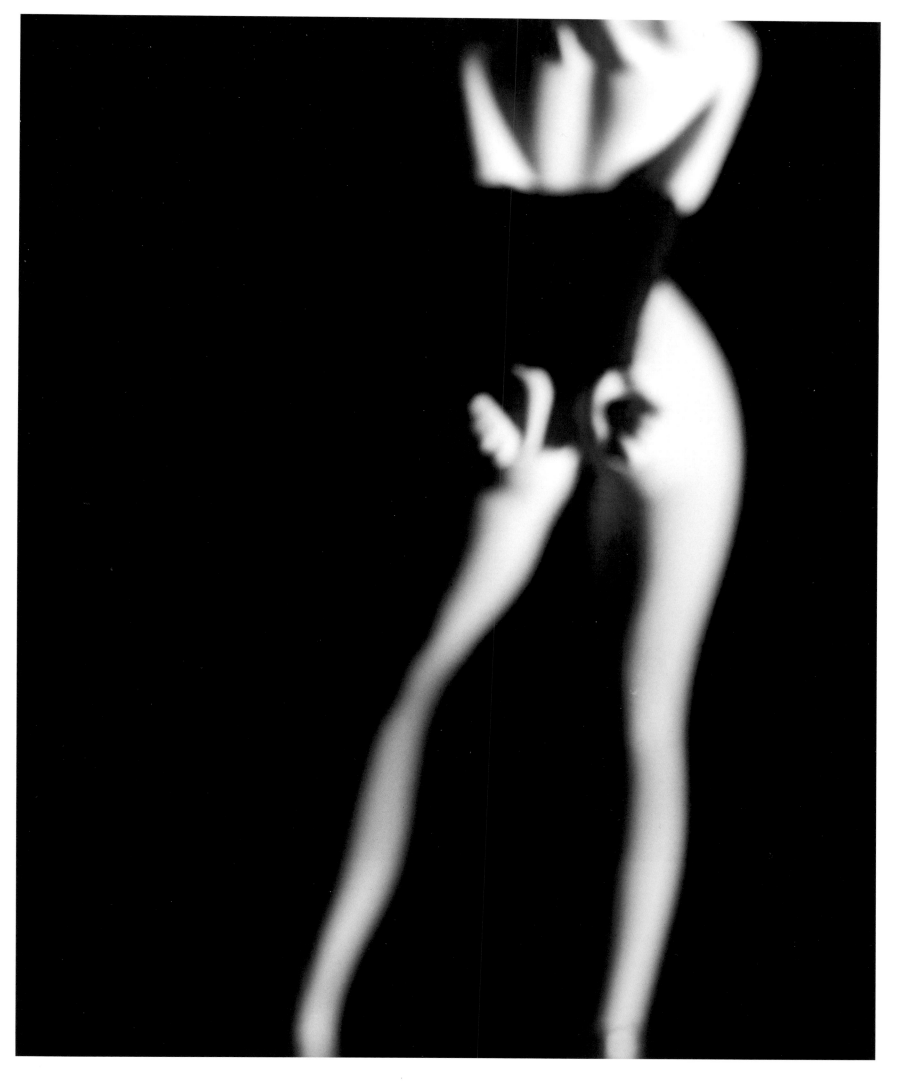

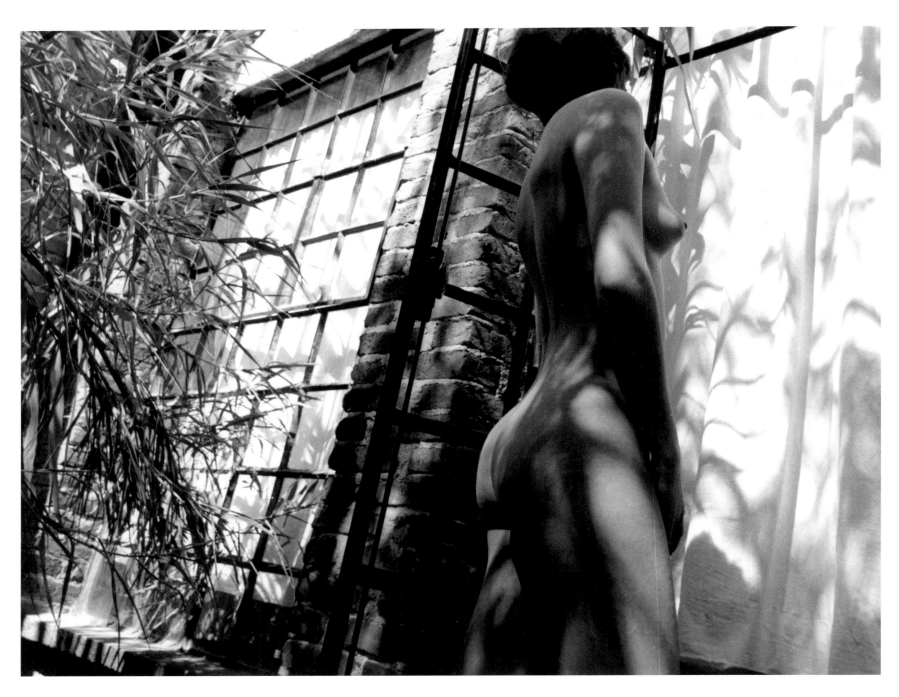

MANUEL ALVAREZ BRAVO, *La tela de la araña*, 1989

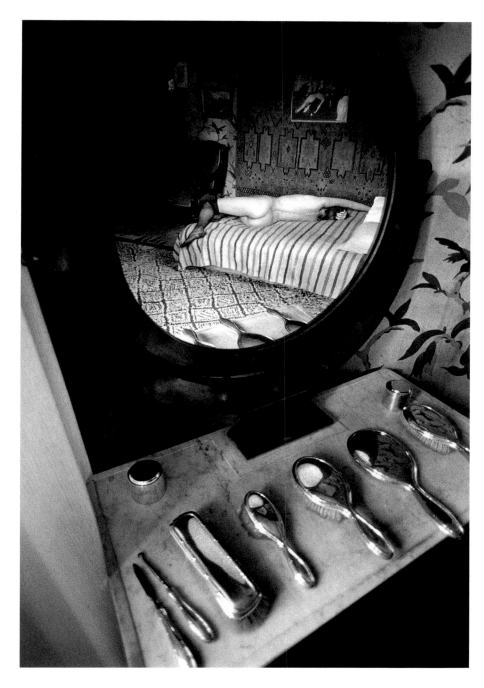

JEANLOUP SIEFF, *Alice's Mirror*, 1976

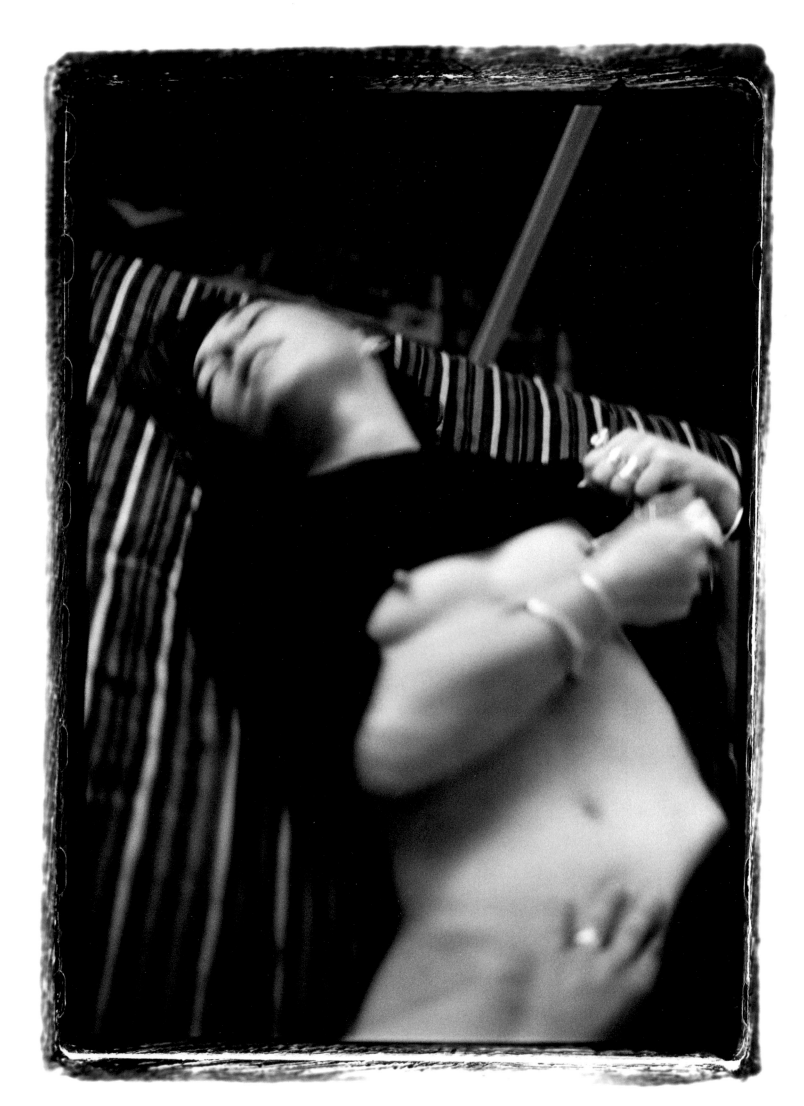

144

These were the external feelings of the bodies discovering each other. From so much touching they grew drugged. Their gestures were slow and dreamlike. Their hands were heavy. His mouth never closed.

How the honey flowed from her. He dipped his fingers in it lingeringly, then his sex, then he moved her so that she lay on him, her legs thrown over his legs, and as he took her, he could see himself entering into her, and she could see him too. They saw their bodies undulate together, seeking their climax. He was waiting for her, watching her movements.

Because she did not quicken her movements, he changed her position, making her lie back. He crouched over so that he could take her with more force, touching the very bottom of her womb, touching the very flesh walls again and again, and then she experienced the sensation that within her womb some new cells awakened, new fingers, new mouths, that they responded to his entrance and joined in the rhythmic motion, that this suction was becoming gradually more and more pleasurable, as if the friction had aroused new layers of enjoyment. She moved quicker to bring the climax, and when he saw this, he hastened his motions inside of her and incited her to come with him, with words, with his hands caressing her, and finally with his mouth soldered to hers, so that the tongues moved in the same rhythm as the womb and penis, and the climax was spreading between her mouth and her sex, in cross-currents of increasing pleasure, until she cried out, half sob and half laughter, from the overflow of joy through her body.

—ANAÏS NIN, from *Elena* in *Delta of Venus*

GULNARA SAMOILOVA/STEVEN KASHER, *Untitled,* from the series *Scenes,* 1995

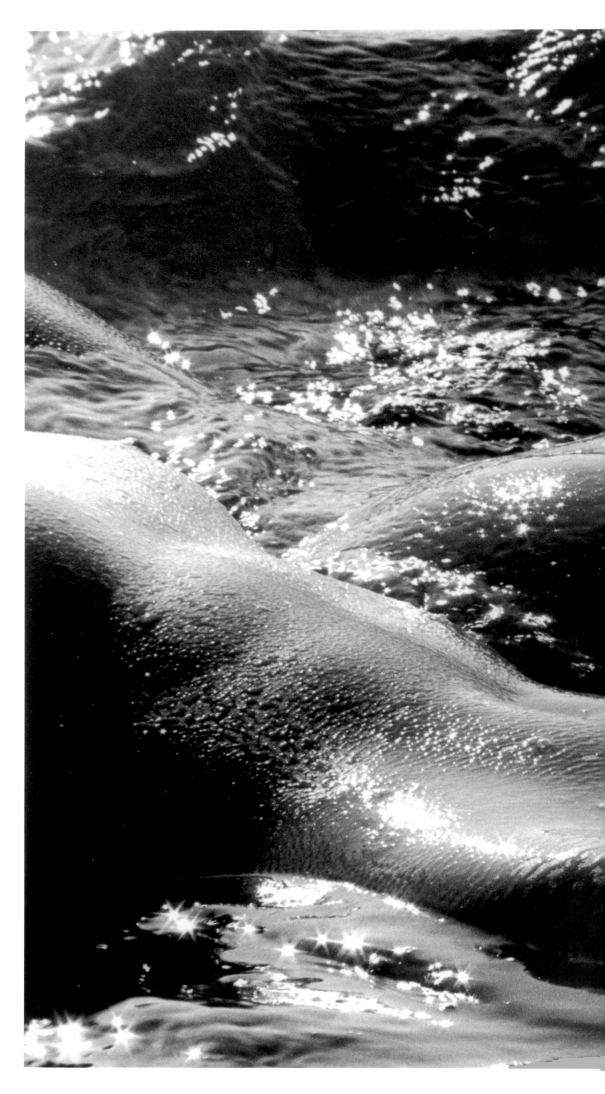

146

LUCIEN CLERGUE, *Les Géantes*, 1978

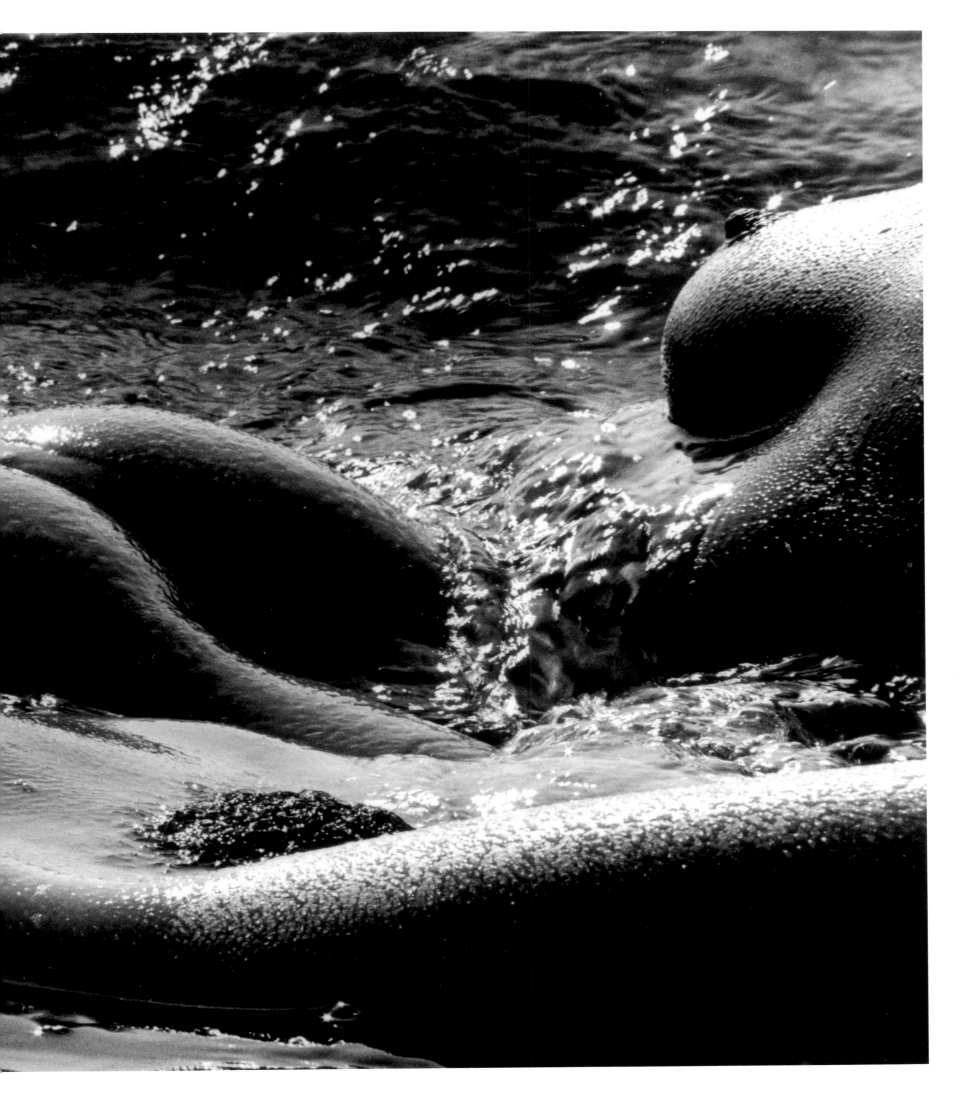

I find my love fishing
His feet in the shallows.

We have breakfast together,
And drink beer.

I offer him the magic of my thighs
He is caught in the spell.

—EGYPTIAN, from 1500–1000 B.C.,
translated by Ezra Pound and Noel Stock

CHRISTINA HOPE, *First Light I*, 1990

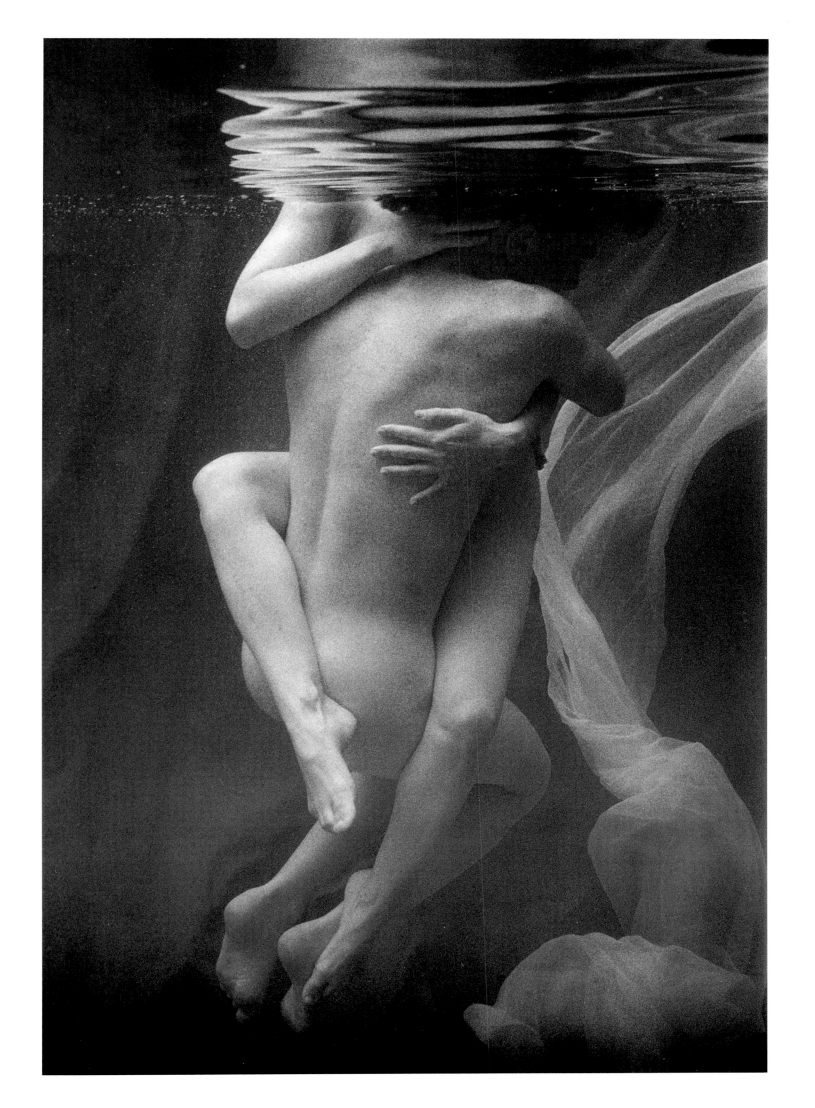

149

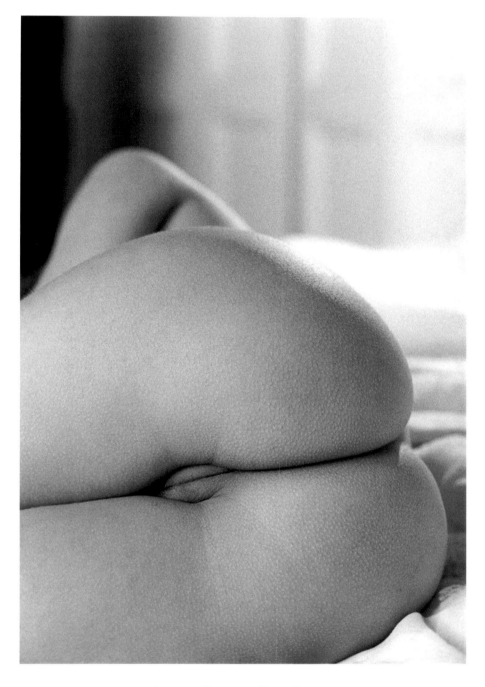

ANDREW BRUCKER, *Untitled*, 1990

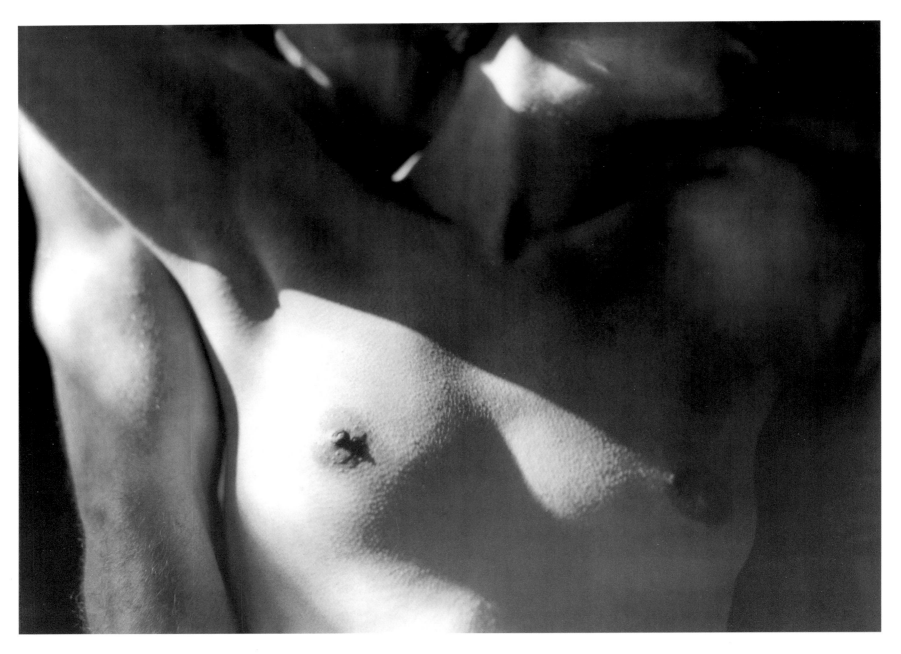

IMOGEN CUNNINGHAM, *Nude*, 1923

She started out of her muse, and gave a little cry of fear. A man was there.

It was the keeper. He stood in the path like Balaam's ass, barring her way.

"How's this?" he said in surprise.

"How did you come?" she panted.

"How did you? Have you been to the hut?"

"No! No! I went to Marehay."

He looked at her curiously, searchingly, and she hung her head a little guiltily.

"And were you going to the hut now?" he asked rather sternly.

"No! I mustn't. I stayed at Marehay. No one knows where I am. I'm late. I've got to run."

"Giving me the slip, like?" he said, with a faint ironic smile.

"No! No. Not that. Only—"

"Why, what else?" he said. And he stepped up to her, and put his arms around her. She felt the front of his body terribly near to her, and alive.

"Oh, not now, not now," she cried, trying to push him away.

"Why not? It's only six o'clock. You've got half an hour. Nay! Nay! I want you."

He held her fast and she felt his urgency. Her old instinct was to fight for her freedom. But something else in her was strange and inert and heavy. His body was urgent against her, and she hadn't the heart any more to fight.

He looked round.

"Come—come here! Through here," he said, looking penetratingly into the dense fir trees, that were young and not more than half-grown.

He looked back at her. She saw his eyes, tense and brilliant, fierce, not loving. But her will had left her. A strange weight was on her limbs. She was giving way. She was giving up.

He led her through the wall of prickly trees, that were difficult to come through, to a place where was a little space and a pile of dead boughs. He threw one or two dry ones down, put his coat and waistcoat over them, and she had to lie down there under the boughs of the tree, like an animal, while he waited, standing there in his shirt and breeches, watching her with haunted eyes. But still he was provident—he made her lie properly, properly. Yet he broke the band of her underclothes, for she did not help him, only lay inert.

He too had bared the front part of his body and she felt his naked flesh against her as he came into her. For a moment he was still inside her, turgid there and quivering. Then as he began to move, in the sudden helpless orgasm, there awoke in her new strange thrills rippling inside her. Rippling, rippling, rippling, like a flapping overlapping of soft flames, soft as feathers, running to points of brilliance, exquisite, exquisite and melting her all molten inside. It was like bells rippling up and up to a culmination. She lay unconscious of the wild little cries she uttered at the last. But it was over too soon, too soon, and she could no longer force her own conclusion with her own activity. This was different, different. She could do nothing. She could no longer harden and grip for her own satisfaction upon him. She could only wait, wait and moan in spirit as she felt him withdrawing, withdrawing and contracting, coming to the terrible moment when he would slip out of her and be gone. Whilst all her womb was open and soft, and softly clamouring, like a sea-anemone under the tide, clamouring for him to come in again and make a fulfilment for her. She clung to him unconscious in passion, and he never quite slipped from her, and she felt the soft bud of him within her stirring, and strange rhythms flushing up into her with a strange rhythmic growing motion, swelling and swelling till it filled her all cleaving consciousness, and then began again the unspeakable motion that was not really motion, but pure deepening whirlpools of sensation swirling deeper and deeper through all her tissue and consciousness, till she was one perfect concentric fluid of feeling, and she lay there crying in unconscious inarticulate cries. The voice out of the uttermost night, the life! The man heard it beneath him with a kind of awe, as his life sprang out into her. And as it subsided, he subsided too and lay utterly still, unknowing, while her grip on him slowly relaxed, and she lay inert. And they lay and knew nothing, not even of each other, both lost. Till at last he began to rouse and become aware of his defenceless nakedness, and she was aware that his body was loosening its clasp on her. He was coming apart; but in her breast she felt she could not bear him to leave her uncovered. He must cover her now for ever.

But he drew away at last, and kissed her and covered her over, and began to cover himself. She lay looking up to the boughs of the tree, unable as yet to move. He stood and fastened up his breeches, looking round. All was dense and silent, save for the awed dog that lay with its paws against its nose. He sat down again on the brushwood and took Connie's hand in silence.

She turned and looked at him. "We came off together that time," he said.

—D. H. LAWRENCE, from *Lady Chatterley's Lover*

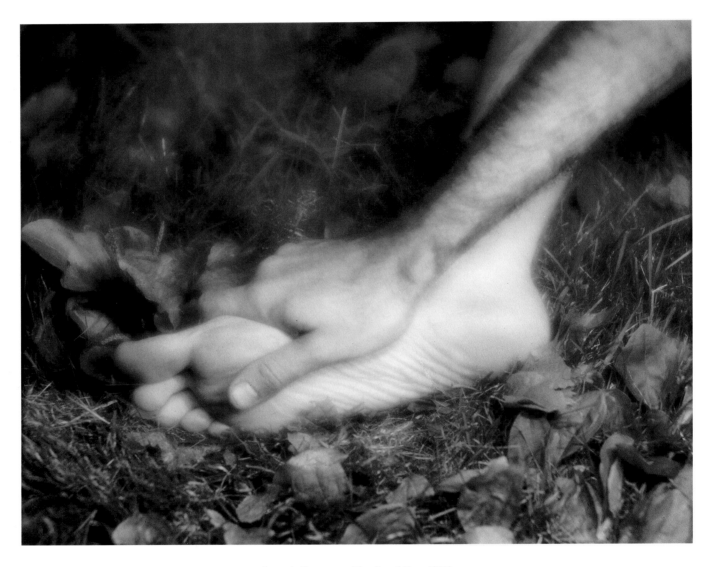

LINDA CONNOR, *Hand and Foot*, 1975

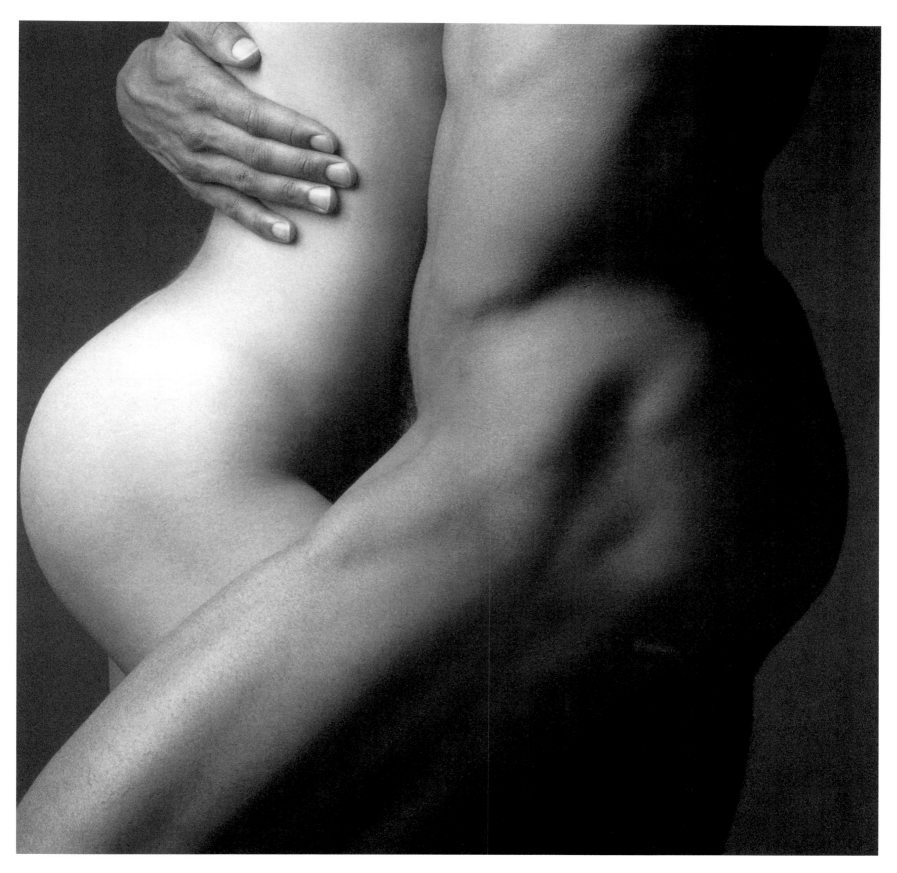

155

BARBARA BORDNICK, *Untitled*, 1996

I remember, the preacher said: "Let them be joined together forever in the Holy Spirit," and I kind of wrinkled my brow because God is easy and Jesus is easy but the Holy Spirit thing was always way beyond me, and I wasn't really sure that what I had in mind was a ménage à trois with some supposedly benevolent essence, and in my poor agnostic head I imagined the two of us suspended in the spiritual plasma of the Holy Ghost for eternity, like watermelon pickles.

But when we headed out of the old adobe church that day so far as I could tell it was still just the two of us, just you and me, light-headed as teenagers in the summer in the evening in the park, our vows an exotic narcotic wrapped in plastic and shoved down deep in our socks.

And I remember we didn't even make love that night, but consummated our marriage in the deep sweet of sleep. In the morning there were tiny roses of blood on the bed and I knew that my dreams had ferried across the occult water of sleep and with a broad flat sword had broken through the soft dense flesh of your maidenhead to dance with you to the beat of feral drums.

And when the morning had come, sure enough, there was the Holy Spirit, less like a poltergeist and more like a cat, perched on a comforter on the old steamer trunk at the end of the bed.

"Go ahead," the Holy Spirit dared me. "Touch her." And I touched you and the walls shuddered like an old miner's shack teetering into the San Andreas fault.

"Holy shit," I said, thinking this could be dangerous, and then I realized that I had blasphemed and I was afraid and embarrassed.

"It's okay," the Holy Spirit told me. "You go right ahead. Don't worry. Nothing can harm you."

So I kissed your ear, and Aretha Franklin began to sing.

And I pulled off your T-shirt and the bed danced a samba across the floor.

And you said "that's cool," and I said "you try it" and you kissed me on the lips and instantaneously the bedroom walls shattered, covering us in gypsum dust and little puffs of pink insulation and bright shards of glass.

I cupped your breast in my hand and bit at your nipple and the trees moaned with pleasure and all the neighborhood children gathered around us in the rubble and danced in a ring, their little hands holding each other gingerly, like hamsters.

I touched your belly and Gideon appeared, his trumpet blasting a Hallelujah into the quivering sky.

Then you pulled hard at my back and fire roared down from the sky like napalm, sucking the air from my lungs and smoldering in jellied splotches on the soles of my feet.

I stroked your side and buck naked laughing seraphim appeared fluttering all around me, randomly shooting morphine-dipped arrows into my butt.

Light stuck to your naked body like a fresh-cut haystack after a rain. You looked just like a desert sunrise and you tasted just like filé gumbo and you smelled just like the spray from the breakers at Patrick's Point.

Puppies played under your skin and some unseen hand snaked a length of hairy twine up from my tailbone and out through the center of my skull, harmlessly pulling out bits of unused brain tissue that stuck to my hair like marshmallows.

And when I pulled your thighs apart the sky opened and God himself came thundering down wearing a porkpie hat with a press pass stuck in it, taking a seat at the announcer's desk of some celestial sky box, surrounded on every side by bleachers full of rowdy drunken angels.

"Don't mind Me," He said into the microphone.

And then He filled us so full of the Holy Spirit that It oozed out of us, and we slipped and slid across each other, the Holy Spirit sticky in our mouths, the Holy Spirit leaking liquid blue light from our fingertips, the Holy Spirit trickling down our foreheads and stinging into our eyes, the Holy Spirit pouring from our armpits and off our legs and our shoulders and from between your legs and making a holy mess on the bed.

We were speaking in tongues. We were rolling holy rolling in the sheets. Our tongues were driven mad with Pentecostal ecstasy, our tongues were epileptic, our tongues were frothing, our tongues were crying, our tongues were screaming, our tongues were babbling holy nonsense, our tongues were repentant of every sin, our tongues praised God, our tongues were baptized, our tongues were washed with the Blood of the Lamb, and our tongues were born again. And again.

And as our tongues gave witness to the power of the Holy Spirit, I heard the strange words rise up into Heaven and rattle the very cage of the universe, building, like an argument, shattered, like the Tower of Babel, resurrected, like Jesus, emerging from the dark cave of our souls.

And then it was night again, and the Holy Spirit settled down on us like a feather comforter, a soft weight that pulled us close in the night, down toward the dark beat of drums around a fire in the forest along a turgid river of sleep.

And as I drifted slowly down from the headwaters of consciousness, I remembered what the preacher said: "Let them be joined together forever in the Holy Spirit," and I pulled you closer, and I murmured from my tired, tired tongue, "oh, baby, amen."

—CARSON REED, *Speaking in Tongues*

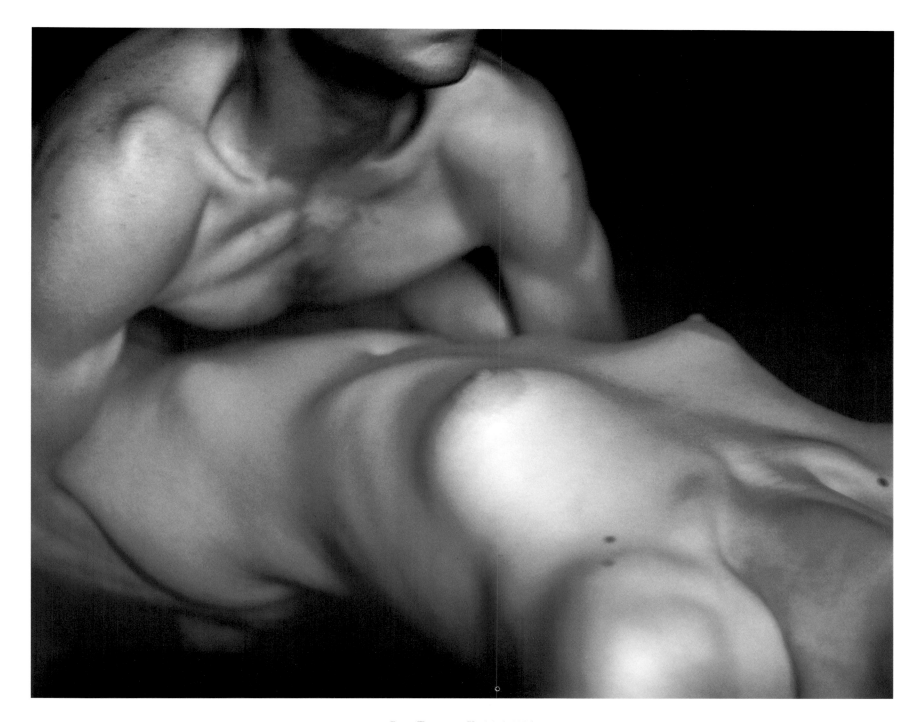

RON TERNER, *Untitled*, 1985

On my belly as you enter me,
I think in flowers,
taste names of roses:
Gloire de Dijon.
Crimson.
Starburst.

—NOELLE CASKEY, *Seedbed*

SANDI FELLMAN, from the series *Secrets*, 1977

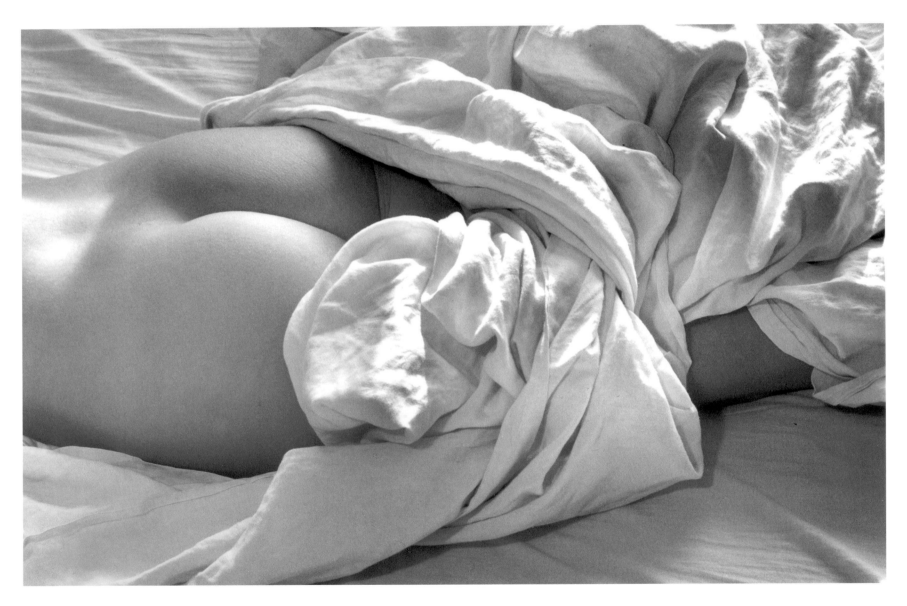

FRÉDÉRIC BARZILAY, *Woman in Bed*, 1983

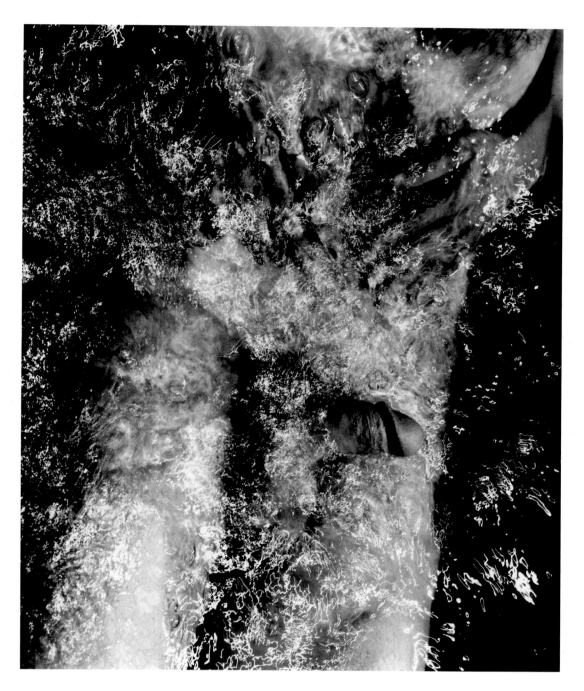

Leeanne Schmidt, *Untitled*, 1993

this has

got to stop

not the passion

us not being

able to resist

each other

the endless craving

in my groin

the hunger of

my lips

to taste

you

 the pull

of my arms

to wrap you

to me

this has got to stop

not the unquenchable

desire

the tongue

massaging flesh

the arms

that caress

and enfold

but the interruption

of daybreak

the demands

of work

the intrusion

of friends

all those

petty things

that steal us

from each other

temper our

rhythm

wipe our

wetness

that's what has

got to stop

not you

deep in me

bodies thrashing

drinking love

from each other

not being able

to get enough

of ourselves

the moon

refusing

to surrender

her place

to the sun

us

 interconnected

riding waves

smelting iron

us

 resisting

drowning ourselves

in each other

this has

got to stop

but i pray

it never

—OPAL PALMER ADISA, *Insatiable*

LISA SPINDLER, *Couple Embracing*, 1990

162

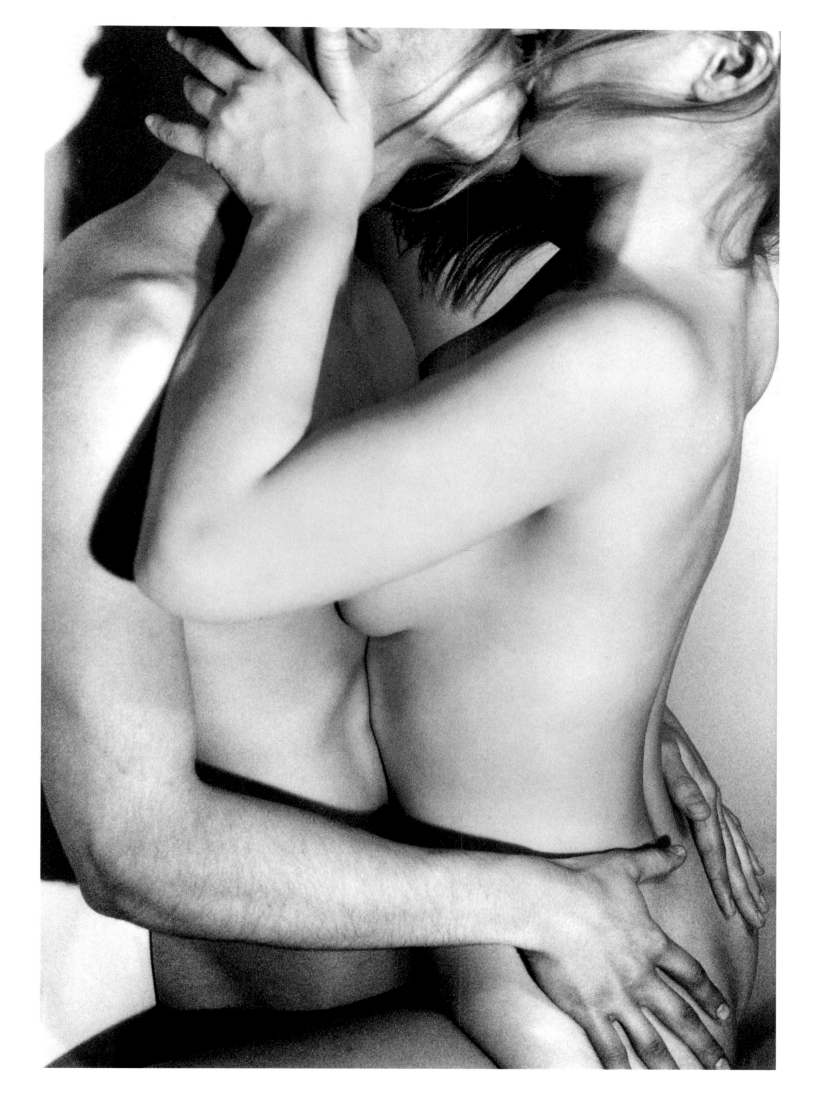

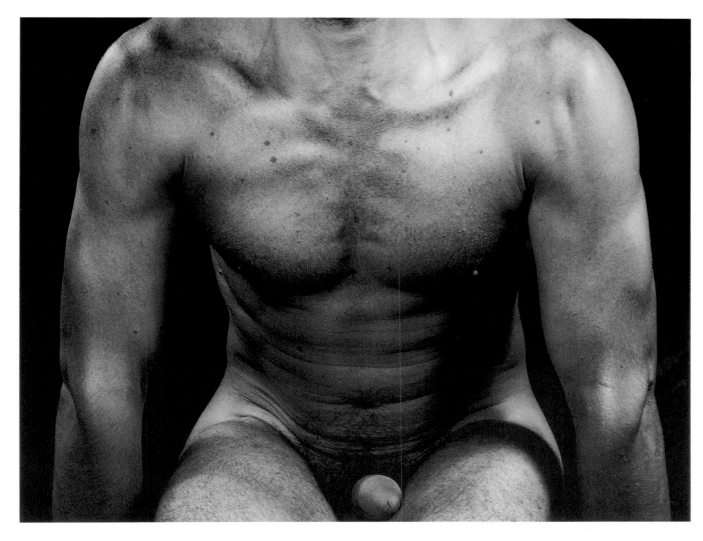

Dianora Niccolini, *Untitled*, 1981

Lisa Spindler, *Bending Torso*, 1991

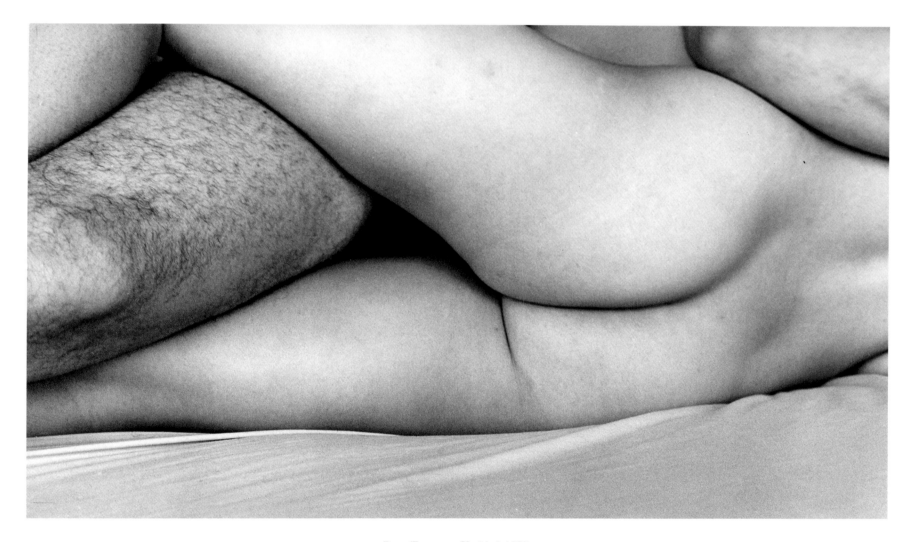

167

RON TERNER, *Untitled*, 1972

ERWIN BLUMENFELD, *Wet Veil*, 1937

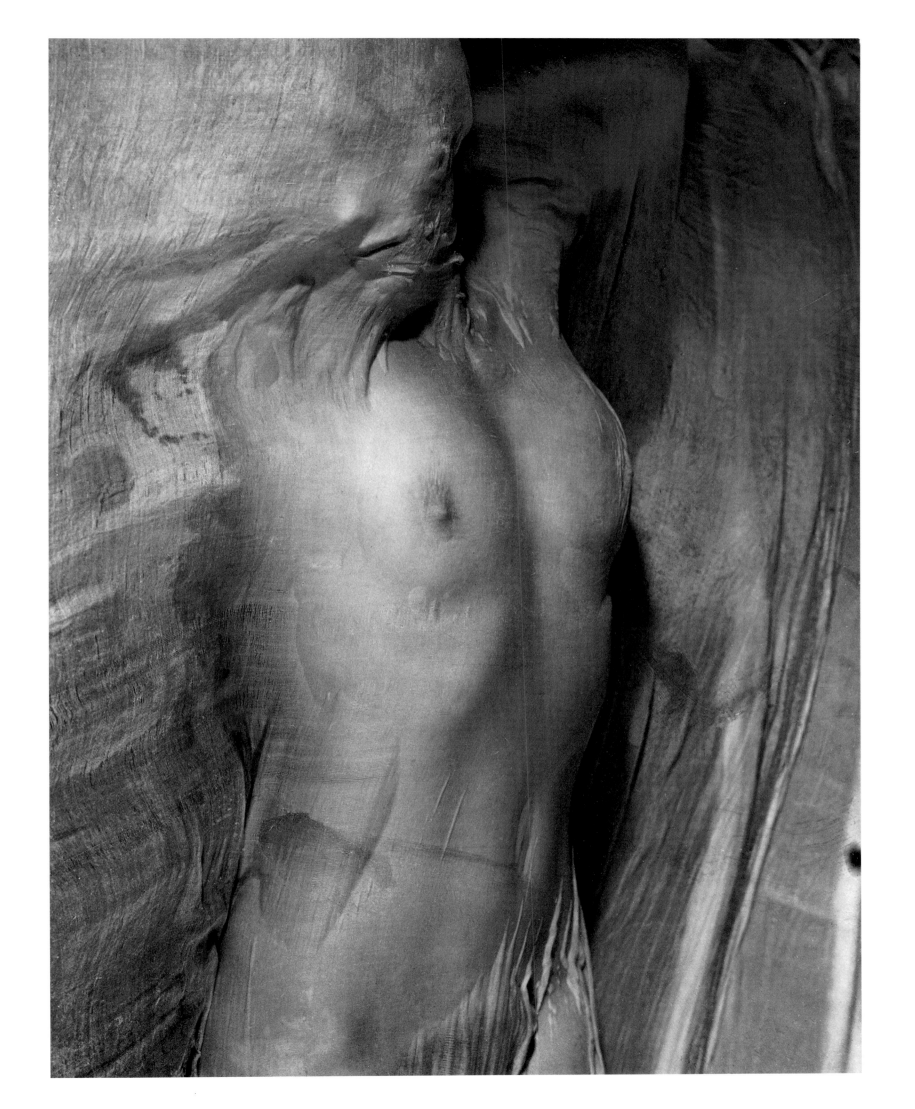

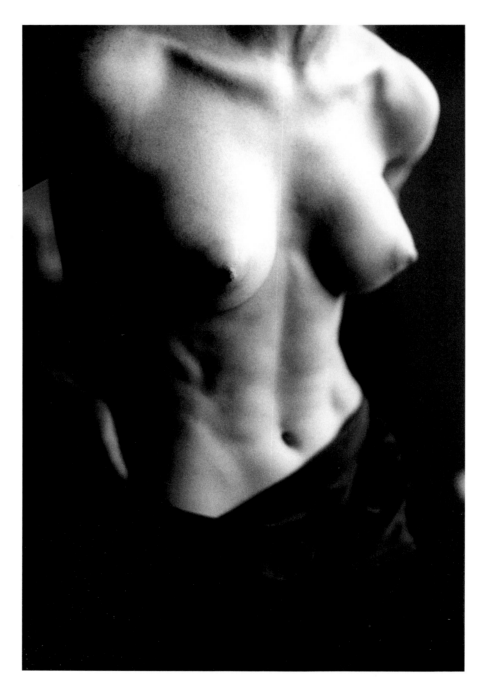

ANDREW BRUCKER, *Melora*, 1989

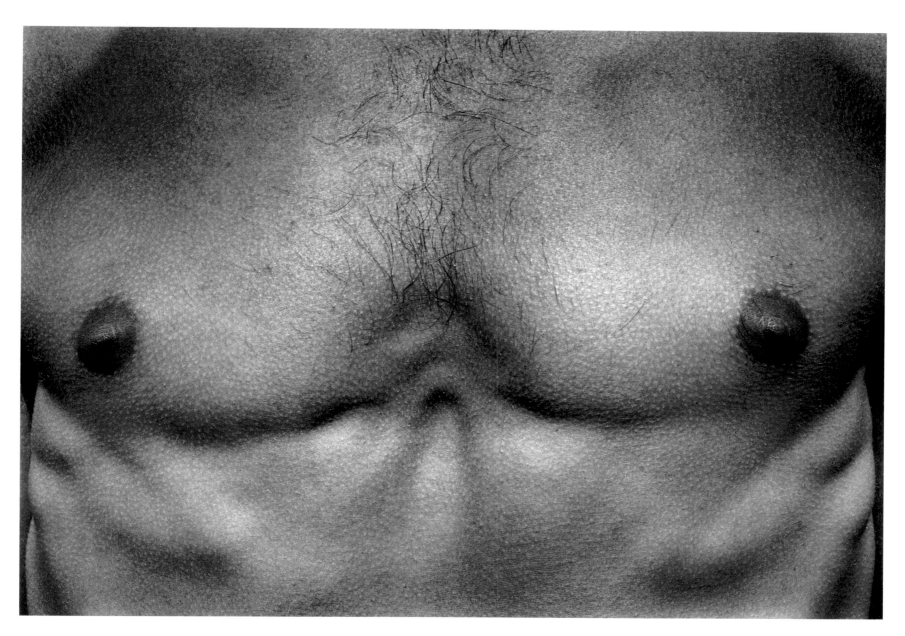

DIANORA NICCOLINI, *The Male Chest*, 1975

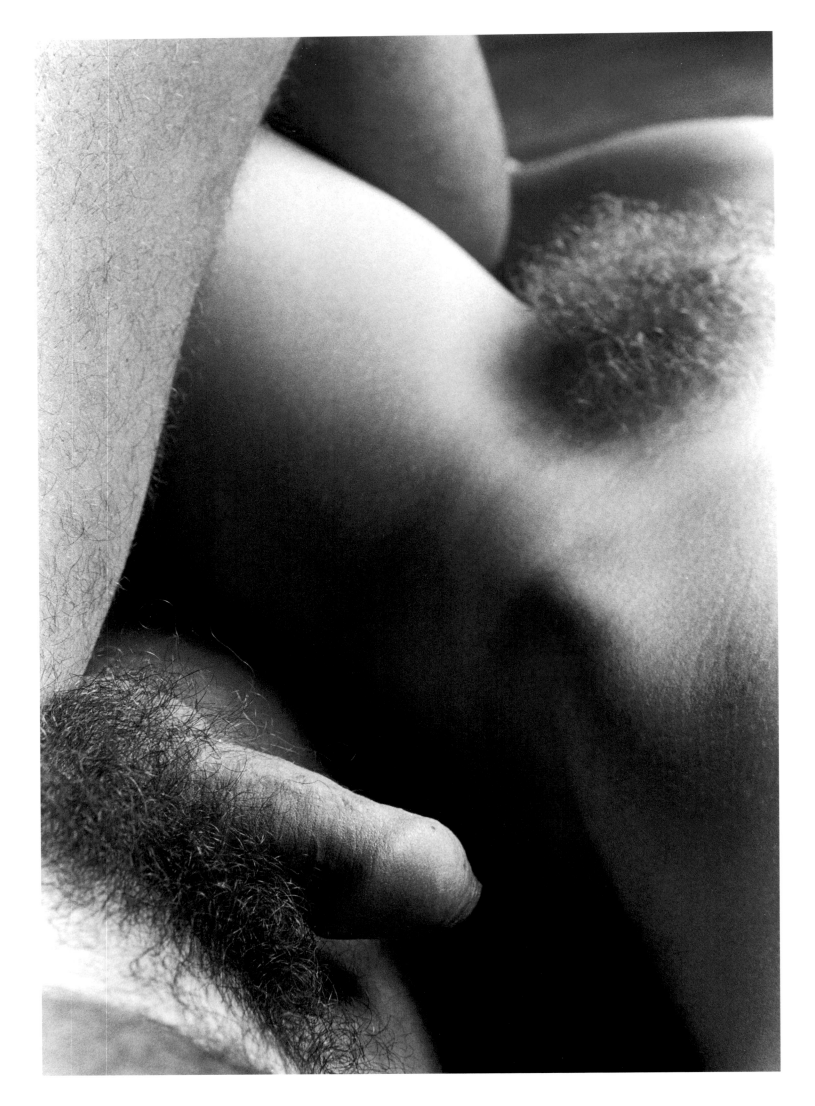

When we have loved, my love,

Panting and pale from love,

Then from your cheeks, my love,

Scent of the sweat I love:

And when our bodies love

Now to relax in love

After the stress of love,

Ever still more I love

Our mingled breath of love.

—SANSKRIT,
translated by John Brough

173

SUZANNE PASTOR, *Untitled*, from the series *Body Still-Lifes*, 1980

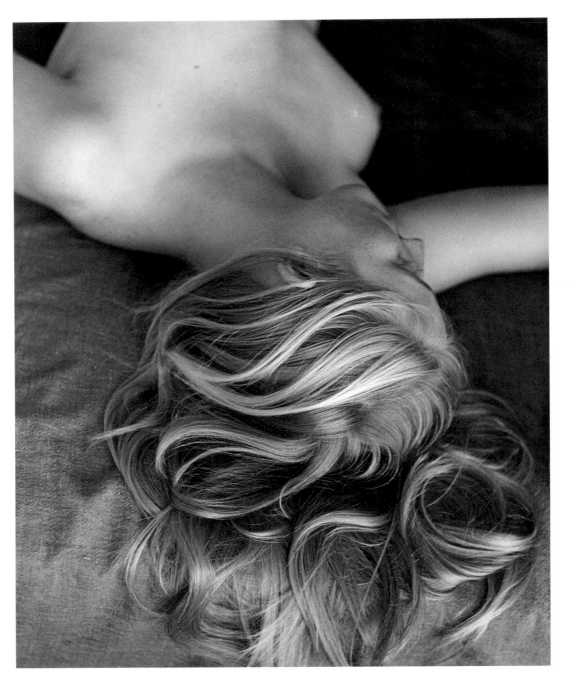

IMOGEN CUNNINGHAM, *Phoenix Recumbent*, 1968

KARIN ROSENTHAL, *Untitled*, 1983

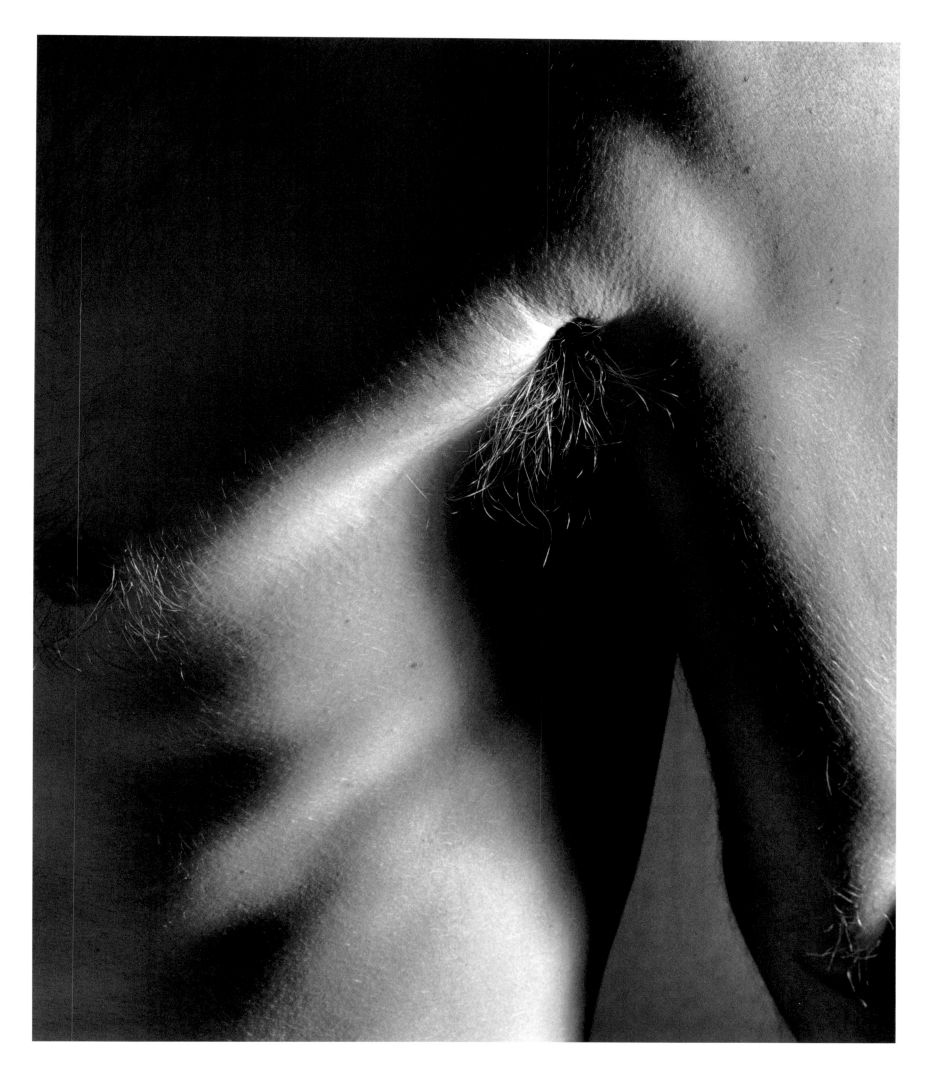

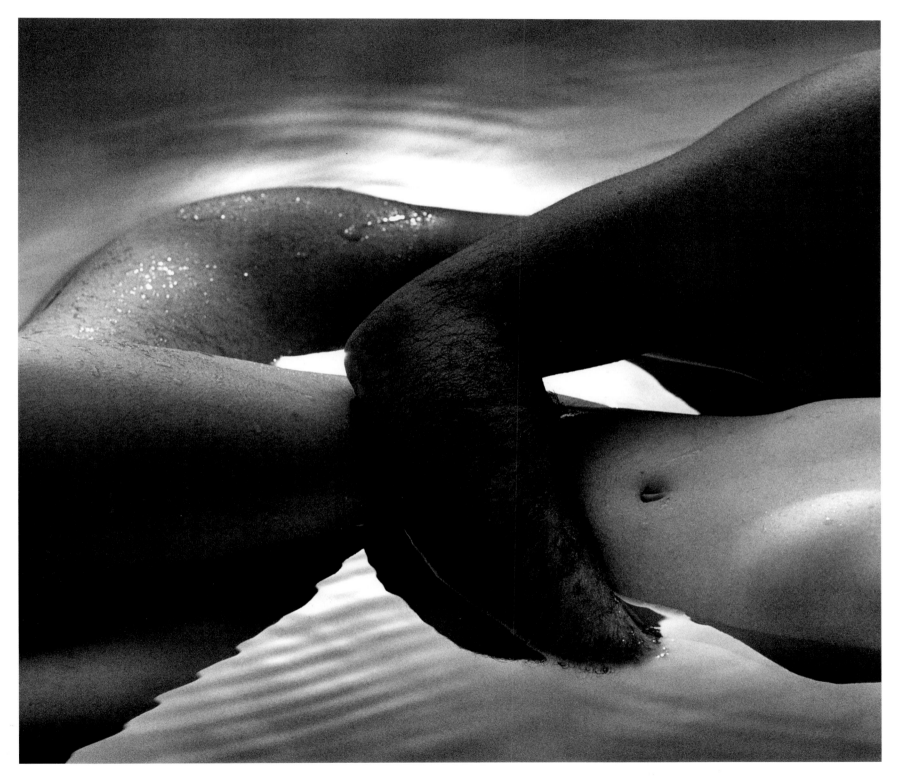

KARIN ROSENTHAL, *Love Knot*, 1991

To enter that rhythm where the self is lost,

where breathing : heartbeat : and the subtle music

of their relation make our dance, and hasten

us to the moment when all things become

magic, another possibility.

That blind moment, midnight, when all sight

begins, and the dance itself is all our breath,

and we ourselves the moment of life and death.

Blinded; but given now another saving,

the self as vision, at all times perceiving,

all arts all senses being languages,

delivered of will, being transformed in truth —

for life's sake surrendering moment and images,

writing the poem; in love making; bringing to birth.

—MURIEL RUKEYSER, *To Enter That Rhythm Where the Self is Lost*

178

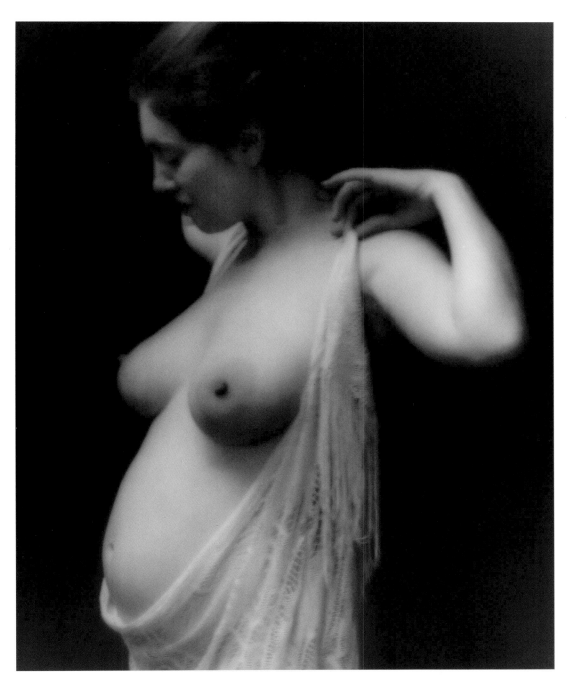

EDNA BULLOCK, *Michaelle with Scarf*, 1986

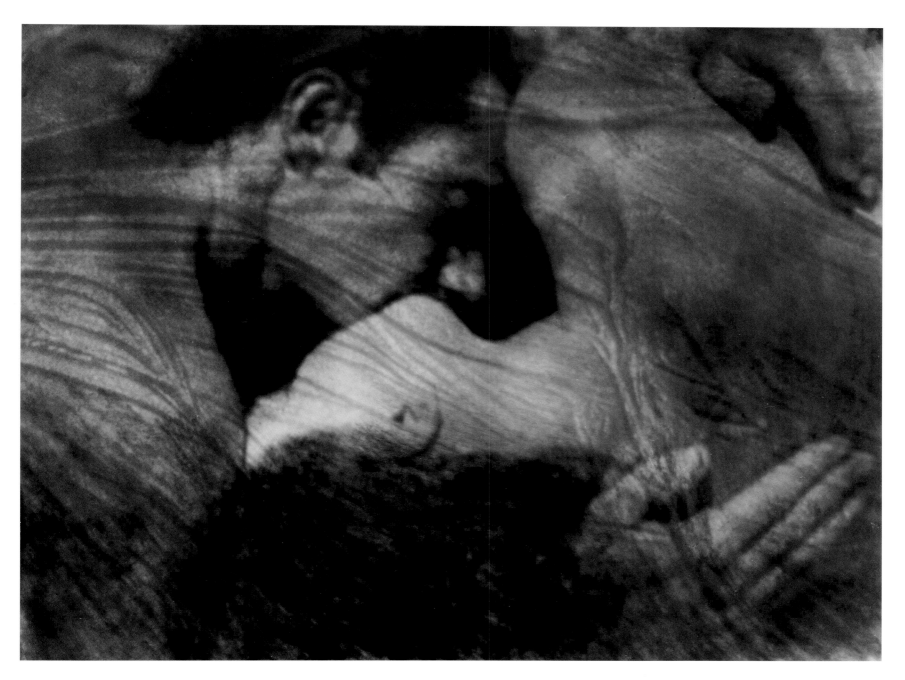

ANNE BRIGMAN, *Quest*, 1931

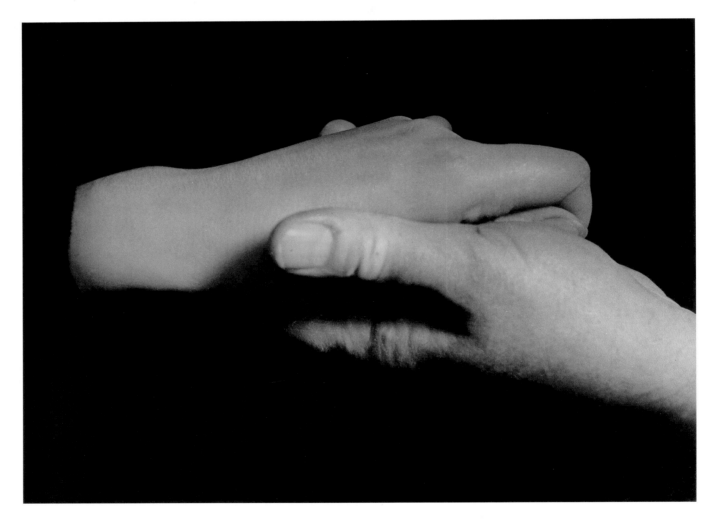

Brassaï, *Pigeondre*, 1934

look

my fingers,which

touched you

and your warmth and crisp

littleness

—see?do not resemble my

fingers. My wrists hands

which held carefully the soft silence

of you(and your body

smile eyes feet hands)

are different

from what they were. My arms

in which all of you lay folded

quietly,like a

leaf or some flower

newly made by Spring

Herself,are not my

arms. I do not recognise

as myself this which i find before

me in a mirror. i do

not believe

i have ever seen these things;

someone whom you love

and who is slenderer

taller than

myself has entered and become such

lips as i use to talk with,

a new person is alive and

gestures with my

or it is perhaps you who

with my voice

are

playing.

183

—E. E. CUMMINGS, *III, 8,* from *Poems from the 1920s*

I had long known the diverse tastes of the wood,
Each leaf, each bark, rank earth from every hollow;
Knew the smells of bird's breath and of bat's wing;
Yet sight I lacked: until you stole upon me,
Touching my eyelids with light finger-tips.
The trees blazed out, their colours whirled together,
Nor ever before had I been aware of sky.

—ROBERT GRAVES, *Gift of Sight*

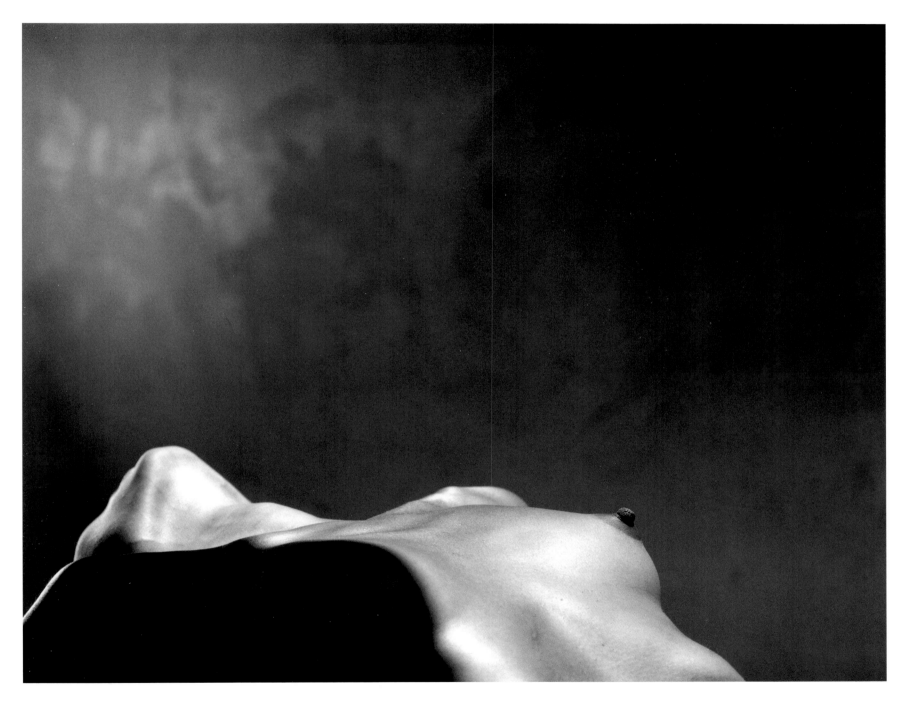

GREG GORMAN, *Marlenné Horizontal*, 1988

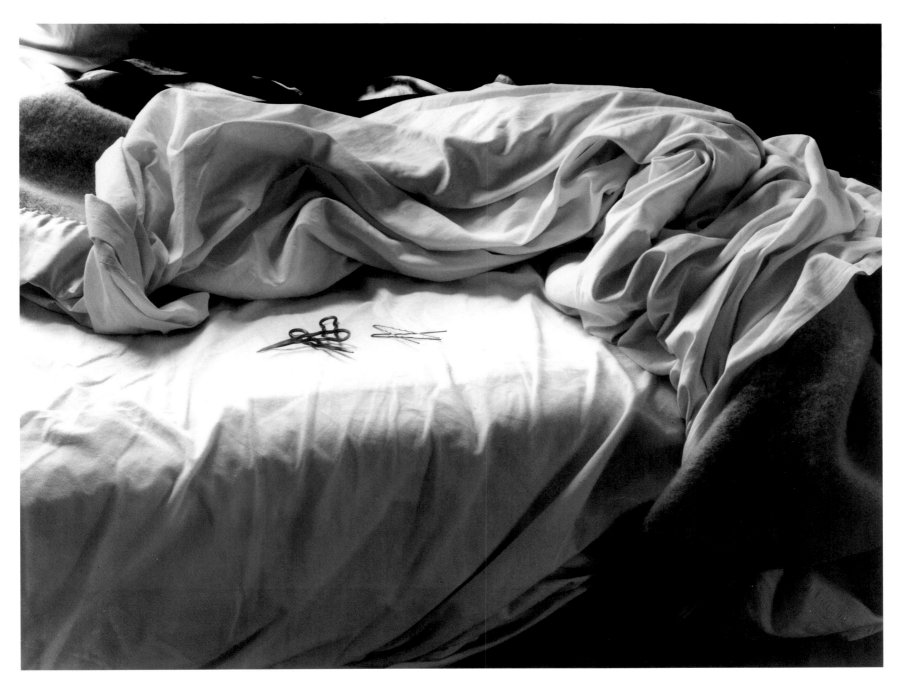

IMOGEN CUNNINGHAM, *The Unmade Bed*, 1957

Compilation copyright © 1996 Welcome Enterprises, Inc.

Photographs copyright © individuals or estates as noted specifically on pages 190–191, which constitute an extension of this page.

Texts copyright © individuals or publishers as noted specifically on page 189, which constitutes an extension of this page.

Note: Every effort has been made to locate the individual copyright owners of the material used in the book. In the event of an error, please contact the publisher and all necessary changes will be made in subsequent printings.

All rights reserved. No part of the contents of this book may be reproduced by any means whatsoever without the written permission of the publisher.

Produced by Welcome Enterprises, Inc.
575 Broadway, New York, NY 10012

Project Directors: Hiro Clark, Ellen Mendlow
Designer: Gregory Wakabayashi
Project Manager: Rachel Balkcom

Published in 1996 and distributed in the U.S. by
Stewart, Tabori & Chang, Inc.,
a division of U.S. Media Holdings, Inc.
575 Broadway, New York, NY 10012

Distributed in Canada by
General Publishing Company Ltd.
30 Lesmill Road, Don Mills, Ontario, Canada M3B 2T6

Distributed in Australia and New Zealand by
Peribo Pty Ltd.
58 Beaumont Road, Mount Kuring-gai, NSW 2080, Australia

Distributed in all other territories by
Grantham Book Services Ltd.
Isaac Newton Way, Alma Park Industrial Estate
Grantham, Lincolnshire NG31 9SD, England

Library of Congress Cataloging-in-Publication Data

Eros / curator of photographs, Linda Ferrer ; text editor, Jane Lahr.
 p. cm.
 "A welcome book."
 ISBN 1-55670-487-9
 1. Photography, Erotic. 2. Erotic literature. I. Ferrer, Linda. II. Lahr, Jane.
TR676.E7 1996
779' .28--dc20 96-20761
 CIP

The plates were printed in duotone on 150gsm Biberist Allegro coated demi-matte.
The type was set in Monotype Walbaum.

Printed and bound in Italy by Arnoldo Mondadori Editore
10 9 8 7 6 5 4 3 2 1

Grateful acknowledgment is made for the following literary sources:

p. 1: "To Eros" from *Sappho and the Greek Lyric Poets*, translated by Willis Barnstone, Schocken Books, 1972. Copyright © 1962, 1967, 1988 by Willis Barnstone.

p. 5: From "The Force That Through the Green Fuse Drives the Flower" by Dylan Thomas, from *The Poems of Dylan Thomas*. Copyright © 1939 by New Directions Publishing Corp. Reprinted by permission of New Directions Publishing Corp.

p. 17: "i think of you" by Kalamu ya Salaam. Copyright © 1992 by Kalamu ya Salaam. Reprinted by permission of the author.

p. 21: From *The World of Sex* by Henry Miller. Copyright © 1959 by Henry Miller; © 1965 by Grove Press, Inc. Used by permission of Grove/Atlantic, Inc.

p. 33: "Book of Ancestors, Part III" from *You Are Happy, Selected Poems 1965–1975* by Margaret Atwood. Copyright © 1976 by Margaret Atwood. Reprinted by permission of Houghton Mifflin Company. All rights reserved.

pp. 46 and 130: "Help Me With the Buttons" and "Peaches" from *Letters from the Floating World*, by Siv Cedering, copyright © 1984. Reprinted by permission of the University of Pittsburgh Press.

p. 68: From *My Life and Loves* by Frank Harris. Copyright © 1925 by Frank Harris; © 1953 by Nellie Harris; © 1964 by Arthur Leonard Ross as Executor of the Frank Harris Estate. Copyright renewed © 1991 by Ralph G. Ross and Edgar M. Ross. Used by permission of Grove/Atlantic, Inc.

p. 72: "Odor" from *To The Center of The Earth* by Michael Fried. Copyright © 1994 by Michael Fried. Reprinted by permission of Farrar, Straus & Giroux, Inc.

pp. 79 and 90: From *Written on the Body* by Jeanette Winterson. Copyright © 1993 by Jeanette Winterson. Reprinted by permission of Alfred A. Knopf, Inc.

p. 80: From *Fanny Hill* by John Cleland, Penguin Classics, 1985.

pp. 101, 124, and 183: "i like my body when it is with your", copyright 1923, 1925, 1951, 1953, © 1991 by the Trustees for the E. E. Cummings Trust. Copyright © 1976 by George James Firmage, "she being Brand", copyright 1926, 1954, © 1991 by the Trustees for the E. E. Cummings Trust. Copyright © 1985 by George James Firmage, "look", copyright © 1973, 1983, 1991 by the Trustees for the E. E. Cummings Trust. Copyright © 1973, 1983 by George James Firmage, from *Complete Poems: 1904–1962* by E. E. Cummings, Edited by George James Firmage. Reprinted by permission of Liveright Publishing Corporation.

p. 104: From *Talk Dirty to Me* by Sallie Tisdale. Copyright © 1994 by Sallie Tisdale. Used by permission of Doubleday, a division of Bantam Doubleday Dell Publishing Group, Inc.

p. 116: "Because I am tactful and lewd" by Rick Kempa. Copyright © 1996 by Rick Kempa. Originally published in *Yellow Silk: Journal of Erotic Arts*.

p. 126: *Shoes* by Lawanda Powell. Copyright © 1994 by Lawanda Powell. Reprinted by permission of the author.

p. 134: From *Fear of Fifty* by Erica Jong. Copyright © 1994 by Erica Jong. Reprinted by permission of HarperCollins Publishers, Inc.

p. 145: From "Elena" in *Delta of Venus, Erotica* by Anaïs Nin. Copyright © 1977 by The Anaïs Nin Trust. Reprinted by permission of Harcourt Brace & Company.

p. 148: by anonymous, translated by Noel Stock, from *Love Poems of Ancient Egypt*. Copyright © 1962 by Noel Stock. Reprinted by permission of New Directions Publishing Corp.

p. 153: From *Lady Chatterley's Lover* by D. H. Lawrence, Bantam Classic edition, Bantam Books, 1983. Reprinted by permission of Laurence Pollinger Ltd. and the Estate of Frieda Lawrence Ravagli.

p. 156: *Speaking in Tongues* by Carson Reed. Copyright © 1994 by Carson Reed. Originally published in *Yellow Silk: Journal of Erotic Arts*.

p. 158: "Seedbed" by Noelle Caskey. Copyright © by Noelle Caskey. Originally published in *Yellow Silk: Journal of Erotic Arts*.

p. 162: "Insatiable" by Opal Palmer Adisa. Copyright © by Opal Palmer Adisa. Reprinted by permission of the author.

p. 173: "When we have loved, my love" from *Poems from the Sanskrit*, translated by John Brough, Penguin Classics, 1968. Copyright © 1968 by John Brough. Reproduced by permission of Penguin Books Ltd.

p. 178: "To Enter That Rhythm Where the Self is Lost" by Muriel Rukeyser, from *The Collected Poems of Muriel Rukeyser*, McGraw-Hill, 1982. Copyright © by Muriel Rukeyser.

p. 184: "Gift of Sight" by Robert Graves, from *Collected Poems 1975*. Copyright © 1975 by Robert Graves. Reprinted by permission of Oxford University Press, Inc.

95 ROBERT MAPPLETHORPE
Lisa Lyon, 1981
© 1981 The Estate of
Robert Mapplethorpe

96 BLAKE LITTLE
The Balance, 1992
© 1992 Blake Little
Courtesy of Wessel O'Connor Gallery,
New York

97 MAN RAY
Main sur lèvres, 1929
© 1996 Artists Rights Society (ARS),
New York/ADAGP/Man Ray Trust, Paris
Courtesy of Telimage, Paris

98 KEITH CARTER
Moon and Star, 1989
© 1989 Keith Carter
Courtesy of Paul Kopeikin Gallery,
Los Angeles, and Gallery of
Contemporary Photography, Santa
Monica

99 JEANLOUP SIEFF
Nu montant un escalier, 1976
© 1976 Jeanloup Sieff

100 ANDREW ECCLES
Couple Embracing 3, 1994
© 1994 Andrew Eccles

102 ANDREW ECCLES
Couple Embracing 1, 1994
© 1994 Andrew Eccles

103 ANDREW ECCLES
Couple Embracing 2, 1994
© 1994 Andrew Eccles

105 MANUEL ALVAREZ BRAVO
El trapo negro, 1986
© 1986 Manuel Alvarez Bravo
Courtesy of The Witkin Gallery,
New York

107 ALBERT WATSON
Charlotte, Torso, NYC, July 26, 1988
© 1988 Albert Watson

108 HOWARD SCHATZ
Torso, 1995
© 1995 Howard Schatz and
Beverly Ornstein

109 ROBERT MAPPLETHORPE
Derrick Cross, 1982
© 1982 The Estate of
Robert Mapplethorpe

110 KARIN ROSENTHAL
Untitled, 1983
© 1983 Karin Rosenthal

111 EDWARD WESTON
Nude, 1934
© 1981 Center for Creative Photography,
Arizona Board of Regents

113 ROBERT MAPPLETHORPE
Christopher Holly, 1980
© 1980 The Estate of
Robert Mapplethorpe

115 BARBARA BORDNICK
Nude: Blurred Embrace, 1996
© 1996 Barbara Bordnick

117 JOHN SCHLESINGER
Untitled, 1994-5
© 1994-95 John Schlesinger
Courtesy of Julie Saul Gallery, New York

119 LEONARD FREED/MAGNUM PHOTOS
Lovers in a bed, 1971
© 1971 Leonard Freed

120 HELMUT NEWTON
Woman Examining Man, 1975
© 1975 Helmut Newton
Courtesy of tutti i diritti riservati, Milan

121 DAVID SELTZER
Her Men Had No Faces, 1989
© 1989 David Seltzer
Courtesy of Yancey Richardson
Gallery, New York

123 HELMUT NEWTON
Office Love, 1976
© 1976 Helmut Newton
Courtesy of tutti i diritti riservati, Milan

124–25 ARTHUR ELGORT
Helena in Limousine, Los Angeles, 1990
© 1990 Arthur Elgort
Courtesy of Staley-Wise Gallery,
New York

129 HELMUT NEWTON
The Shoe, 1983
© 1983 Helmut Newton
Courtesy of tutti i diritti riservati, Milan

131 MAN RAY
La prière, 1930
© 1996 Artists Rights Society (ARS),
New York/ADAGP/Man Ray Trust, Paris
Courtesy of Telimage, Paris

132 HORST
American Nude I, NY, 1982
© 1982 Horst
Courtesy of Staley-Wise Gallery,
New York

133 TOMAS SENNETT
Untitled, 1982
© 1982 Tomas Sennett

137 JUDY DATER
Lovers #2, 1964
© 1964 Judy Dater

138 GREG GORMAN
Male Torso, 1988
© 1988 Greg Gorman

139 WAYNE MASER
Untitled
© Wayne Maser
Courtesy of A + C Anthology/
Staley-Wise Gallery

141 DAVID LEVINTHAL
Untitled, from the series *Desire*, 1991
© 1991 David Levinthal

142 MANUEL ALVAREZ BRAVO
La tela de la araña, 1989
© 1989 Manuel Alvarez Bravo
Courtesy of The Witkin Gallery,
New York

143 JEANLOUP SIEFF
Alice's Mirror, 1976
© 1976 Jeanloup Sieff

144 GULNARA SAMOILOVA/STEVEN KASHER
Untitled, from the series *Scenes*, 1995
© 1995 Gulnara Samoilova/
Steven Kasher
Courtesy of Yancey Richardson
Gallery, New York

146–47 LUCIEN CLERGUE
Les Géantes, 1978
© 1978 Lucien Clergue
Courtesy of Collection, Center for
Creative Photography

149 CHRISTINA HOPE/GRAPHISTOCK
First Light I, 1990
© 1990 Christina Hope

151 ANDREW BRUCKER
Untitled, 1990
© 1990 Andrew Brucker

152 IMOGEN CUNNINGHAM
Nude, 1923
© 1923 The Imogen Cunningham Trust

154 LINDA CONNOR
Hand and Foot, 1975
© 1975 Linda Connor
Courtesy of Paul Kopeikin Gallery,
Los Angeles

155 BARBARA BORDNICK
Untitled, 1996
© 1996 Barbara Bordnick

157 RON TERNER
Untitled, 1985
© 1985 Ron Terner
Courtesy of Focal Point Gallery,
City Island, New York

159 SANDI FELLMAN
From the series *Secrets*, 1977
© 1977 Sandi Fellman

160 FRÉDÉRIC BARZILAY
Woman in Bed, 1983
© 1996 Frédéric Barzilay

161 LEEANNE SCHMIDT
Untitled, 1993
© 1993 Leeanne Schmidt
Courtesy of Gallery 292, New York

163 LISA SPINDLER/GRAPHISTOCK
Couple Embracing, 1990
© 1990 Lisa Spindler

164 LISA SPINDLER
Bending Torso, 1991
© 1991 Lisa Spindler

165 DIANORA NICCOLINI
Untitled, 1981
© 1981 Dianora Niccolini

167 RON TERNER
Untitled, 1972
© 1972 Ron Terner
Courtesy of Focal Point Gallery,
City Island, New York

169 ERWIN BLUMENFELD
Wet Veil, 1937
© 1996 Blumenfeld Estate

170 ANDREW BRUCKER
Melora, 1989
© 1989 Andrew Brucker

171 DIANORA NICCOLINI
The Male Chest, 1975
© 1975 Dianora Niccolini

172 SUZANNE PASTOR
Untitled, from the series
Body Still-Lifes, 1980
© 1980 Suzanne Pastor

174 IMOGEN CUNNINGHAM
Phoenix Recumbent, 1968
© 1968 The Imogen Cunningham Trust

175 KARIN ROSENTHAL
Untitled, 1983
© 1983 Karin Rosenthal

177 KARIN ROSENTHAL
Love Knot, 1991
© 1991 Karin Rosenthal

179 EDNA BULLOCK
Michaelle with Scarf, 1986
© 1986 Edna Bullock

181 ANNE BRIGMAN
Quest, 1931
Courtesy of George Eastman House

182 BRASSAÏ
Pigeondre, 1934
Photographie Brassaï
© 1996 Estate Brassaï

185 GREG GORMAN
Marlenné Horizontal, 1988
© 1988 Greg Gorman

187 IMOGEN CUNNINGHAM
The Unmade Bed, 1957
© 1957 The Imogen Cunningham Trust

ACKNOWLEDGMENTS

The producers would like to acknowledge and thank the following
individuals for their contributions to the creation of this book:

Wendy Burton; Virginia Dodier at The Erna and Victor Hasselblad
Photography Study Center; Daniela Ferro at tutti i diritti riservati; Paul
Kopeikin; Phyllis Levine; Dolores Lusitana; Jennifer Miller; Dianne Nilsen
and Marcia Tiede at the Center for Creative Photography; Kelly O'Neil at
A + C Anthology; Ruby Palmer; Elizabeth Partridge at The Imogen
Cunningham Trust; Lily Pond and Shelly Hebert of *Yellow Silk: Journal of
the Erotic Arts*; Yancey Richardson; Lucia Siskin at The International Center
for Photography Library; Michelle Slung; Jean-Marc Vlaminck; and Barbara
Bullock Wilson.

Special thanks to Lena Tabori for her unique vision and unwavering heart.